"In a genre that's been overwhelmed with Ted Bundy's poisonous tale, at last we get an antidote: a full-length memoir from one of his victims, arguing that she's so much more than one of his victims. A compelling and encouraging account of survival from someone who's been the footnote in a serial killer's story for far too long."

—**Tori Telfer**, author of *Confident Women*

"*A Light in the Dark* puts the story of unimaginable crime exactly where it belongs: with the victims, not the monster. Kleiner Rubin and Lucchesi bear witness and speak for those who cannot. Unflinching, resolute, and above all compassionate, Kleiner Rubin and Lucchesi give us a powerful story about the resilience of the human soul."

—**Arnie Bernstein**, author of *Bath Massacre*

"A coming-of-age narrative wrapped inside a survivor's testimony, Kleiner Rubin and Lucchesi put another crack in the myth of Ted Bundy, not just with Kleiner Rubin's own life story but also with the stories of the other women and girls who met with Bundy's violence."

—**David Nelson**, author of *Boys Enter the House*

"In this era with the fascination of the true crime genre, Kleiner Rubin emphasizes she is a real person who is more than a survivor of Ted Bundy. . . . A must read for anybody who wants to better understand the impact serial predators have on victims and their loved ones."

—**Paul Holes**, author of *Unmasked*

A LIGHT IN THE DARK

SURVIVING MORE THAN
TED BUNDY

KATHY KLEINER RUBIN
AND EMILIE LE BEAU LUCCHESI

CHICAGO
REVIEW
PRESS

First hardcover edition published in 2024
First paperback edition published in 2025
Published by Chicago Review Press Incorporated
814 North Franklin Street
Chicago, Illinois 60610
ISBN 978-0-89733-411-2

The Library of Congress has cataloged the hardcover edition under
the following Control Number: 2023938599

Cover design and typesetting: Jonathan Hahn
Cover image: Lane V. Erickson / Shutterstock
All interior images from the author's collection

Printed in the United States of America

In memory of all the women and girls
whose lights were extinguished by Ted Bundy

CONTENTS

AUTHOR'S NOTE

IN THIS BOOK, some names have been changed or omitted to protect the individual's privacy. Only the first names of survivors and key witnesses are used, to allow these women privacy and the right to control their own narrative.

PREFACE

New Orleans, Louisiana
April 2021

CREPT INTO THE attic looking for memories. I passed boxes with the Christmas decorations and my son's old baseball cards. Among the happier memories of my life, I had also saved documents related to Ted Bundy, the notorious serial killer. The man who tried to murder me in 1978. One box was labeled BUNDY NEWSPAPERS in large letters. I hauled it downstairs and began to sift through the yellowed newsprint and folded letters. My mother had saved most of these news articles. She started when the papers first reported how I was hospitalized after the Chi Omega sorority house murders. She continued clipping through the years until Bundy was finally executed in 1989. Mama didn't like to speak about the attack, and she seemed to think that staying quiet was the best way to protect me. The stacks of articles reminded me how the attack hurt her as well. Most people didn't realize how far the pain of Bundy's violence stretched. It reached well past the victims and touched anyone who ever loved them. They

never saw the world the same way again. Even as their days settled back into a routine, life had a new hue.

I found a smaller box within the BUNDY NEWSPAPERS box filled with my wedding mementos. There were napkins that read SCOTT AND KATHY, and small bags of rice for guests to toss. Many people might have thought that party favors didn't belong with a news article about Bundy's execution in the electric chair. But it fit my story. I had married months after Bundy was executed. I boxed up my memories, moved to a new state, and pushed forward with my life. More than thirty women and girls never did the same. Bundy viciously cut their lives short. I often worried that these women had become nameless shadow figures while Bundy had become legendary.

Bundy's story has been told countless times in books, documentaries, and television series. But what about the victims? What about the stories of the dozens of women and girls who were murdered by this monster? Where was their story? It couldn't be found in the fading newspaper articles. Reporters typically had several hundred words to inform readers about Bundy's arrest, trial, or execution. The victims' quotes or statements by their families were trimmed down to mere sentences. And the amount of misinformation in these clippings was staggering. Most newspapers reported that I didn't remember the attack and insinuated that I had nothing to say. That was not the truth. I remembered the attack vividly. I still remember, all these years later, attending the deposition and the trial. And I can distinctly recall the day he was finally put to death.

Victims like me have a story to tell. My story is painful and violent, but I am a survivor. I endured childhood lupus, survived Ted Bundy, and withstood early-onset breast cancer. Now I want people to remember the Bundy victims who are not here to speak their truth. These victims have become numbers. Their entire lives have been reduced to the times and places where they were murdered. I know there is so much more to their life stories, just as there is more to mine.

And so I tell my story on behalf of the dozens of Bundy victims who cannot speak for themselves. All the popular Bundy narratives have pushed these women into the shadows and made them secondary to the demon who killed them. My hope is that my story shines a light into this space that has been too dark for too long.

1

I SLOWLY BEGAN TO die when I was twelve years old. Physicians didn't know what was killing me. They only knew the prognosis was grim and my parents should prepare themselves. They would have to tell my older sister, then in high school, that I wasn't coming home from the hospital. They would have to call my brother at college and tell him to return to Florida for my funeral. They would have to pick out a small casket and see if the cemetery in Miami would make room near my biological father's grave. Then they would have to brace themselves for the string of well-meaning but unhelpful comments. *She was too young. At least she is no longer suffering. She is with her father now.*

The vague prognosis was my first death sentence—the first of three I would experience in the next two decades. It wasn't the same type of death sentence that a jury gives as a punishment for a crime. It was a warning that my life was coming to an end and I was powerless to stop it. I didn't want to die. I wanted to return to the time before my body began attacking itself and my kidneys started to fail.

The symptoms had come like a unified force ready to fight me for my life. I had a low-grade fever, a rash that spread across my nose and

cheeks, and a constant feeling of exhaustion. In physical education class, we had to take the President's Fitness Challenge to see how fast we could run and how many pull-ups we could do. Our scores were compared nationally to other sixth graders, and the top 15 percent earned recognition. I think I must have been in the bottom percentile. I was too fatigued to even make it past the first few events. I sat to the side and watched as the other kids tried to see how many sit-ups they could do in a minute. Some of the kids actually cared. They wanted to know they were one of the fastest boys or girls in the country. They eagerly awaited the challenge's second test in the springtime to see if they had improved. I didn't know it yet, but I'd be in the hospital with organ failure by then.

I soon became the last one picked for volleyball or kickball. At recess, I sat next to the teacher on a playground bench while the other kids ran and shrieked. They were eager to expel all the energy they had contained while they were sitting at their desks. That had been me at the beginning of sixth grade, and then I began fading as the weeks passed. Soon I couldn't dangle from the monkey bars or pump my legs on the swing. I sat next to the teacher with my head in my hands, yearning to hear the final dismissal bell. After school, my sister readied herself for her activities as I climbed into bed and pulled up the covers. In my old life, I had loved to dance and perform. I had been enrolled in jazz and tap classes at the local community center, but I no longer had the stamina to attend.

There were so many parts of my daily routine that splintered and fell apart. I was new to my current elementary school, and I met a few neighborhood girls who rode their bicycles each morning. I joined them at the beginning of the semester, even though my parents were nervous and my dad followed behind in his car. I happily rode my pink bike with the banana seat and streamers flowing from the high handlebars. By the holiday break, I struggled to pedal and I fell behind the other girls. Mama made arrangements for the school bus to pick

me up directly outside the house. The other kids had to wait at a designated bus stop, and my special treatment signaled to them—and to me—that something was different about me. I was the sick kid.

In my old life, I arrived at school early to work at the school store that sold pencils, notebooks, and other supplies. The store was just a utility closet, and I sat in the doorway with another sixth grader, waiting for customers. It was an easy job, but it soon exhausted me. I quit within a few months. My now husband was a student in the other sixth-grade class. He used to buy his supplies from the little store, but he has no memory of me selling him his protractor and number two pencils. That's how diminished I had become. I dragged behind the daily rhythm of the school, and no one noticed me fall back.

My parents were anxious about my health and they took me to my pediatrician. He wasn't sure what was wrong with me, and he referred me to a physician at a children's hospital in Miami. In the spring of 1970, I shuffled into the Miami doctor's office and sat with slumped shoulders on the examining table. The situation was dire, the doctor told my parents. I needed to be hospitalized that day. I remained there for the next three months. My parents tried to make my hospital room appear less sterile and severe. They brought in my stuffed animals and a colorful knit blanket. My older sister, Marilynn, made it her job to monitor the helium balloons near my bed. She swapped them out with fresh ones from the gift shop whenever one of the balloons began to sink.

In my old life, our family visited Mama's parents in the Florida Keys during the summer. My grandfather, whom we called Papa, owned a seafood restaurant in Key Largo. I'd go every morning with him to the pier as he haggled with the fishmongers and picked the catch of the day. I'd spend the rest of the day swimming with my sister. We'd visit Papa at his restaurant, using the back door to slip into the kitchen and help ourselves to buttered Florida lobster. Papa didn't speak much English, and Marilynn and I didn't speak any Spanish.

But we understood each other, and I loved visiting my grandparents. From my hospital bed, my summers in the Keys seemed as though they were from another lifetime. I remembered how my grandmother used to give me a towel and tell me to collect key limes from a tree in her yard so she could make a pie. The energetic girl who carried a bundle of limes was long gone.

My medical team didn't understand what had brought on my death sentence or how they could stop it. Teams of physicians circled around my bed, glanced at my chart, and asked each other questions to determine if I needed more tests. The medical team typically spoke to each other, and to Mama as well, in Spanish. I didn't know Spanish and I didn't comprehend their medical terms, but I understood the meaning of their concerned faces. The pursed lips and frowning faces continued to visit my hospital room each week, and each week I showed no improvement. Nothing they tried was working, and tests revealed my kidney function was worsening.

My parents made sure that a family member was with me at all times. This wasn't easy, because our house in Fort Lauderdale was at least an hour's drive from the hospital, and it wasn't a quick commute. Mama recruited my two aunts, Linda and Grace, to stand in when she was busy at work. I know one of them was with me when I had the kidney biopsy, I just can't remember which one of them had to watch it happen. A nurse wheeled me into a huge, sterile operating room, where a doctor waited near the steel examining table. They directed me to lie facedown on the cold metal table while they pushed a biopsy needle into my back, through my muscles and into my kidney. They didn't give me any anesthesia, and I felt as though I had been stabbed. I howled in pain as the doctor removed the needle and the nurse put a Band-Aid over the puncture wound. It seemed unreal that a procedure that caused such agony concluded with a mere Band-Aid.

The kidney biopsy confirmed what my medical team suspected. My left kidney had stopped functioning. A surgical team made plans

to remove the failed organ. When my aunts visited, Mama told them in Spanish what was happening. Spanish was her secret language in front of the children so that we couldn't understand important adult discussions. She always said she wanted her kids to be American, not Cuban, and my Spanish was limited to phrases learned from a text-book, like *¿Dónde está la biblioteca?* I was fluent, however, in reading my mother's facial expressions. I could tell she worried I was fading fast and the doctors wouldn't be able to save me. The night before my operation, Mama allowed Aunt Grace and her husband to visit along with members of their church. There must have been a dozen people around my hospital bed. They prayed over me in Spanish and put their hands on me to try to heal me with prayer. I passively watched these visitors as they closed their eyes, lifted their hands, and called for a miracle. I didn't understand their words either, but I understood the situation was desperate.

I woke up feeling agitated the next morning. It felt as though some of my energy had returned. I insisted I didn't need surgery and that something had improved overnight. My change in behavior prompted the medical team to run another test before they prepped me for surgery. The test revealed my kidney function had improved. My aunt was convinced her prayer had brought on a miracle. To my parents, skipping the surgery was merely a reprieve. I still didn't have a diagnosis, and my doctors still didn't have much hope. After three months, my medical team released me from the hospital and sent me home to be more comfortable.

Mama had made connections at the hospital, and she wasn't done fighting for me. She brought me to see Dr. Marta Teresita Lavastida in Miami. Dr. Lavastida was a recent refugee from Cuba, and I thought she was remarkably beautiful. She had long, dark hair and beautiful olive skin. She didn't wear much makeup, and she pulled her hair back into a sensible low ponytail. She still struck me as glamorous. I waited while Mama and the doctor spoke in Spanish about me and my

case. When Mama was ready for me to know, I learned my diagnosis. Dr. Lavastida had experience with my condition and she knew what was killing me. I had systemic lupus erythematosus. She had never seen it in a patient as young as me, but she was confident in her diagnosis. It all made sense—the fatigue, the rash, the fever, and the organ failure. My parents learned that with lupus, a person's immune system attacks healthy tissue, often organs like the kidneys or the bladder. In my case, my immune system had damaged my kidneys. Kidney failure, Dr. Lavastida explained, was the leading cause of death for lupus patients. At the time, only 50 percent of lupus patients were expected to live past three years. It was a death sentence. There was no cure, and there were few lupus treatments available in 1970. Dr. Lavastida, however, had an idea. She had seen an experimental treatment being successfully used in Cuba—chemotherapy. If my parents consented, I would visit her office every few weeks for chemotherapy. She warned my parents the treatment might not work. I had already suffered kidney damage, and my organs might have been too far gone. But my parents were desperate. Mama had seen death sentences before, and she had to save her daughter.

My biological father, Jackson Nordin, was a kind man who complemented my strong, petite Cuban mother. They were perfect opposites. Mama was strict and serious. My father was gentle and relaxed. Like Mama, my father was Cuban, and he had dark, wavy hair and olive skin. They mostly spoke to each other in Spanish, but also like Mama, he always switched to English when he spoke with me. I remember the first time he took me to the pier in Miami. The wooden planks stretched over the ocean. I was small, perhaps four years old, and I was unnerved by the spaces between the planks. Each step felt unstable, and I had the overwhelming sensation I was going to plummet to the

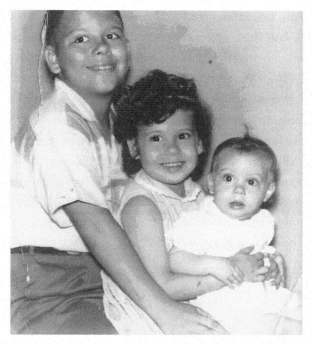

Jack, Marilynn, and Kathy (baby), 1958.

waves below. He sensed my fear and swooped me up into a protective embrace. A year or so later, we moved to Wilmington, North Carolina, after he received a job promotion. He set up a checkers set in the living room and patiently taught me how to play. And then one day, I waited for him in front of the checkers board. Mama had to tell me that he wasn't coming home. He died in 1962 at the age of thirty-six from a heart attack.

My older brother, Jack, was a freshman in high school at the time, and Marilynn was eight. Jack understood the conflict Mama faced when she had to bury her husband and then battle his parents. His parents were divorced, and both were on to someone new. Mama had to fight each of them on multiple fronts as they tried to claim my

father's insurance money and navy benefits, even though they knew my mother had three children to raise on her own. The relationship was permanently destroyed, and we never saw my paternal grandparents again. I think those months must have been tremendously painful for my brother—he lost his father and then his grandparents. And within six months, his mother was married to a new man. Mama had no other choice but to remarry. She had been a housewife her entire adult life. She had never worked outside the home, and she didn't have a way to support the family. Several of her friends introduced her to an accountant, Harry Kleiner, who was close to her age, never married, and interested in finding a wife. They wed a few months later and we moved to Norfolk, Virginia.

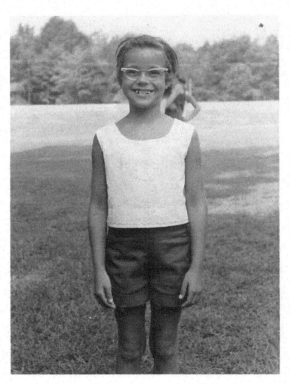

Kathy, Jackson, Mississippi, 1967.

Once again, Mama had chosen a kind and gentle man to marry, and a year later he adopted Marilynn and me. My brother was already sixteen and he wanted to keep our biological father's name. I think he was also adjusting to a very new household. Without my dad, the energy of the household changed. It wasn't just a new man in my brother's life but a man who came from a different background. The Spanish chatter we had heard between our parents our whole lives was hushed. Dad Kleiner was from Pennsylvania, and he didn't speak Spanish or have much knowledge of Cuban culture. His father was from Germany and his mother from Finland. He didn't whistle bolero when he was in a good mood or delight when my mother fried bananas. He didn't have the stomach for the frog legs my mother fried, and he wasn't interested in going frog hunting in the Keys with my grandfather, like my dad had done.

But for me, Dad Kleiner became my dad. He was the man who would care for me through my many hardships in the years to come. He was the one who followed me in his car when I rode my bike to school, and the one who paid for my dance lessons and acted like my recitals were important events. He was the one who laughed hysterically when I was eight years old and dragged home a small spruce tree I had cut down with a friend. I hauled it into the living room and announced we had our Christmas tree for the holiday. Mama didn't see the humor. We already had a silver tinsel tree with a rotating floor lamp that changed the tree's color. And my tree hunt had taken me out of her line of vision, which was against her rules. Mama thought I deserved a spanking. Dad Kleiner just laughed.

Dad Kleiner was a tall man who stood a foot taller than Mama but wisely accepted that she was the boss. I also accepted that Mama was in charge of the household, unlike my sister. Marilynn was the type to push back, and she bickered with my parents often. I saw no point in arguing, and I always went along with what they wanted or at least gave the appearance that I was going along. I felt it was the easiest

Jackson, Mississippi, 1968.

way, even if I had no intention of actually doing something my par-
ents asked. If we went to a friend's house, the rule was that we had to
call home and put the mother on the phone so Mama had proof there
was an adult present. Marilynn would argue against the principle of
having to make the call and fought with my parents. I just agreed in
the moment and then did what I wanted later. If my friend's mother
wasn't present, I'd call home and say, "Her mother is napping in the
bedroom. Should I go in and wake her up?" I knew full well Mama
would have been mortified if I went into a sleeping adult's bedroom
and woke her up. The answer was always as expected—please don't!

I was the happy kid, the one who liked to get along. I made friends
easily and I adapted quickly when we moved for Dad's job from Vir-
ginia Beach to Jackson, Mississippi, to Miami and then to Fort Lau-
derdale. We moved four times in six years and it never bothered me.
I had what I needed with each move—parents who cared for me, an

Kathy (right) and Marilynn, Jackson, Mississippi.

older sister and brother to look out for me, a nice school to attend, dance classes, and our elderly dog, Poochie. The sudden loss of my happy nature was like an alarm bell for my parents. The fatigue from the lupus was out of character for me. I knew my parents wanted their little girl back. They wanted to have me back at the dinner table chatting in detail about my day at school. They wanted me back in their living room, insisting that they sit on the couch while I performed the latest steps I had learned in dance class. Chemotherapy was the only option to save their dying daughter.

———————

While the other kids started seventh grade, I began attending a support group for women with lupus. The group sometimes met at the library or in someone's living room. Mama drove me to the meetings and

Mom and Dad Kleiner in Jackson, Mississippi, 1967.

then tried to give me privacy during the sessions, as if I might con-
fide in the other group members how I felt about my death sentence. I
had nothing in common with these women. The group member closest
to my age was more than two decades older, and many were actively
dying from the disease. During the start of the meeting, someone
would announce who had died the previous week. The group members
then described how they had struggled since the last meeting. Others
nodded in agreement when someone said she was in so much pain
she couldn't even get out of bed.

These women were aware their death sentences were being carried
out. They had to prepare their husbands and children to continue
life without them. They were all dying young and enduring a terrible
nightmare. I sat stiffly on the couch and listened to their stories. I
didn't want to be like them. I wanted to live. I left in tears, and Mama
had to guide me down the front sidewalk and back to the car. She
quickly agreed I should stop attending. The meetings were horrifying
not helping me. I didn't want to know what it was like to die from
lupus. I wanted to know what it was like to live with lupus.

I started chemotherapy in the autumn of 1970. Mama, Marilynn,
and I drove the ninety minutes to Dr. Lavastida's office. Each time,

I sat in the backseat with my forehead pressed against the window, actively trying to think about anything but the chemo drip I was about to receive. I felt a horrible sense of dread. I knew what to expect from the appointment, and I had nothing to look forward to; nausea and fatigue awaited. The sessions were spaced several weeks apart, which gave me enough time to recover before the next round of poisoning. It was a constant cycle of discomfort. I lagged behind as we crossed the speckled terrazzo floor at Dr. Lavastida's office. Dr. Lavastida didn't have a traditional setup with a waiting room for parents, an exam room for patients, and then a private office for herself. She had one room that functioned as all three spaces. Mama and Marilynn were chatty, and I think they hoped it would normalize the experience for me. They settled into cushioned chairs while I climbed onto the examination table and situated myself on the thin mattress. Dr. Lavastida set up the chemotherapy drip into my right arm and then sat at her desk doing paperwork.

Before I could feel the chemotherapy in my body, I could taste it in my mouth. It was a warm, metallic sensation that stayed in my mouth the entire time I received the drip. The taste was followed by a burning sensation that started in my arm. The fire spread through my whole body, and I could trace the chemicals circulating. It wasn't painful and I wasn't scared. But I felt terribly alone and uncomfortable. The process was isolating. Although Mama and Marilynn were in the room, they couldn't relate. They weren't the ones who had to hold their bald heads over the toilet to retch in the days after the drip was removed. They weren't the ones without eyebrows. And they weren't the ones who were locked away from the world. My death sentence, I was learning, included long bouts of solitary confinement.

My seclusion was for my own protection. During chemotherapy, my white blood cell count was low and I was at risk of catching infections with fatal potential. After chemotherapy, I was put on several immunosuppressants and had to continue my isolation. Everyday

diseases like the flu or chicken pox lurked in places like schools, grocery stores, and churches. Other people contracted these viruses, healed, and recovered. Dr. Lavastida warned my mother that I might not be able to do the same. And so, I was not permitted to leave the house. A homebound teacher brought my coursework every two weeks and picked up my completed assignments. Mama forbade me to attend church and dance classes—not like I had the energy for either—and she refused to let me to interact with anyone outside of our family.

For almost an entire year, I was home alone all day. Mama and Dad had bought an industrial metal painting business the year before, and they had to leave early in the morning. Mama made me eggs, bacon, and sweet rolls before she left and set aside food for my lunch. She left behind substantial quantities, because one of the immunosuppressants made me intensely hungry. I had been food adverse during chemo, and then suddenly I was so starved that I could eat an entire loaf of bread at lunch. There were times when I was so ravenous that Mama had to pull the steak she was cooking out of the broiler and let me eat it nearly raw. Other times, she made a tray of cinnamon rolls and watched with astonishment as her sixty-pound daughter aggressively consumed roll after roll.

I was responsible during the day for taking my medication at the appointed time. My parents took charge of my midnight dose. Each night, Dad woke me up and brought me to their bed. He was a mammoth man, well over six feet tall, and he lifted me easily. His embrace was comforting, and I felt like a doll in his arms. He sat me upright against Mama's pillows and leaned me against their headboard. Her side of the bed smelled flowery and familiar from her White Shoulders perfume. He gave me a glass of water and my pills to swallow. Mama brought in a mixing bowl, a gallon of milk, and a box of Frosted Flakes. She refilled the bowl until I felt stuffed. They waited until I fell asleep in their king-size bed, and then Dad brought me back to my bed. I'm not sure why they didn't bring everything to my room.

I think it would have been easier for Dad to not have to carry me between beds. I suspect they were trying to ease my loneliness. I fell asleep knowing I was safe in their bed and they were nearby.

My parents understood that I was experiencing tremendous loss. I was isolated, and soon my hair began falling out in clumps. For a while, I had thin hair like an old lady's, and then I was scruffy and bald. My parents got me a wig to help with the traumatic change. I'm sure the wig was expensive, but Mama and Dad always kept costs from me. The wig was real human hair, and it was very stylish. It was chin-length with bangs and light brown in color, and the ends had a loose, flipped-up curl. I appreciated their thoughtfulness, but I hated the wig. When I put it on and looked in the mirror, I didn't see myself. I didn't recognize the girl looking back at me, and I didn't want to be someone new. I wanted to be the girl I was before I had lupus. I didn't have the heart to burden my parents with my true feelings. I told them I loved the wig and then I never wore it.

My parents were also sensitive to my loneliness. One evening, they opened the door to my bedroom and brought in a tiny dachshund puppy with a light blue ribbon tied around his neck. I was thrilled. We decided that a German breed needed a German name, and we toyed with options before settling on Strudel. For a while, little Strudel and our old dog Poochie were my only companions. And then one day, I walked into the kitchen and found Poochie dead on the floor. I was home alone and completely traumatized by seeing Poochie's body. My parents' business was more than a ninety-minute drive away, and I couldn't sit all afternoon with a dead dog in the house. I frantically called our next-door neighbors. The husband came over with a blanket and collected poor Poochie.

Poochie had been Mama's dog. Strudel eventually changed his allegiance from me to Mama, but for the time being, he was my very best friend. Mama lost her beloved Poochie at a time when she needed him most. Her days were long and her daughter's future was

Kathy, age fifteen, Fort Lauderdale, with Strudel the dog.

uncertain. I began lying to her every night when she asked how my day had been. I would say it was fine or even nice. I knew she was suffering too, and I just wanted my family to be happy. But I was far from happy. For the first time in my life, I found myself without friends, mostly because I still didn't know anyone in my new neighborhood. In my most lonely moments, I picked up the phone and dialed 0 for the operator. I just wanted to hear a voice and have a connection to the world beyond my sickbed. Some of the operators were friendly and played along. They talked to me for a minute or two and then cheerily signed off. Other times, the operators were humorless and ended the call quickly.

I think one of the hardest parts about the isolation was that it was happening only to me. The demands of daily life continued for my family, and I could see my neighbors carrying on with their lives. Sometimes I stood at the front window and watched my suburban neighbors. Kids walked down the sidewalk carrying their lunch boxes. Adults collected their newspapers from the front sidewalks or lugged

paper grocery bags from the car to the kitchen. Meanwhile, I stared at the television all day. We had a small, fifteen-inch black-and-white television. I couldn't see it from the couch, so I lugged a reclining lawn chair into the TV room and positioned it close to the screen. Under layers of blankets, I watched soap operas and quiz shows during the day that were aimed at adults. In the afternoon, I turned on the cartoons meant for kids a few years younger than me. It felt as though the programming was short and the hours were mostly filled with commercials. I stared at endless advertisements promising solutions to pesky problems I did not have. The commercials targeted busy people with busy lives, not bored seventh graders undergoing chemo. There was instant coffee to make the mornings more energetic. Shampoos to make people cleaner and more attractive. And cereals intended to entice fussy children to eat. None of these applied to me. I had no hair to wash and a lethargy that even caffeine couldn't cure. The constant hunger from the immunosuppressants meant I would have eaten that fussy kid's cereal if given the chance.

Some of the fatigue lifted once the chemotherapy ended. I wasn't ready to be mobile, but I needed activity. I turned to my records to fill these open hours. My collection was quite small, because Mama had strict rules about music, and she typically felt most popular music was the work of Satan. I had to be strategic in how I presented an album to her when I asked for permission to buy it. Once, I convinced her that an Elton John album was religious by telling her the song "Daniel" was about the biblical Daniel who was saved from the lion's den. It worked! I also loved Diana Ross. My parakeet loved the song "Aquarius/Let the Sunshine In." He danced to the song by bopping his head and then side-shuffled down the perch. My parakeet was green, and I had named him Theodore—"Teddy" for short.

I began dressing in shorts and flip-flops instead of wearing pajamas all day. And I began looking for things to do. I had a toy weaving loom to make pot holders, and I busied myself with making

hideous gifts for my aunts and cousins. I also worked on organizing
Mama's immense supply of S&H Green Stamps. Customers received
the stamps if they spent a certain amount at a gas station or grocery
store. The stamps were tiny and they had to be carefully separated,
licked, and then placed into designated squares in a redemption book.
I then studied the redemption catalog and considered the items we
could order. Similar to the TV commercials, the catalog was filled
with products that did not fit my homebound life. There were curl-
ing irons that cost 5.5 stamp books, luggage sets for 18.5 books, and
alarm clocks for 2.5 books. I barely had any hair, no travel plans, and
no need to keep time. I had lost my sense of time during my year
of isolation. I had nothing to distinguish my dull days, so the weeks
blended together. I sensed I had entered a holding pattern. I wasn't
permitted access to my old life. But we weren't sure yet whether my
lupus had entered remission. I was neither dead nor living. I was
waiting.

In the spring of 1971, I began to beg my parents to let me out of
the house. Mama was typically immune to her children's whines and
woes—except for one Sunday morning when I pleaded with them to
take me to church with them. They reluctantly agreed. I was so excited
as I dressed with shaking hands. I wore a white baby doll dress with
cap sleeves and an elastic waist. It was a dainty, lace dress that I paired
with black patent leather shoes and cuffed lace socks. Mama helped
me tie a handkerchief around my head. We arrived last at the church
and intentionally sat in the back row. Mama worried I'd pick up a
virus, and I don't think she was fully comfortable with the outing.
We left immediately after the service and stopped at Baskin-Robbins
on the way home. Mama and I waited in the car while Dad went in
to get our orders. I had a soft-serve cone and was so happy eating it
in the backseat. The outing gave me a glimpse of my old life, and I
had a moment of hope that I could be the person I was before my
death sentence.

I contracted shingles ten days later. The rash started on my left shoulder and wound up my neck and onto my cheek. The blisters were intensely painful and left behind pockmarks. Most people only endured the blisters for ten days, but mine lasted more than a month. I felt the infection made a bad situation worse. We were already uncertain as to whether my death sentence had been lifted. My parents were looking for signs of progress, and the shingles obscured any indication that my health was improving.

As the summer progressed, Dr. Lavastida told Mama it was safe to end my isolation. Mama was hesitant, but she saw new signs of life in me. I had more energy and I was growing stronger. My hair was coming back as thick, dark curls. Prior to chemo, I didn't have Mama's dark, Cuban hair like Marilynn did. My hair had been a sun-streaked brown that I wore in a pixie cut. That summer, I picked my new curls with a comb and appreciated my new look. As my hair grew out, my parents continued to take me to Dr. Lavastida's office for exams and tests. With great relief, we learned that the chemotherapy had suppressed my autoimmune system and the attack on my body had stopped. I had gone into remission. I survived my first death sentence.

2

THERE'S A DIFFERENCE between surviving and living. To me, surviving meant that I would continue to exist. I would still wake up every morning and move through my day. But surrounding me, like a ghost, would be the memory of lupus. I would remain haunted by the warning that my life was fragile. Living, in contrast, felt like a choice. It meant the death sentence no longer had a grip on my life. My death sentence instead became a narrative that I controlled. Perhaps I talked about it when it felt interesting or relevant. Or perhaps I forgot about it for days at a time.

Living was an easy path for me to follow. I was young, and high school brought a daily rhythm that fit me back into the swift pulse of the world. I started high school in the autumn of 1972 with a note excusing me from physical education due to my lupus. Sun exposure triggered many lupus patients, and Mama had spent the past two years holding an umbrella over my head when I walked from our car into a store. She wasn't going to have me kicking a ball on a soccer field in the scorching Florida sun, and I was relieved from ever having to take PE. I used the extra class period to sign up for theater. The theater teacher was a kind woman who sympathized with my recent ordeal.

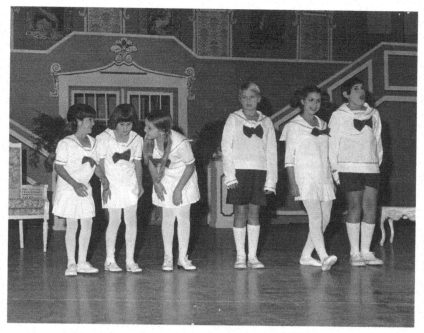

Kathy, second from right, in high school musical, 1975.

She realized that I didn't know anyone even though I had moved to Fort Lauderdale three years earlier. She pulled aside several classmates and urged them to befriend me. She chose well. Betsy, Tony, and Nora became lifelong friends. I also befriended Suzy White, a soft-spoken sophomore who became one of my closest friends.

I was allowed to visit my new friends' homes, but only after Mama called their parents to make sure they seemed like decent people whose households had the same established rules—no guests without supervision and no boys unless an adult was present. She was very nervous about boys, and I validated her concerns during my freshman year when I attracted a senior boy's attention. He was the lead in all the school musicals, and I thought he was tall, dark, and handsome. I went to his house one afternoon and made out with him on the couch. A week later, I started feeling fatigued, and Mama worried my lupus

had returned. She took me to the pediatrician and we learned I had mononucleosis, or "the kissing disease" as most kids called it. A person could also get mono from sharing a drink, but an excuse like that didn't work with Mama. I was terribly embarrassed that Mama knew I had been kissing a boy.

She became much stricter about boys after the mono incident, but I still had my stealth ability to tell her what she wanted to hear in the moment and then do what I wanted later. Sometimes I would say I was going to a friend's house when I was really at a party. My friend Betsy had a wild streak, and she brought me to parties where the other kids drank and passed a joint around the room. I wasn't into drugs or alcohol, but I liked the freedom of being around kids who didn't care. The teenage years were supposed to be a time when people felt immortal. I had survived organ failure, so I certainly didn't have the need to test the limits of my mortality. But it was nice to be around others who did. The kids chugging beers or taking bong hits acted like they were immune to fear. Consequences be damned—maybe parents or even the school would find out—these kids were going to have a good time and that was worth the risk.

I didn't have to lie when I went to my best friend Nora's apartment. Nora's family had a piano in the living room, and it was the hangout for the theater kids. Mama had met her parents and found their home acceptable. We all called Nora's mom Goody. She was a former lounge singer who had an old-fashioned, vintage style. Goody and her sister, Aunt Riva, wore red lipstick and stylish dresses that reminded me of Marilyn Monroe. They were laid-back, easygoing people, but they turned on the formality when needed and that made Mama comfortable. Nora's family had a two-bedroom apartment that felt like the exact opposite of our home, which made it the perfect escape. My house always had the curtains open and sunshine streaming inside. The light made everything inescapable from Mama's attention. Nora's unit was on the ground floor, and her parents put up dark

curtains across the living room to keep the apartment cool. It was the mid-1970s, and most of my friends' houses had shag carpeting in unfortunate colors like avocado or gold. My own house had forest-green shag carpet in every room except the kitchen and bathrooms, where the floors were covered in yellow-gold linoleum. I thought my house was beautiful. But I also loved how Nora's apartment was dim and stylishly vintage.

Mama was so comfortable with Nora's family that I was allowed to spend the night as often as twice a week. Nora had twin beds in her room, and one of them was always reserved for me. I think Mama sensed that Nora was an old soul who would rather stay at home and sing Cat Stevens or John Denver songs in her living room than get high in someone's basement. Mama knew that when I was at her house I was safe and keeping out of trouble. I don't think Mama realized how Nora's family was ushering me to a world beyond my own, and that was very exciting for me. Goody, for example, was Italian American and she introduced me to Italian food. We ate all sorts of pasta and sausage links, and it was a nice change from Cuban food. In my house, breakfast and lunch were typically cereals, sandwiches, and other convenience items. Mama's dinners were mostly Cuban meals that she had learned to cook from her parents. And if she wasn't cooking Cuban food, she seasoned a dish with enough garlic, saffron, or adobo that it became Cuban. Goody's meals were distinct, and the table experience was also different. At home, Mama fussed and worried about me. Nora's parents talked to me like I was an adult. They asked me at the dinner table what I thought of a news story or a piece of music Nora was learning, and then they'd listen while I expressed myself. Their apartment, in a way, was a bridge from childhood to adulthood that I wasn't able to get in my home because of Mama's nervousness. The mono incident meant Mama feared I would meet another boy and find myself in trouble. Sometimes her ways weren't productive. One time, she saw me getting

ready to leave the house and she stood in my doorway with a look of concern on her face.

"You know you can get pregnant if you kiss a boy?" she warned.

I almost laughed at her. I knew that wasn't true. We had sex education in the sixth grade. She had signed the permission slip, and then I went to the school library with the rest of the class and sat cross-legged on the carpet while an instructor told us where babies came from. I think Mama was afraid and thought scaring me would help keep me safe. She also wanted to prevent me from using tampons or wearing light makeup, but my older cousin Cynthia intervened. Cynthia was about ten years older than me, and she was young enough to remember a teenager's needs but old enough to stand up to Mama. Cynthia worked on Mama, vacillating between English when she wanted me to understand and then Spanish when she sensed the topic might embarrass Mama to the point of ending the conversation. A girl who used tampons, Cynthia assured Mama, was still a virgin. Mama relented and it was an important victory. At school, I wasn't Kathy, the girl with lupus. I was Kathy, the normal girl at the lunch table whom my friends could ask to borrow a tampon from during an emergency. Kathy, the normal girl in history class whose compact mirror another girl could peek at to check her reflection.

The new items in my purse were just another way I absorbed the pace of the school and blended with the other kids. I wasn't left behind anymore. I was living. After years of loneliness, my stamp-licking and pot-holder-making days were long gone. I had a spot at Fort Lauderdale High School, and that was with the theater and mime troupes. Mime was having a moment of popularity in the 1970s, and our troupe performed skits and improv set to guitar music that Nora provided. This meant a lot to me. Just years earlier, my group had been those support sessions for women dying of lupus. Now I was whizzing between classes during the passing period, waving at friends and having a note stuffed into my hand by

Suzy or Nora. I'd call out promises to read and write back as soon as I had a free moment.

I met my now husband in high school through the theater group. Our paths had crossed many times as children, but we never connected. Scott had bought his school supplies from me in that little store in sixth grade. And we realized that we both visited the Keys around the same time. His family had a second home near mile marker ninety-eight, and my grandparents were at mile marker one hundred. We both frequented the same swimming hole but never noticed the other one there. We joked that we probably splashed each other without knowing it. Scott considered me just a friend in high school. I was still so tiny—barely five feet tall and not even one hundred pounds. I know he saw me as a kid sister, and I wasn't ready for a boyfriend, so I was happy with friendship. I actually didn't have much luck with boys in high school, despite my strong start freshman year with the mono-infected senior. The only boy who asked me to senior prom did so because his friend planned on taking Betsy. My date called it off a few weeks before the dance, and I had no one to take me. In a show of solidarity, Betsy dumped her date and we spent prom night at the horse racetrack. These were the friendships that typified my high school years—a friend actually skipped her senior prom simply because I couldn't go too. I was living.

Toward the end of high school, I began thinking that I might want to be an elementary education or theater teacher. I had loved the theater program so much, and my high school theater teacher had made such a difference in my life. When it was time to consider colleges, Suzy encouraged me to apply to her school, Florida State University. I was greatly interested in FSU. My parents were planning to move to Miami after my high school graduation, and Tallahassee was more than a seven-hour drive north. It was the farthest I could get from Miami and still pay in-state tuition. I studied the school brochure and looked at the pictures of the campus. I tried to picture myself

walking under the oak trees on Landis Green after class. I thought of myself standing in the stadium wearing a garnet-and-gold T-shirt like everyone else. I then pictured myself with my high school friends all at FSU. Suzy was already there. Betsy, Tony, and Jeff planned to attend as well. Nora was a year younger, and there was hope we might convince her to head north for school when her time came.

The application required a handwritten essay about what I wanted to achieve at FSU. I wrote how the theater education major was well established and I hoped to join the program. When prompted, I wrote a careful list of all my extracurriculars, including the prom committee (minus the detail about not being able to attend), thespian society, and community service club. I also made note of my participation in Spanish club, although my language abilities were still limited to asking directions to *la plaza* as well as some choice swear words such as *mierda* that my grandfather taught me. At the end of my essay, I wrote that I would be waiting anxiously to learn whether my application was accepted. I did not realize as I wrote and proofread my application that it would one day be copied and put into a police file as part of a victim profile.

While I was choosing life, there were dozens of women and girls across the country who did not receive the same option. One man, Ted Bundy, issued their death sentence. He hunted these women and girls and struck before they had time to react. He eventually admitted to killing more than thirty women and girls. His prime killing years were 1974 and 1975, when I was a sophomore and junior in high school. Several of his victims were the same age as me at the time. Like me, they were living a life in which they were bridging from their parents' homes into the larger world. Bundy destroyed it all. For many of their family members, life would no longer be the same.

The loss was too profound to begin again, and their lives converted into a pained existence.

Ted Bundy has been called the devil or the root of all evil. He's also received tremendous flattery that has bordered on hero worship. Some considered him handsome. Others believed he was highly intelligent and on the path to success. He was none of those things. Even his friend, the author Ann Rule, noted that he wasn't exceptionally intelligent. He had enough critical-thinking abilities to attend college, but more so, he had the privilege of always having people or organizations give him a chance. He begged his way into schools, internships, and jobs. He had the audacity to believe he was entitled to good things, and people tended to believe him.

Bundy was born on the East Coast in 1946, making him about eleven years older than me. His mother, Louise, was of English descent and his father was absent and unnamed. Rather than give up baby Ted for adoption, his mother allowed her parents to pretend he was their child and she was his much older—like twenty-two years older—sister. The odd arrangement didn't last long. In 1950, Louise changed her last name and took her brother/son to Washington State. She soon met and married a professional cook. Her new husband adopted young Ted and gave him his last name—Bundy. Interestingly, I had a similar experience in the early 1960s when Dad Kleiner adopted me and Marilynn. I always saw Dad as my father, not my stepfather, and I doubt most people knew he had adopted me. Bundy, in contrast, developed a snotty attitude toward his adoptive father and made it known he felt the man was a loser. His adoptive father didn't make enough money, have a large enough house, or do enough to impress young Bundy. Not that Bundy was all that impressive as a young man. His classmates in Tacoma remembered him as average. He wasn't exceptionally smart or notably stupid. He wasn't too tall or too short. He wasn't dashingly handsome but he wasn't homely. On the surface, he was just an average guy. Beneath the surface, Bundy was the epitome of human evil.

Years later, psychiatrists studied his interviews and determined he was a sexually sadistic serial killer. Their diagnosis was based on both his actions and his behaviors as a child and a teenager. Like most sexually sadistic serial killers, Bundy developed an interest in weapons and instruments of torture at a very young age. His aunt told reporters that he was just three years old when she woke up and saw him smiling as he placed butcher knives under her sheets. He later admitted that he was fascinated with murder as a child. As soon as he could read, he looked for violent stories that involved strangulation, slashing, or beating someone to death. He particularly liked looking at graphic images, especially photographs or drawings of dead women who had been sexually assaulted.

As a teenager, he was a compulsive masturbator who snuck into the school utility closet to pleasure himself. On one occasion, three classmates swung the closet door open and found young Bundy with his penis in his hand. The classmates hooted with laughter, and Bundy was angry that he was the subject of their ridicule. Even that humiliation didn't prompt Bundy to change his behavior. He went further. After dark, he crept into the woods behind his house, stripped naked, and roamed about. He was autoerotic at that point, meaning the thought of his own body gave him sexual pleasure. That soon changed. He began sneaking out of his house at night and staring into windows in the hopes of seeing a woman undress. Nude women, however, did not arouse him as much as the thought of violence against their vulnerable bodies. He paged through crime novels in the library until he found stories of women being hit or strangled. He reread the passages and revisited them in his mind.

Bundy admitted he didn't connect well with others in high school, and he spent a lot of time by himself. It's likely that he failed to socialize because he wanted to pursue his criminal pastimes. In addition to being a Peeping Tom, Bundy was an incessant shoplifter. He brought home pricy ski equipment and other luxury items that he couldn't

afford with his after-school, minimum-wage job. His mother, Louise, ignored all these warning signs. She later told reporters his favorite childhood book was *Treasure Island*, even though he had already admitted he relished detective novels with graphic murder scenes. She claimed she thought all the items he brought home had been bought with an employee discount, not shoplifted.

Bundy's postsecondary education was unfocused. He started college in 1965, transferred, and then dropped out. He didn't return for another five years. He finally graduated with a psychology degree in 1972. He wanted to attend law school, but his spotty transcript and mediocre LSAT scores gave him few options. He had to settle for a struggling law school with stunningly low standards. In 1973, he started law school at the University of Puget Sound in Tacoma, which had just opened the year before and was eager to build a student body. Their need for law students was especially great, because their first year had been a disaster. A quarter of the students flunked out and another 10 percent decided to drop out. The school was criticized for accepting students who didn't have the academic aptitude to complete the coursework. This was the condition of the school when Bundy applied. It was a failing law school that used a first-come, first-served approach to approving applications, a different story from the legend that he was brilliant and destined for the highest strata of the legal profession.

Bundy's so-called normalcy has always been part of his legend. He was supposedly an attractive and intelligent man, and that was meant to make his murderous ways more chilling—as if men like Bundy lived among us every day and we simply didn't know it. The mystique was amplified when Ann Rule published her book *The Stranger Beside Me* in 1981 and detailed how she met Bundy when she volunteered at a suicide hotline in the early 1970s. The two talked easily between calls, and she found him to be a sympathetic listener to her personal problems. Rule at the time was in her midthirties, about a decade older

than Bundy, and she was a married mother considering divorce. She described Bundy as thoughtful and kind when giving her life advice. After they both stopped working at the crisis hotline, they kept in touch mostly through letters and cards. For most of the book, she held on to a feeling of disbelief that her one-time friend was a vicious killer. And then she expressed sadness that he derailed his own life.

I see it differently. I don't see Bundy as someone who could have been a top politician or lawyer if only he hadn't killed and been caught. And he wasn't that "average" guy who could have been anyone's coworker or next-door neighbor. He was known for staring at women in public places and making them extremely uncomfortable. He was also secretive, and even his long-term girlfriend eventually suspected he was the man responsible for killing dozens of girls and young women. His family, of course, didn't know him well, because he had limited contact with them after he graduated high school. Bundy kept everyone at arm's length, and other than his girlfriend, he didn't have anyone he considered a close friend.

The signs were always there. His long-term girlfriend glimpsed strange items—such as pantyhose—in his car and his room at the boardinghouse. Sometimes she didn't see him for days or weeks at a time. On occasion, his voice abruptly became detached and mean. Other times, Bundy doted on her young daughter and the girlfriend became reassured that all was well in the relationship. Similar to Bundy's mother, she intentionally ignored the warning signs that he was deeply disturbed and instead focused on the things she wanted to believe were true. The other people in his life did the same. The author Ann Rule enjoyed her conversations with Bundy but ignored how the crisis hotline was concerned that Bundy was turning off the phones at night when he wanted to nap. Suicidal callers heard the lonely sound of the phone ringing before they gave up and ended the call.

These critical details about Bundy's life would one day surface. Even then, people would play with the notion that Bundy was the type

of guy who seemed so normal. One magazine article suggested that he could have dated the reader's teenage daughter or befriended the reader's son. But he didn't have these close friendships in real life. He didn't have close family ties. He was a loner, and at times, he was a concerning creep. He was also increasingly unstable as he progressed into his twenties. Bundy didn't complete his first year at the struggling law school. He later admitted that he found the coursework too difficult and he didn't like being challenged. Law professors, whether they taught at Harvard Law or the University of Puget Sound, mostly employed a teaching style that demanded students answer questions in front of the class. And then it all came down to one exam at the end of the semester to determine whether a student would pass or have to consider a career in another field. Bundy stopped attending classes during the second semester. Instead of being the promising law student his lore made him out to be, Bundy starting stalking and attacking women in 1974.

The first woman he would ever confess to attacking, Karen, was a student at the University of Washington whom he targeted in the first few days of January. She had brought her wash to the nearby laundromat where Bundy stared at her from across the room as she loaded her clothes into the machine, sprinkled in soap, and dropped her coins into the slot. She felt his eyes on her, but he averted his gaze when she looked up. She did not realize that he followed her home and knew exactly where she lived. On the night of the attack, she was reading in bed when she thought she saw a man looking through her window. He disappeared instantly and she assumed she must have imagined the silhouette. When she awoke in the hospital, she learned an intruder had beat her with a metal rod and then jammed it so high up her vagina that he punctured her bladder. She lost hearing and vision on the left side of her head where Bundy had beat her. For more than a decade, she would not know the identity of the man who attacked her and left her for dead.

In the coming months, nine other women disappeared in Washington and Oregon. Some of the victims' remains were never found, and their families were without answers. Police suspected the same person might be involved and tried to build a profile of the suspect. Then in the autumn of 1974, the killings in the Pacific Northwest abruptly stopped. Bundy had begged his way into the law school at the University of Utah and moved to Salt Lake City. His girlfriend was from Utah, and he insisted to school officials that he was marrying her and adopting her young daughter and needed to be enrolled at the school. However, he left for Utah without his girlfriend and her child.

The law program at Utah was not a good fit for Bundy. He was lost from the start. The program was highly ranked and attended by many ambitious and intelligent students. Bundy couldn't keep pace. He didn't have the aptitude for law school, and he was also preoccupied with hunting girls and young women. He had a particular type he liked to target. He looked for slim women or girls he could easily overpower. But none of the victims' families knew this yet. They only knew their daughter was found dead in her bed. Or they knew she had left her dorm but never arrived at the concert hall as expected. Bundy sometimes used crutches to seem injured when he asked the unsuspecting woman to help him to his car. Most refused and later told police they found him to be creepy. Bundy resorted to hiding in the shadows and waiting for a petite woman to walk past. He then smashed her skull with a heavy object, dragged her body into his Volkswagen, and drove her deep into the mountains where nobody could hear her scream. Authorities found the victims' bodies on occasion. More often, the families had no answers as to what happened to their loved ones.

All his attacks were horrendous. Even by that standard, it's upsetting to think how Melissa Smith, age seventeen, suffered one of the most terrifying deaths. On a Friday night in October 1974, Melissa left her house in a Salt Lake City suburb to go to a nearby pizza parlor

where her friend worked. The friend was having romantic difficulties and Melissa went to comfort her. She called home to her family around nine o'clock and told her sister she'd be home within the hour. But she crossed paths with Bundy on her way home. Authorities weren't sure how he found Melissa. Her typical route to the pizza parlor included a shortcut through a poorly lit middle school campus. Bundy most likely hid in the shadows, pounced, and dragged her to his car. He never admitted to authorities how he trapped her. More than a decade later, he admitted that he kept her confined for seven days before he murdered her.

Bundy revealed little as to what he did to his victims. He typically only acknowledged that he took their lives. We can imagine that poor Melissa suffered greatly that week. She was physically and sexually assaulted. She was probably hungry, cold, and immensely fearful. Her family was also fearful during the same time. Her father was the police chief and had the personal knowledge he needed to imagine the worst was happening to his daughter. And then his nightmare was realized. Nine days after Melissa went missing, her nude body was found in the mountains among short, shrub-like oak trees. Authorities believed she had been dead for about two days. She had been raped and sodomized. Her body showed signs of beatings, including large abrasions and scrape marks on her butt cheeks. Her navy blue sock was tied around her neck.

I was the same age as Melissa in 1974. She was six months older than me. We probably had the same teen magazines on our bedside tables. Who was she? Did she like the same things as me? At the time, I was obsessed with the annual telethon that Jerry Lewis hosted every September. Every year, I'd go to watch it at Betsy's house, because they had a color television with a large screen. I'd watch with her family until they each had enough and retired to their rooms. I'd stay in the living room with a pillow and blanket watching until the early hours. Did Melissa like the same? What was she like as a person? Did she

have a pile of stuffed animals on her bed that she moved when her friends came over so they wouldn't know she still slept with them? Did she hug her parents tight? Did she want to go to college? Travel? Learn a trade?

These are the questions I feel have been lost. There has been so much emphasis on *who* was Ted Bundy, *why* he committed his crimes, and *how* he attacked all those girls and young women. I wonder why some people want to know so badly. Why do they want to know his thought process? He wasn't some artist in the midst of creation. He wasn't an inventor on the verge of a breakthrough. His thought process wasn't complex or poetic. It was barbaric, and it was intentionally cowardly. Bundy didn't pick bar fights with hefty men. He didn't box or study martial arts. He attacked women while they were sleeping or he hit them so hard they became unconscious. Bundy picked girls and young women who weighed less than him and couldn't defend themselves.

Melissa's murder was one of the most revolting. She endured a week as Bundy's personal prisoner. Within days of finding her body, police found another teenager's body in the same area. Authorities suspected the two victims were killed by the same person, but there were few clues that would lead them to the killer. At the time, they didn't realize the same person who murdered the young women in their state was also responsible for killings in at least three other states. In Florida, we heard the news like we heard about anything else of national significance. I don't remember hearing about these victims, and I had no way of connecting their loss to mine. I didn't know the same person who had issued a death sentence for them would soon be issuing one for me.

3

AS PLANNED, MY high school friends and I were all accepted to FSU. We soon began receiving letters and information about student orientation, dorm move-ins, and start dates. The student orientations happened at the end of summer, and to my disappointment, they involved parents. I would have much preferred to pile into a car with my friends and then report back what my parents needed to know. Betsy and I arranged for our families to take the trip together. Our fathers were busy with work, and I should have called off the carpool when I learned it would just be us and our mothers.

Mama was a critic. *A criticona.* She had perfected her ability to sit quietly and judge others. She had a standard of behavior that conveniently matched her way of life, and it gave her great pleasure to criticize anyone who lived differently. It was terribly awkward for me when Mama didn't like someone that I did. I almost felt like I was torn between two allegiances. I loved Mama and wanted to please her, but I didn't see the same faults and I wanted to like the other person as well. Mama disapproved of Betsy's mother, whom we all called Libby, and I should have called off our trip to Tallahassee rather than agree to have us all spend eight hours in the car together. Mama

Kathy graduating high school.

thought Libby drank too much and took life too lightly. I had inadvertently disclosed how Libby was a schoolteacher and she enjoyed unwinding after a long day by the backyard pool with a drink in one hand and a cigarette in the other. Her husband's uncle, Norman, often kept her company and the two talked for hours.

I saw Mama tense up when Betsy and Libby came to pick us up. Uncle Norman was in the front seat and he was coming to orientation. Mama shot me an angry look and whispered her disapproval as we put our luggage in the trunk and sat in the backseat with Betsy. Libby and Uncle Norman were cheerful on the trip and chatted the whole drive as they smoked out the window. They often made references to good times involving heavy drinking. I stayed neutral in order to not incriminate myself, and I acted like I had never heard of wine

coolers. In the moment, Mama might have regretted not teaching me Spanish. She missed an opportunity to criticize freely and not have the others understand. Instead of hissing things like *no puedo creer que el tío raro esté aquí,** she settled for deep sighs and irritated eye rolls.

Betsy's family was free-spirited and not devoutly Catholic. Her parents didn't bother much with weekly mass, but Betsy went now and then and I occasionally tagged along with her. I knew nothing of their rituals. When Betsy stood, I did the same. I kneeled when she did. Once I made a swatting motion in front of my face until I realized she was only shooing a fly. My parents were also not interested in organized religion, which meant Mama was an interesting combination of prim, religious, yet unaffiliated. Mama's family was Pentecostal (a sizable religious minority group in Cuba), and we went to services on the holidays, but we weren't regulars.

To Mama, carousing with your uncle-in-law was not Christian behavior. At dinner that night, Mama eyed Libby and Uncle Norman as they had three drinks to her one. Then at the hotel, Betsy, Mama, and I shared a room while Libby and Uncle Norman each had their own room. Mama whispered great disapproval when she learned their rooms were adjoining. I knew the two were just good friends, and I pointed out that the hotel likely randomly assigned the rooms and a person could keep the door locked if they wanted. Mama was looking for things that weren't there, and it made me feel torn because I wanted to please her, but I also knew she was just looking to find fault in people and that wasn't fair to Libby or Norman.

The orientation, fortunately, separated us for the day. The students took a tour and received a thick course catalog. The parents learned how to make tuition payments and select a food plan from the cafeteria. I was excited for college, and I wasn't homesick when my parents dropped me off the next month. I started the quarter

* I can't believe the strange uncle is here!

with sorority rush, which was the process of sorority sisters and potential new members picking each other. It felt like a busy blur of smiling faces and house tours. At the time, FSU had about fourteen sororities and each had a big, beautiful house. Many of the houses resembled mansions with grand balconies and striking columns. At each house, the rushees stood on the front sidewalk and waited until the front doors swung open and the sisters pranced out single file. As they approached us, they clapped, chanted their sorority names, and sang songs about why they were the best. We were ushered inside, where a sister met with us briefly before another member came over smiling and ready to chat. The conversations were quick, and the turnover between sisters was rapid and well choreographed. I learned later that the sisters evaluated us as soon as we left. Many kept notepads underneath the couch cushions where the rushee sat, and they jotted notes as soon as the house cleared. At Chi Omega, those little notes were mediated by my high school theater friend, Suzy. She wanted me in the sorority and kept encouraging the recruitment committee to advance me to the next round of interviews.

All the sororities had generalized reputations. One sorority attracted the "smart" women. Another was known as "pretty." One was composed mostly of rich girls, and they were the type to ask you where you spent your summer vacation and what your father did for a living. Chi Omegas, I learned, were the popular girls. They were involved in activities on campus, and they were very sociable with the fraternities and sororities. The Chi Omega house wasn't the most ornate on the outside, but the foyer had a beautiful wooden staircase. It was a two-story house, and it had a small balcony over the front door. Many of the other sorority houses looked like plantation homes or mansions. Chi Omega was a raised ranch-style house with a midcentury look. It looked like it belonged in a suburban cul-de-sac, which I found to be a little disappointing.

I continued to return to Chi Omega as the week progressed. I was also interested in, yet intimidated by, Delta Delta Delta. Our recruitment guides kept telling us during the week to envision ourselves living in the sorority house. Could we see ourselves letting our guard down with these sisters? Could we see ourselves in the communal bathroom brushing our teeth alongside them at the sink? I wasn't so sure about Tri Delta. It seemed as though all the sisters had long, silky blond hair. I had short, thick curls and imagined myself sticking out in the sorority portrait. And I was pretty sure none of them had ever overheard their family have a really good screaming match in Spanish. In the long run, I didn't think I would fit in.

I was the first in my family to join a sorority. My parents supported my decision, but they knew as little as I did. We didn't have anyone we could ask for recommendations from alumni, and those letters typically helped rushees advance in the recruitment process. I did, however, have Suzy at Chi Omega serving as my reference. When it came time to choose between Tri Delta and Chi O, I liked that I already had a close friend at Chi Omega. On the last day, I marked Chi Omega at the top of my preference list. Betsy also listed Chi Omega as her top choice. We hoped to join together.

On "Bid Day," we learned whether our favorite sororities had picked us as well. We went to a conference room where our recruitment guides had an envelope for each of us. We all ripped open our envelopes at the same time. When I pulled out my card, I saw the Chi Omega emblem and an invitation to join. Betsy held up her card and showed me a different emblem. She wasn't invited to join Chi Omega. I was sad for my friend but caught up in the moment. The other women in the room were hugging each other, shrieking with joy, or biting back tears. Other new Chi Omegas were coming up to me to introduce themselves. In the commotion, I didn't fully register how the sorority's official symbol was the skull and crossbones, the same type used on a pirate flag or a box of rat poison. It should have been

Chi Omega pledges, 1976.

a warning. I wasn't just pledging a sorority. I was locking into a track that would steer me toward my second death sentence.

———————

During the fall semester, I was busy learning the Chi Omega songs and attending my classes. I regretted signing up for a meteorology course, Introduction to Atmosphere, to fill my science credit. I had hoped the class would offer insight on how to become a TV weather reporter. Instead, I was in a heavy science course that required me to learn about different layers of atmospheric gases, all of which bored me. I wrote letters home to my parents and described my new room-mate and our all-girls dormitory, Reynolds Hall, which I referred to as "the nunnery." My parents had insisted on the all-girls' dormitory while the rest of my high school friends were in the coed dorm. At the nunnery, boys were permitted on the lower floors, but I was on

Kathy in her room in Reynolds Hall, FSU, 1976.

the third floor, where residence life strictly forbade males from entering. A few times during my freshman year, groups of guys staged panty raids on the lower floors of Reynolds Hall. We could hear the other girls shrieking with mock outrage as the boys zipped into their rooms and snatched a pair of underwear from their dressers. My friends on my floor and I could hear the action below, and we felt terribly excluded from the excitement. The panty raid was a flirtation with the forbidden—a boy in a girl's room, touching her most intimate possessions. There was a sexual energy pulsing through the dorm, and we were missing it. We each grabbed a pair of panties from our drawers and tossed them down the open staircase as the boys retreated. They looked up at us with smiles and we felt victorious.

My life was miles away—both figuratively and literally—from Bundy's in the Utah State Prison. He had been sentenced in June 1976 to a vague term of one to fifteen years for the attempted kidnapping of a teenage girl named Carol. The attempt had happened in November 1974, just weeks after Bundy had kidnapped, imprisoned, raped, and then murdered young Melissa Smith. Bundy had seen Carol in a bookstore at the local shopping mall. She had been browsing paperbacks,

perhaps thinking about buying a book or wondering what it would be like if she wrote her own book one day. Bundy presented himself as a policeman, Officer Roseland, and told Carol that thieves had attempted to break into her car. He directed her to come with him to the precinct. She expected Bundy would lead her to the satellite police station at the mall—the back room where shoplifters nervously waited in handcuffs and anxious parents reunited with lost children. Instead, Bundy strode toward the parking lot and aggressively ordered Carol into his car. She was suspicious that Bundy's car was a Volkswagen Beetle and not a police cruiser, and she hesitated to go along.

I want to stress that Carol, who like me was born in the 1950s, grew up in a much different time regarding how girls were taught to obediently follow authority. Many children today are taught that they don't have to hug anyone, even relatives, if it makes them uncomfortable. Girls in my era were typically expected to be respectful to adults, even if we didn't feel safe. I think this is important to note, because accounts about Bundy and his victims often included a bit of criticism for the girl or young woman as if she should have been smarter in the situation. These stories were written decades after the fact, often by a man, and I think they are designed to make the reader feel safe—as if what happened to all these teenage girls and women couldn't happen to them too.

Carol sat cautiously in the front seat as Bundy drove the car from the parking lot. She soon realized he wasn't heading toward the police station. In a panic, she told Bundy she wanted out of the car. When they reached a stoplight, Bundy grabbed her wrists and tried to handcuff her. Carol resisted and the two fought. In the struggle, Bundy clasped the handcuffs around the same wrist. Both her hands were still free and he was flustered. She used the chaotic moment to open the door and flee. Bundy couldn't catch her, and he apparently had no fear that Carol would report the kidnapping attempt to her parents or authorities. He seemingly didn't worry that police might

be looking for a man and a vehicle that matched his description. He didn't leave the area. Instead, he began to hunt again.

A few hours later, Bundy went to an area high school where a musical was in production. Prior to the show starting, he slipped backstage and tried to get the drama teacher's attention. He said he needed her help and asked if she would come to the parking lot to identify a car. The drama teacher was a young woman in her early twenties, and she was busy getting her actors and crew ready for the show to start. She refused and walked past him. Bundy remained in the hallway for the next twenty minutes. When the drama teacher saw him again, she asked if he had found anyone to help him. He stared intensely without answering, and she walked away feeling unnerved.

Bundy stayed backstage and waited until the drama teacher reappeared. He tried complimenting her appearance and then asked if she would give him "a hand" with the car. It would only take a minute, he promised. The drama teacher felt creeped out by Bundy. She told him she would find her husband and have him help identify the car in question. She sidestepped him and walked away. With the threat of a man intervening, Bundy left the back hallway and joined the crowd watching the performance. He stood in the back of the auditorium, and several people reported he was pacing back and forth. Pacing might have been acceptable by a nervous parent at his or her child's state championship swim meet. But it wasn't typical theatergoer behavior. The drama teacher watched from a distance and then noted the strange man was gone before the end of the performance.

Bundy apparently left the theater when his next victim walked up the aisle and out the door. Debra Kent, age seventeen, had seen the play before and offered to let her parents and siblings stay while she went to collect her younger brother from the roller rink. She assured her parents she would return to pick up the entire family by the time the show ended. She was never seen again. Bundy attacked and abducted her in the parking lot as she walked to the family car.

Several people who lived in the area later reported they heard a female screaming. It might have been poor Debra as Bundy shoved her into his car.

More than a year later, an officer pulled Bundy over for driving suspiciously slowly in a residential subdivision. The officer found alarming items in Bundy's car, such as handcuffs, an ice pick, and a pair of pantyhose meant to be used as a face mask. The officer assumed Bundy was a burglar and detained him. The police were highly suspicious of Bundy at that point, and although they couldn't keep him in custody, they followed him constantly. They believed he was the man who had tried to kidnap Carol from the shopping mall. They also thought he was involved with other murders, including that of Debra Kent.

The evidence mounted. Carol was able to sort through a stack of photographs and identify Bundy as "Officer Roseland" even though both his hair and facial hair were different in the photograph. The drama teacher from the high school musical also successfully identified Bundy from a lineup. The trial began in February 1976, and Bundy presented himself as a persecuted man who was wrongly accused by corrupt authorities. It was a ridiculous portrayal. Bundy wasn't a political enemy in a hostile state. He didn't have any business holdings that his supposed persecutors were trying to seize for themselves. He was a defendant whom witnesses could place at separate crime scenes. The judge found him guilty.

Bundy waited until June 1976 to learn his sentence. These were the months when I was deciding on FSU, learning my prom date had jilted me, and then celebrating my high school graduation. Our lives were far apart, both physically and in terms of life stages. I was a young woman beginning a chapter of semi-independent adulthood. He was a convict headed to the state penitentiary. The problem, however, was that Bundy did not settle well into prison and immediately began plotting his escapes.

In October 1976, as I was wearing my pledge pin and learning the names of the Chi Omega sisters, Bundy plotted his first prison escape. He made it over the prison wall, but he was still in the yard when guards apprehended him. Prison officials realized that someone—likely one of his girlfriends—had helped in the attempt. He was carrying road maps, airline schedules, and a fake social security card. He was trying to get as far away from Utah as possible. Guards dragged him back into the building, and he spent the next few weeks in solitary confinement. It was meant to be a punishment that would keep him from contacting the people who had helped him get over the wall. All it did was give him time to learn from his mistakes.

At the Utah State Prison, Bundy was prisoner number 13819. At Florida State University, I was student number 800940, and I had finals to worry about. We were on the quarter system and we took our exams before Thanksgiving. We had a long holiday break before classes reconvened in the first week of January. I left for break feeling worried about my freshman composition and meteorology grades. When my report card came in the mail a few weeks later, I was relieved to see that I had earned two Bs and two Cs. My parents were satisfied, and I enjoyed my time at home. I reconnected with Nora and went a few times to see her sing in a jazz club. She was in her senior year of high school and narrowing down her college choices. I had hoped she would join me at FSU and maybe even join Chi Omega, but she decided to stay local for college.

I returned to Tallahassee in January 1977 to start my second quarter at FSU. I enrolled in another composition class, as well as biology, religion, and geography. Early in the quarter, I wrote a gushing letter home to Mama. I told her about a Chi Omega event in which the pledges put on a show for the sisters. I performed a song and assured

FSU, 1976.

Mama that I hammed it up. I wrote that I just loved all the sisters
and I was so happy to be in the sorority. I also noted that although
we were far apart, I felt very close to Mama. Perhaps even closer than
before. The distance had a way of making me think about my parents
and appreciating the life they had given me.

The life they gave me allowed for exploration. Mama had always
been watchful of me, but she let me attend a faraway college and she
supported my interest in finding myself. I initially thought I might
want to be an elementary school or theater teacher, but neither career
remained appealing. I had hoped my meteorology course might lead
me to a career as a TV weather reporter, but atmospheric science was
not for me. In the spring, I signed up for an introductory anthropology
course. I was highly fascinated by early humans, and I enjoyed the

lectures and did well on the tests. Sometime during the quarter, the professor arranged for us to go on a field trip during which we dug for fossils. I was delighted by the assignment, and I dressed in khaki, ready to assume the role of scientist. The professor had roped off areas in which we were supposed to search for artifacts. The process involved digging and then sweeping aside the soil with our hands. I followed the procedure and then broke a nail as I brushed away the dirt.

"Oh my God. This job is too physical!" I complained to my field partner as I held up my ruined manicure.

I spent the rest of the field trip pretending to be involved, but I was done with anthropology. Although I earned an A in the course, I crossed the subject off my list of possible careers.

As the spring progressed, I also found myself in a relationship with a boy from South Florida named Simon.* Looking back, it feels like I fell into the relationship. I met him through my roommate in the dorm. They belonged to the same church and youth club. My roommate often invited me to attend and I was always game, because the church's recreation room had a Ping-Pong table. I loved Ping-Pong. It was one of the few sports I could enjoy, because of my lupus. I didn't think of the youth club as my church—it was like all those times I followed Betsy to mass. I was a guest, and I politely sat through services in anticipation of the moment we could take out the Ping-Pong paddles.

Simon had a car—a Volkswagen Bug—and I often rode with him to events. We typically saw each other within a larger group outing until the spring, when we began going out on our own. He was an average guy who wasn't particularly exciting. He was of Scandinavian heritage and he had short, blond hair and wore wire-rim glasses. He wasn't particularly tall and he wasn't very handsome. There really wasn't anything unique about him. He wasn't too motivated about school, and he planned to work for his father's business once he was done

* "Simon" is a pseudonym.

Kathy, 1977.

studying. He didn't belong to any clubs or play any sports. He was just kind of there. He was my first boyfriend, and he moved slowly and that's what I needed at the time. He was content to only hold my hand or put his arm around me for the first few months. We got along nicely, but there wasn't a deep spark. We weren't passionately in love and burning to be together. We probably would have drifted apart in the coming years. But forces outside of my control were sending a violent maelstrom in my direction. He'd be there for me to cling to in the violent turmoil, and the track of my life would be forever altered.

———————

Ted Bundy didn't last long in the Utah prison system—he was wanted in Colorado for the suspected murder of Caryn Campbell. Caryn was a twenty-three-year-old nurse from Michigan. She had been at an

Aspen ski resort in early 1975 with her fiancé, a physician, and his two children while he attended a medical conference. After dinner, the family settled into the hotel's lounge for some quiet time. Her fiancé had a newspaper, and Caryn said she would head upstairs to retrieve her magazine. Witnesses saw her in the lobby, on the elevator, and then on the second floor. But she disappeared in the short distance between the elevator bay and her room. She was never seen again. A month later, her nude and beaten body was found dumped by a dirt road. Forensic pathologists found the remains of her last known meal in her stomach and determined she had been killed within hours of disappearing. She had been raped, badly beaten with a blunt weapon, and possibly strangled.

The author Ann Rule wrote that Caryn had most likely gone willingly with Bundy when he approached her in the hotel hallway. Rule had fabricated a mystique that Bundy was charming. But we know from many witnesses, particularly those who saw him in the hours before he killed, that he was actually alarming and odd. He stared at women in laundromats, paced at school plays, and leered at dancers in discos. He was creepy, and people did not forget that they saw him. In the coming years, there were accounts from women who described being approached by Bundy and feeling unnerved. Yes, there were two known instances in which he smiled at women and asked for help and they acquiesced. Mostly, there are accounts of his victims being intimidated, physically overcome, and then brutally ripped from their lives.

There were other reasons to believe that Caryn did not go willingly with Bundy. Her fiancé reported that she wasn't feeling well that evening and she had been getting over the flu. She had a light dinner and skipped drinks while all the other physicians and their spouses enjoyed a comped cocktail. It was very possible that if Bundy had approached her in the hallway with some lie about needing help, Caryn wouldn't have had the energy or the interest in following along. So I don't accept the persisting legend that Bundy charmed his way

into having Caryn follow him out of the hotel. We simply don't know how Bundy got to Caryn, and he doesn't deserve the default narrative that he charmed a woman into following him. It's a terrible narrative, and it has unfairly opened up interpretations that made the victims seem naive or even stupid.

With Caryn, we know from her fiancé that she was on a quick trip to her room to collect a magazine. She was likely thinking of other things, and if Bundy spoke to her in the hallway, he might have startled her and raised her defenses. Perhaps Bundy did ask her for help and she agreed. But given that Caryn spoke with conference attendees outside the elevator—who then watched her walk down the hallway toward her room—it's more likely that Bundy was hiding in the shadows and waiting to pounce so that he could drag her down the stairs and into his car.

Investigators weren't sure how Bundy got Caryn into his Volkswagen, but they believed they found samples of her hair in the car. They also had receipts from gas stations in the area, placing him near the crime at the time it occurred. Authorities had enough to charge him with the murder of Caryn Campbell and extradite him to Colorado to stand trial. For the first half of 1977, he was held in a small county prison and escorted by deputies to the courthouse. He used the time to act natural and harmless to the men charged with his watch. When he wanted to be, he was good at complying with other men and letting them feel as though they were in charge. Over time, the deputies allowed him to go into the courthouse's law library without the customary handcuffs and leg irons.

In June, Bundy discreetly dressed in two layers of clothing and then jumped from a window during his allotted law library time. He ripped off the top layer of clothes so that his appearance would not match the description he knew would be broadcast across law enforcement radios. Then, he wandered into the mountains and tried to leave the area. He failed to get far. He didn't have a clear sense of

direction and wandered in a circle for the next ten days. He also had poor survival skills, and he sought food and shelter from vacant vacation cabins. By the time police found him sluggishly walking down the road, he was hungry, cold, and only a few miles from the courthouse. The county jail intended to keep a close watch on Bundy after his escape, but they didn't have to deal with him for long. Bundy was planning his third and final escape attempt.

4

AT THE END of my freshman year, my parents began insisting that I move into the sorority house for my sophomore year. But the rooms were already assigned. The current sophomores and juniors had picked their roommates and their designated rooms. Mama would not take no for an answer. She felt the sorority house was much safer than the dorm. Anyone could walk into the dorm, she reasoned. The same was actually true for the front door to the Chi Omega house. It was left unlocked during the day, and then at night one of the sisters was tasked with locking the front door. Locking the door was not a desirable job, because it meant a sister had to be home from a night out or a date by eleven o'clock in order to turn the dead bolt. The back door was a different situation. It was always locked and it had a keypad entry with a combination only the sisters knew. Both these locks made Mama feel safe, as did the house mother who had a suite on the first floor and provided the illusion of adult supervision. My parents both felt confident I would be much safer in the sorority house.

I'm not sure who Mama called or how it happened, but Mama was determined to get her baby into the safety of the sorority house, and

I'm sure the Chi Omega house manager had never met a force like Mama. Sometime during the summer I learned a room had opened up for me. I had to tell my roommate from the dormitory that I wouldn't be able to room with her for our sophomore year. She was disappointed, but I was delighted about moving into Chi Omega. All the sisters considered it a privilege to live in the house. The house was much more attractive than the dorm. The dorm had lounges with stained sofas that no one used except for guys waiting to take their girlfriends out. The sorority house had beautiful upholstered furniture in our formal living room. The food was also much better at the sorority house, and I was looking forward to not having to walk several blocks for a meal like I did when I trekked from the dorm to the dining hall. And the house was so much cleaner than the dorm. A housekeeper came through once a week to vacuum the carpets, sweep the floors, and spiff up the bathrooms.

On move-in day, I didn't have any furniture to move—only clothes, linens, and books. Mama and Dad drove me to school, and the anticipation I felt while riding in the backseat was so contrary to all those times I rode to my chemo appointments. I had depressively rested my forehead on the window and watched the world blur past. Now I excitedly told them stories about life with the sorority and all my plans for the quarter. The parking lot buzzed with parents dropping off their daughters, and sorority sisters seeing each other for the first time in months. Mama, I could tell, was content. She was happy because she had gotten what she wanted and her daughter was getting the best and safest housing option available. She didn't join in with the other parents' joking as they lugged laundry baskets filled with clothes into their daughters' rooms. But she also didn't throw daggers with her eyes, so I could tell she was pleased.

Mama and Dad helped me carry my belongings up to the second floor, where I was assigned to share a room with an upperclassman. I didn't know my new roommate well, but I felt optimistic about the

year ahead. There were girls in my pledge class who were still living in the dorms, and they told me I was lucky to get a room assignment. As we were settling into our room, my new roommate and I made two fateful decisions. First, we agreed to leave the window shades open and hang planters from the curtain rod. Our bedroom faced the back parking lot and we loved the natural light. I had to smile to myself about my new affinity for natural light. In high school, I had loved how Nora's apartment was dark and old-fashioned and how well it contrasted with our home, where every shade was open. When given my own opportunity to choose, I shared Mama's preference for streaming sunshine. My new roommate and I realized we'd have to change our clothes in the bathroom, but it seemed like a fair trade-off for the brightness and the greenery.

We spent more time considering whether to keep the shades open than we did addressing our second decision—whether to lock the bedroom door at night. My old roommate and I locked our room in the dorm. It seemed the sensible thing to do, given that anyone could enter the building and roam the hallways. And we realized that we didn't know all the dorm residents or their guests, and we couldn't determine whether they were trustworthy. The sorority house seemed different. There were locks on the exterior doors and strict rules about men not visiting the upper floor. And we knew all the other women. Locking our door, however, seemed like a lack of faith in our sorority sisters.

My new roommate and I got along fine that quarter. We planned over Christmas break that we would each get coordinating bed comforters. I took the task seriously as I had just declared interior design as my new major. In an echo of my fleeting interest in meteorology and anthropology, I tended to focus on one aspect of the major and

assume it represented the full experience. Interior design attracted me simply because I loved shopping. It seemed sensible to me that if I were an interior designer, I could design a client's decor *and* go shopping with their money. That seemed like a great career, and I began by thinking of how I wanted my bedspread in the sorority house to match the green carpeting. I dragged Mama to multiple stores until we found the perfect cover with beautifully detailed trees. I thought it was just lovely.

As Mama stood in store aisles asking me, "What's wrong with this one? Can't this do?" we were unaware that dangerous elements were connecting and advancing an abrupt violence into our lives. The force began to build at the end of December 1977 in the small jail in Colorado where Ted Bundy was still awaiting trial for the murder of nurse Caryn Campbell. For the holidays, the warden furloughed the nonviolent prisoners and then let his guards take vacation days. The small jail was empty and quiet—just what Bundy needed. On the evening of December 30, Bundy piled books on his bed and pulled back the covers to make it seem as though someone was sleeping. He hoisted himself into a vent and crawled through the air duct until he was above the warden's personal apartment. The warden and his wife were out for the evening, and Bundy had a quiet moment to collect himself. He descended into the warden's closet, changed his clothes, and walked out the front door.

In the time he had been at the jail, Bundy made a habit of not taking his breakfast tray in the morning. A sleeping prisoner was an easy prisoner, and guards let him be. Bundy knew the guards would not check his cell until later that morning. That gave him more than half a day to get as far from Glenwood Springs as possible. He had learned from his past two escape attempts that he needed to vacate the area immediately. A manhunt would begin as soon as guards realized he was missing. The locals would be on the lookout and the news outlets would carry the story. The farther he went from Glenwood

Springs, the less people cared. They wouldn't sit by him on a train or take the barstool next to him in a tavern and think, "Is that the guy from the news?"

The small jail sat alongside Interstate 70, and Bundy was just a half mile from the nearest entrance. He stole a parked car and began driving east through the mountains. He didn't get far before the car sputtered and stopped. Walking along the interstate, he posed as a stranded motorist and found sympathy from a passing driver. He rode to Vail, where he took a bus to Denver and then caught a morning flight to Chicago. Bundy was at a Chicago bus terminal looking at the day's schedules by the time the guards unlocked his cell door and realized the lump under the bedsheet was a pile of books. Seventeen hours had passed.

The FBI quickly became involved in the search for the escaped prisoner and named him to their top ten most wanted list. Alerts warned that he was armed and dangerous. His "wanted by the FBI" poster described him as a thirty-one-year-old male with brown hair, blue eyes, and a slender build. Tipsters called their local FBI branches and said they had seen him at a gas station or a hotel elevator. The FBI suspected he was possibly heading to Utah, and they called the teenager whose testimony had sent Bundy to the Utah prison for attempted kidnapping. They warned the young woman and her family that Bundy was on the loose. At the same time, authorities in Washington State thought he was heading home to Tacoma or Seattle. But Bundy did neither. From Chicago, he headed north to Ann Arbor, Michigan.

He went far in a short period of time, and he didn't do it for free. He started the journey with about $500 cash, most of it ferried illegally into the jail by his girlfriend at the time. She was the same one who was suspected of trying to help him escape the Utah prison by providing him with a map and a fake social security card. She long claimed that she believed in his innocence, and she held that stance for another

decade. After what transpired in the next few weeks, it's infuriating to wonder why this woman wasn't investigated and charged with a crime. She put him on the path to Tallahassee.

In early January 1978, Bundy stole another car and drove from Ann Arbor to Atlanta. He then abandoned the car and bought a bus ticket to Florida. He arrived on January 8 in Tallahassee, where classes had resumed and students were settling into the winter quarter. He picked Tallahassee because it was a college town and he had been in school on and off for all those years. He might have thought he could blend in with the student body. He assumed a fake name, Chris Hagen, posed as a student, and rented a room at a boardinghouse near campus called the Oak. The boardinghouse stood on College Avenue among the sorority and fraternity houses. Chi Omega was just three blocks away.

To get to us, Bundy only had to go through the parking lot next to his boardinghouse and come out on Jefferson Street. He then would have walked west, passing the law school, a place where he would have failed miserably. He would have crossed the street at Macomb and come upon the sorority houses—Kappa Kappa Gamma, Alpha Delta Pi, and Kappa Delta—all with lush lawns and grand white columns. On the next block, he would have passed an elm tree draped in Spanish moss and then watched as sisters walked up the double staircase at Gamma Phi Beta. And then, he was at the Chi Omega house, where he would soon discover that the back-door keypad lock, which my parents trusted, was broken.

I went out with Betsy on the night of Friday, January 13. Betsy still had her wild streak, and I liked to keep pace now that I was out from under Mama's watchful eye. I felt stiff and sluggish the next morning from all the hours of dancing and drinking beer. The weather had

turned bitterly cold that week, dropping from the mid-sixties to the low forties for a daily high. The temperature that morning was barely in the thirties and I would have been glad to stay in bed, but life in a sorority house was noisy. Before 8:00 AM, I could hear sisters in the hallway talking to each other, laughing, and shutting doors much more loudly than I appreciated. I tried putting a pillow over my head but eventually gave up trying to sleep. I went downstairs in my pink robe to the communal kitchen and helped myself to a toasted bagel as other sisters shivered in their robes, commenting on how the weather was too cold for Florida. I smeared peanut butter on my bagel and then discreetly went back to my room. We weren't supposed to eat in our rooms, but I was hungover and achy.

The sorority house had multiple staircases—one in the foyer, one in the rec room, and one near the kitchen. The main staircase was in the foyer near the front door and had the beautiful banister I always admired. Most of the sisters used the main staircase to move between the first and second floors. The rec room and kitchen staircases were on opposite ends of the house, and they were only convenient if your room was right next to one of them. The downstairs was interesting, because we didn't have hallways, just connecting rooms. From the kitchen a sister walked into the dining room, then the formal living room, and ended up in the rec room. The rec room was a lively room, and it had a big sectional couch that a person just fell into. There was a TV constantly tuned to soap operas, and a wood-burning fireplace we lit in cold weather. We all used the rec room a lot, and it was very relaxed. Unlike the formal living room, we were allowed to wear our pajamas in the rec room and bring in plates of food. It felt like a family room in a home. I liked the rustic look of the room, and it was the first time in my life that I lived in a house with a fireplace.

The second floor had a large communal bathroom as well as nineteen rooms that housed about forty women. The second floor was

almost L-shaped. If a sister came up the rec room stairs, she started at the short end of the *L*, then walked past a few bedrooms and the communal bathroom before turning into a second hallway that passed the foyer. I was in the second hallway in a room between the main and the kitchen staircases. I found that kitchen staircase helpful when I wanted to sneak food upstairs.

I climbed back into bed to eat my bagel. I was still pleased with my bedspread choice. I liked it because it was cheerful. It had a white background and then a pattern of brown and green trees. It was defined and clean looking. I paired it with a dark green, armed bolster pillow. I was leaning against my pillow, chewing my bagel, and watching the sisters walk by in the hallway as they started their day. I would have stayed under the covers all day if I didn't have plans. Friends I knew from the youth group were getting married. The bride was a year or two older than me and a student nurse. They were a kind and popular couple, and they had invited the entire youth group to their wedding. I dressed in navy corduroy pants and a big white sweater with a comforting cowl neck. It wasn't exactly wedding attire, but it was the fanciest cold-weather clothes I had in my closet. The wedding was an afternoon ceremony followed by an hors d'oeuvres reception at a nearby hotel. The celebration ended early, because the bride was scheduled for a hospital shift that evening.

Afterward, I went with a few other friends to another student's apartment. We had a casual potluck dinner. I was ready to retire after we ate. I was cold and still tired from my night out with Betsy. I also had a test on Monday that worried me. I asked Simon to drop me off early at the Chi Omega house. I washed up for bed alongside girls who were getting ready to head out for the evening. The temperature dropped to thirty degrees and only a few wore a jacket. Most of the sisters were headed to nearby bars where they could cover the distance quickly. They planned to be drunk enough to not care about the cold as they trudged home. Several sisters were headed next door

to Sherrod's, a big bar with multiple levels for dancing, darts, and drinking. I waved off invitations to join the women heading out, and I climbed into bed wearing white socks and a long, yellow flannel nightgown. I pulled up my covers and tried to study. My roommate was also in for the night.

Our room, like the others in the sorority house, was small. For storage, we had tiny closets on the wall near the door and a footlocker between our beds. Furniture lined the walls. Next to my closet, I had a tall dresser where I kept a heart-shaped ceramic bowl with a lid that hid my necklaces inside. I had an earring tree next to it, and a long ceramic dish for my watch. I had another little container for lipsticks. My desk was crammed between my dresser and my bed. I had a pile of books on top, a pencil holder, and a small lamp.

My roommate's side mirrored mine. We used the window ledge to display our Chi Omega paddles and other initiation gifts. Our beds were under the windows and against the walls in opposite corners. My bed was next to a shared wall with room 9, where two upper-classmen lived. Margaret Bowman had the bed that shared my wall. She was a pretty, slim brunette who was kind to the younger sisters. I didn't know her well, but I knew she had gone out that night on a blind date arranged by another sister. Her roommate was out for the night. Several other sisters had gone home for the weekend or were spending the night with a boyfriend. But a few were tired like me and my roommate. Around 11:30 PM, I switched off my light and told my roommate I was going to sleep. She did the same.

Nearby at Sherrod's, Ted Bundy watched women dance. He was more than a decade older than the other bar patrons, and the young people could tell he didn't belong. He was out of place. He wasn't there with a pack of graduate students who had FSU LAW written across their

sweatshirts. Nor was he there as an alumnus, reminiscing with other men his age and wincing about how weird it felt to be back. He was a thirty-one-year-old man alone at a college bar, and he unnerved the women around him. He briefly danced with one young woman, who told her roommate she was about to dance with an "ex-con." He struck her as sinister, and she left the dance floor quickly. The bar closed at two in the morning, and the revelers poured into the street outside. Bundy followed three Chi Omega sisters as they crossed into our parking lot and went in the back door. Bundy waited in the dark. He had been stalking a young woman who lived in a nearby duplex, and he planned to attack her that evening. On his way, he noticed that the back door to the Chi Omega house easily swung open. The keypad lock that my parents had trusted had been broken for days.

Inside the Chi Omega house, Margaret Bowman was waiting for the sister who had arranged her blind date. The two talked in the other sister's room while she changed into her pajamas. Then they went to Margaret's room for about half an hour before the friend said goodnight and went back to her own room. In the parking lot, Ted Bundy grabbed an oak log from a pile of firewood stacked near the back door. He entered through the back door with the broken padlock and began making his way through the downstairs.

I suspected he might have been in our house before that night, because it seemed like he knew the layout of the house. He went up the main staircase, and it appears he paused to unscrew the overhead light bulbs to darken the passage. He began trying doorknobs and found that room 9 was unlocked. Margaret was alone in her room, lying on the other side of the wall from me. I didn't hear anything. I didn't hear a scream or a struggle. It's been thought that she was sleeping when Bundy approached her bed. He slammed the oak log so hard on her temple that her skull broke and her brain was exposed. He had a pair of pantyhose with him, knotted in advance just the way he wanted it. He wound the nylons tightly around her neck. As he pulled, her neck

constricted as if it were a torso in an old-fashioned corset. Within a few moments, her neck was half its normal size. Bundy pulled her bedsheet over her body and made it seem as though she was sleeping.

Bundy went back into the hallway. He continued to check the doors. He found room 4 was also unlocked. Lisa Levy was alone. We're not sure exactly how Bundy attacked her, if she was aware, or if she suffered. I hope that she was asleep when the attack began and that she remained unaware of the sudden violence. When investigators found her later, they saw swelling that indicated strangulation. Her right nipple was nearly bitten off, and her body had several brutal bite marks. Investigators also deduced that Bundy had taken a spray bottle from her nightstand and rammed it into both her vagina and her anus. He pulled the bedsheet over her body and left her for dead.

In the darkened hallway, Bundy again began twisting doorknobs to see which rooms were unlocked. He wanted more victims who were sleeping and unaware. One sister was actually in the communal bathroom and could hear someone creaking around. She assumed it was another sister and didn't think much of the footsteps outside the door. If she heard him, it was likely that he heard her as well. But he didn't want screams and he didn't want sounds. He wanted to murder a woman so taken by surprise that she couldn't react and she couldn't resist.

Outside room number 8, Bundy turned the knob to our bedroom and found it was open.

5

I REMEMBER HEARING THE bedroom door open as it pushed across the carpet, but I wasn't awake enough to process what the sound meant. My first instinct wasn't fear. I was in my bed in a houseful of women whom I trusted. The front door was dead-bolted every night, and the back door was supposed to be secured by that keypad lock. I didn't have the expectation that a stranger would break into our house and quietly attack women in their beds. And so, the sound of the door panel brushing against the carpet didn't send jolts of fright through my body. I was aware, not alarmed.

Bundy strode across our room toward me. He tripped over the small trunk my roommate and I kept between our beds. The crashing sound woke me. I was confused by the commotion, and I didn't have time to panic or register the meaning of the silhouette in front of me. I wasn't wearing my glasses, but I could tell a man was towering over my bed. I felt as though I was in a fog, and although I was cognizant enough to understand my surroundings, I didn't have a sense of how to respond to what was happening to me. Bundy gripped the oak log he had grabbed from the firewood pile by the back door. I saw him

raise his left arm into the air. He slammed the log onto my face with tremendous force.

At first, I felt pressure, not pain. I began moaning and my roommate woke up. I'm not sure if Bundy initially realized there were two of us in the room. Now he knew. Bundy turned toward my roommate, tripping again over the trunk. He did the same to my roommate as he did to me. He stood over the helpless body of a woman he didn't know—a woman he couldn't even *see*—and he pummeled the side of her face with the oak log. He beat her twice, and at one point she raised her arm in resistance. The force of the log pounding against her hand nearly severed her finger.

In my mind, I screamed for help. In reality, I made gurgling sounds that no one outside our room could hear. This moment was the actualization of the nightmare that has visited all of us in our sleep when we dream we can't move or make a sound, and that if only we could, we might be saved. I know my mind instructed my throat to scream and my tongue to form words calling for help. But I couldn't make the connection. The sounds I made were nonsensical. They wouldn't wake anyone, and no one could hear me.

I didn't know at that moment that the woman who slept on the other side of my bedroom wall, the person most likely to hear me and call for help, was already dead in her bed. And even if one of the other women heard me call for help, what good would it have done? She would have come into our room and been immediately knocked out by the oak log. Even if a sister heard us scream and called the police quietly from her room, Bundy would have been done with us before the police cruisers even reached our parking lot. My roommate and I were at the mercy of a monster who had none to give. No one could help us.

I didn't have these complex thoughts as I heard the oak log crack against my roommate's jawbone. My responses were primal. I wanted to scream for help, but I could not. And I was increasingly aware of my

physical state. My mouth was filling with the unfamiliar metallic taste of blood. I had to either swallow it, which was an incredibly unnatural response for a person to do, or I needed to open my mouth and let the blood pour down my chin and onto my yellow flannel nightgown.

I don't think I even had the wherewithal to swallow my blood. I was trying to move my mouth to call for help, breathe, and process a new sensation—scorching pain. In the brief moments it took for Bundy to turn his attention to my roommate, the initial pressure I felt in my jaw faded and a searing sensation engulfed my entire head. I didn't yet know that both my jaw joints were broken and disconnected from my cheekbone. My chin was so badly smashed that it shattered, and my cheek had been ripped open, as though I had been hit by a bullet. My teeth were still in my jaw, but the intense force of the blow had pushed my molars forward. They were like cars on the highway that had been rammed forward in a massive, multicar pileup. The log had struck my body from my head down to my shoulder. I was unaware of it, but there were splinters of wood piercing my face, neck, and shoulder.

The damage to my tongue, however, was the most distressing injury. My back teeth tore into my tongue when Bundy slammed the log into my face. From left to right, my tongue was almost bitten through. It was barely still attached, and any words I tried to form drowned in my own blood. My tongue immediately began to swell, and I suddenly found myself with a mutilated mouth that worsened with each word I tried, and failed, to pronounce. I felt as though I was burning, but there was no fire to put out. Nothing could stop the pain.

Bundy heard my desperate sounds. He heard the blood gurgling in my mouth as I frantically gasped for air. He listened to my whimpers as I realized no one could hear me and no one could help me. Bundy had no humanity for me. He didn't see an innocent woman who had been sleeping in her bed one moment and then pouring blood from her mouth the next. He saw a woman who had the nerve to live when

he had sentenced her to die. By the time he stood at my bedside, he had killed dozens of women and girls, and brutally left a handful of survivors for dead. Many, like me, were attacked in their beds while they slept, unaware that a stranger had broken into their room. In these murders before he attacked me, he had developed a method for attacking sleeping women.

He first battered their heads to render them unconscious. Then he violated them while they were lifeless by shoving objects like a spray bottle or metal rod into their vaginas. Later, he altered his approach and added strangulation as a middle step. In his early murders in Washington, he didn't think to strangle these women, and not all his victims died from the head wound. Several woke up after he left or were found unconscious by concerned roommates or friends. By the time Bundy reached the Chi Omega house, he had a three-part process to murdering: pummel, strangle, defile. It's what he did to Margaret and Lisa, and it appeared to be his intent with my roommate and me. Mercifully, I did not know the trajectory he had put me on.

To Bundy, I had not complied with step one, being knocked unconscious by one blow to the head. I think, in hindsight, that he actually had the nerve to be frustrated that my murder was not going to plan. He turned away from my roommate and came again to my bedside. He wanted me dead, and in this moment, I was aware that a second death sentence had been issued in my short life. Lupus had been my first, and now Bundy was my second. I realized entirely that this silhouette of a man whom I could not see was about to end my life.

The prospect of a sudden, violent death was different from the slow, agonizing death sentence I had with lupus. When I was younger, I had sat with those women in that support group as they accepted their fate, cried for their husbands and children, and worried about how they would cope after their death. I defiantly told Mama that wouldn't be me. I was going to live. I so fiercely believed it, too, almost

as if I had been given a choice between life and death. And once the exhaustion from the chemotherapy waned, we were able to see that I had been right. I was going to live. The death sentence the physicians in the hospital had given me, the same one the women in the support group had to accept, no longer applied to me.

But with Bundy standing over my bed, I knew I didn't have a choice between life and death. This demonic figure in front of me had chosen for me, and he wanted me dead. I lay on my side and pulled my knees close to my chest and scrunched myself into the smallest ball possible. My hope was that if I made myself tiny, he wouldn't be able to see me and hit me again. And then I braced myself and awaited the blow I knew would end my life. I didn't accept this death sentence, and I didn't have a resolve in the moment that I was going to a better place or that I would soon reunite with my father who passed away when I was little. I also didn't have time to mourn my parents or siblings, my larger family, and my dear friends. My response was physical, and I simply knew I was overpowered.

And then a light suddenly flooded the room. Our fateful decision at the beginning of the year to leave the drapes open and hang plants from the curtain rod meant there was nothing to block the illumination. The windows ran the entire length of the back wall, and the light shattered the darkness. It was as if in that moment Bundy had stepped into a spotlight, because he could see nothing but the light in front of him. There were no shadows or dark pockets, only light, and to me, the light was extraordinarily beautiful. It was clean and bright, and also commanding. A person had to stop what he was doing and give all his attention to this blinding radiance.

The light came from a car in the parking lot that was driving slowly on its way to drop off one of the sisters at the back door. The U-shaped lot was long and unpaved, so most drivers tended to roll slowly up to the house. Given the freezing weather, the driver might have been worried about skidding on ice into a parked car. He inched

through the lot, and his unhurried pace kept the light mercifully shining into our windows.

The light was so bright that it disrupted Bundy. Before the light came into our room, Bundy had been frenzied. In less than a few minutes, he had barged into our room, beaten each of us, and then intended a fatal hit against me. He had moved erratically between the two beds, tripping over the trunk multiple times in his desperate attempt to kill us both. But he froze in that light. It was like a switch flipped in him and brought him out of his fervor. He was spooked, and I think he was worried he had been seen. He fled the room. As soon as Bundy disappeared, the car curved around the bend, and the beautiful white light disappeared.

6

WITH THE OAK log still in his hand, Bundy bolted from our room and into the hallway. He passed room 9, where Margaret lay lifeless with pantyhose strangling her neck. He sped down the stairs and into the foyer. At the same time, the sister who had been dropped off at the back door was coming through the rec room. Nita saw Bundy from the side as he crossed the foyer and unlocked the front door. Men weren't allowed on the second floor of the Chi Omega house, and Nita immediately sensed the man was malicious. She focused her attention on his appearance as he opened the door and ran from the house.

Nita lived in the room directly across from mine. She hurried upstairs and woke her roommate, Nancy, and described what had just transpired—as she came through the rec room, she heard a man run down the front staircase, turn the dead bolt, and rush out the front door. He was carrying some sort of baton or stick in his hand. She wasn't clear on that detail, but she saw his profile clearly. She wondered whether they should call the police. This man, she said, wasn't our houseboy who helped with repairs and chores around the property. She could tell he was older. He had a distinct, protruding

nose and brown hair. He wore light-colored pants, a dark jacket, and a ski cap. He wasn't the type who would have been secretly visiting one of the sisters in her room at her invitation. No, something was wrong about him. Nita and Nancy crept down the stairs together to make sure the door was locked. They then hustled upstairs to wake the sorority president and report what Nita had seen

In our bedroom, my roommate and I were reeling from the attack. Mere minutes had passed since Bundy stood over my bedside and held the oak log high in the air for the second time. The pain was so violent that I wasn't able to feel relief that he was gone. I knew I was still alive, and that I had survived, but the agony of my injuries made it seem as though I was actively in the process of dying. I remained in my bed, stunned by the attack. My roommate was somehow able to get up. She staggered into the hallway and saw Nita and Nancy.

Nita and Nancy looked at the bloody face stumbling toward them, and it took them a second to process what had happened to my roommate. She was unrecognizable. Her speech was slurred and she was unsteady on her feet. They initially thought she was drunk and perhaps had fallen out of bed. They quickly realized she was badly beaten. Her skull was fractured, and most of the bones in her face were shattered. The arm that she raised in self-defense was broken and her fingers were crushed. As Nancy and Nita guided her back to bed, they turned on the light and saw me sitting upright on my bed. They saw my jaw hanging from the joints and the open, freshly burst flesh of my cheek. I rocked back and forth, cupping my chin with my hands as a pool of blood formed in my palms and spilled through my fingers.

I heard one of the sisters gasp, "My God. Help her."

Nancy and Nita immediately understood the scene in front of them. That man Nita saw holding the baton—he had done this. I moaned and gurgled as they tried to situate my roommate on her bed. She was unstable and she kept slipping off. Nita ran from the room to get help, and another sister came into the room. She looked at the

blood-soaked bedsheets and our butchered faces and left the room to vomit. Elsewhere in the house, two sisters simultaneously called the police. Six minutes had passed since the light had saved me.

The house was beginning to stir. One of the sisters who lived down the hall came into my room and wrapped her arms around me while we waited for the paramedics to arrive. I was so distraught that I didn't look up, and I never remembered who she was—but I remembered her compassion. That was unforgettable. This young woman, who was only just twenty or twenty-one years old, bravely came into our blood-streaked room, ignored the blood spilling from my jaw, and sat on my still-wet bedspread so that she could comfort me in the worst moment of my life.

I understood the sister's voice was kind as she repeated assurances, but I didn't register her words. I was conscious but experiencing moments of amnesia in which I appeared awake but was truly unaware of my surroundings. Later, I learned I called out for Simon as well as the pastor of the church with my youth group. I didn't remember calling for either, and I also didn't think that was very likely. My tongue was nearly severed, my jaw was unhinged, and my mouth was filled with blood. It might have sounded as though I was trying to say their names. Perhaps I actually called out for them. But why them? Simon and I weren't madly in love, and although I appreciated the pastor, he wasn't a close personal friend. I had, however, seen them both just hours before the attack, and in my confused state, I might have thought they were present.

The room continued to fill with people. The police arrived, and one of the officers kneeled next to me, almost as if he was guarding me. I felt immediately relieved by his presence. It was only a fleeting sense of security, because I continued to slip in and out of consciousness, which meant I had to reorientate myself as soon as I regained awareness. My thinking wasn't clear, and I worried the attacker would return, kill everyone in the room, and then finish beating me to death.

The commotion intensified when the paramedics rushed into the room. I remember one paramedic looked at my shredded cheek and assumed a bullet had blasted my face.

"Don't worry," the paramedic told me. "You've been shot in the face. We're going to take care of you."

There were oak pieces from the log on my face, in my sheets, and scattered around the floor. One of the paramedics made a comment about the wood debris, but they didn't know to connect it to our injuries. I felt confused, because I knew I had been beaten with some sort of blunt object. I didn't know why they told me I was shot. Nothing made sense, and I wasn't in a position to sort out the insanity of it all. The paramedics had me lie on the bed and they knelt on the floor beside me. My bewilderment intensified as I continued to lose and regain awareness. I don't recall being lifted onto the stretcher, but I remember being carried down the front staircase on the stretcher, past the beautiful oak banister I had long admired, and into the foyer. The police officer walked alongside the stretcher, and I understood he was a force field between me and my attacker.

When we reached the front door, I felt a blast of wet, frigid air. Being carried over the threshold disorientated my mind further. I no longer understood the relationship between me and the men carrying my stretcher. Their bodies seemed distorted and small, and their heads appeared huge, almost as if they had been inflated like bobbleheads. They stared down at me, and I misinterpreted their gaze as judgmental. *What are you looking at?* I thought angrily.

And then I arrived at a carnival. The police had blocked off the street in front of our house, and the swirling blue and red lights from the squad cars bounced off the sorority house and the pavement. The chaos pushed me into a hallucination, and for a few moments, I believed I was at a carnival. I misheard the police chatter as festive noise, and I felt transported to a carnival midway. I saw people walking past the stands with games and prizes to be won. I heard the barkers

calling for people to step on up and try to win a prize. I saw a Ferris wheel, and the full scene was confusing and nightmarish.

At the time, neurologists didn't know as much about concussions and traumatic brain injury as they later came to learn. I had just endured a massive hit to my head—enough to shred the flesh on my cheek—and I sustained a concussion from the impact. I experienced posttraumatic amnesia in which I remained awake but lost awareness when the paramedics moved me onto the stretcher and out of the house. The carnival hallucination was a symptom of posttraumatic delirium. It was terribly vivid and felt so real in the moment.

Leon County sheriff Ken Katsaris watched me on the stretcher as I quietly hallucinated the carnival. In my mind, I was at a carnival watching people try to shoot a plastic duck with water or toss a ring onto a bottle to win a prize. From his perspective, he saw a petite young woman with dark curly hair caked in blood. Her jaw was cracked and exposed. She had experienced blood loss, and although she was breathing and awake, she wasn't orientated to her surroundings. There was no way, he thought, that she was going to live. He expected the surgeons would do their best before my body gave up and they called the time of my death. He had seen the death sentence my attacker had issued, and he didn't think I would survive.

My sorority sisters watched my roommate and me being carried away in stretchers. They clustered in the hall, sharing information, and trying to make sense of the horror they were forced to confront. One of the sisters, Diane, realized that Lisa Levy was still in bed. She went into Lisa's room with the intention of waking her up. Lisa was still unconscious from the blow to her head. She was barely breathing, and she slipped further from this world with every lengthy pause between her shallow breaths.

Diane and Lisa had been friends since middle school. Diane held her close and called for help. The police and the paramedics ran into the room, which prompted Diane to try to cover Lisa's exposed breasts. Bundy had bit Lisa's right breast so viciously that he nearly pulled off her nipple with his teeth. To Diane, it looked like Lisa had been shot in the chest. The wound seemed like the flesh had been blasted, and it made sense to her that the damage had been caused by a sniper who had aimed his weapon through the windows. Paramedics began working on Lisa, and Diane was pushed from the room. Shaking and covered with her friend's blood, she joined the other women.

Police told the sisters to gather together in one room. They conducted a quick census. Who went home for the weekend? Who was staying with a boyfriend? The women realized that one sister, Melanie, was missing. They told a police officer her room number and braced themselves while he strode down the hall and pushed open her door. Melanie was asleep under the covers, and the officer feared for a moment that she was another victim. She woke up startled to see a strange man in uniform in her room. She was likely disorientated as she followed the officer to join the others. Her head cleared quickly as she listened to the sisters run through the roster and see who was home. Margaret Bowman, someone suggested, wasn't at home.

Melanie knew otherwise. She had been the sister Margaret had waited for downstairs to tell her about her date that evening. They went to Melanie's room while she changed into her pajamas, and then back to Margaret's room to talk more about the date. Melanie shut the door to Margaret's room when she left to go to bed. She told the police officer, Henry Newkirk, that Margaret was home, and she followed him into the hall as he went to conduct a bed check. Melanie realized the door to her friend's room was slightly ajar, and she immediately sensed something was wrong.

From the doorway, Margaret seemed as though she was sleeping on her stomach. Newkirk saw her dark hair on her pillow, and he

might have felt a surge of hope that Margaret had slept through the commotion just like Melanie had. But as he approached, he realized he was discovering another victim. He thought he was protecting Melanie and the other sisters when he slammed the bedroom door shut. He didn't want them to see the extent of the savagery their friend had suffered. Margaret's skull was fractured. Her brain was exposed, and a river of blood leaked down her face. A nylon was wound so tightly around her neck that it seemed broken. The distortion was so profound that Newkirk thought it looked as though Margaret's head had been decapitated and then rested on top of her shoulders. Her body was lifeless, but Newkirk checked for a pulse anyway. He observed shards of bark and wood pieces on the bed and the floor. None of it made sense.

When Newkirk slammed the door in Melanie's face, it was meant to be for her protection, but I think the authorities underestimated these young women. These women had watched as three of their brutally wounded sorority sisters were carried away on stretchers. They had seen the worst of the violence, and in the most intense moments, they had been strong and loving. Sisters had comforted my roommate and me as we reeled in pain and bled over our bedsheets. One of them, Diane, fearlessly held Lisa as she drew the last breaths of her short life. These women had already been traumatized. Trying to "protect" them from the inhumanity they had already witnessed wasn't helpful. The police didn't even tell them Margaret was dead. They saw her body carried down the staircase in a body bag, and they drew the devastating conclusion for themselves. It wasn't just in the moment of chaos that they were denied information. It took them weeks to learn the extent of Lisa's and Margaret's injuries. They had to learn from a newspaper report how Lisa was sexually violated with a spray bottle.

In hindsight, an officer should have come and spoken to the chapter to address all their questions—no matter how painful. But there is no playbook that tells anyone how to handle a surprise attack by

a serial killer on four young women as they slept in their beds. The authorities did what they thought was best. One of their first orders was to have the sisters clear the house. The entire house was a crime scene and it needed to be sealed. With trembling hands, the sisters packed bags of belongings to leave. As they left, they pieced together what they knew of the night—who had come home at what time, who had barely missed crossing the murderer. Melanie realized she had been back and forth with Margaret in the hallway. All of them came to the understanding that they had somehow survived a slaughter.

––––––––––––––

My roommate and I were each rushed to the hospital. Another ambulance carried Lisa to the emergency room, where she was announced dead on arrival. Margaret was taken to the hospital's morgue and placed in the walk-in refrigerator. Newkirk, the police officer who found her, had graduated from FSU just two years earlier. He stayed with her in the morgue and throughout her autopsy. Although no one asked him to do so, Newkirk stood guard over Margaret's body and later said it was to make sure she was secure. I think it was a last act of kindness. Her killer had treated her like she wasn't human, as if she had no right to life. Newkirk's instinct to shield Margaret contradicted Bundy's malice. Her body deserved dignity—in both life and death.

The paramedics who brought my roommate and me to the emergency room left the hospital stunned. They did not realize their radio would soon call them to another crime scene. Bundy was still on the rampage. His next victim, Cheryl, was a dance major who had just come home from an evening out with friends. She lived in a duplex whose other part was occupied by close friends. The walls were so thin between the units that the women could hear each other's radios playing or phones ringing. Her friends knew Cheryl had come home because she initially played her television too loudly and they asked

her to turn it down. They all went to bed, and then the friends woke to the sound of a hammer banging. When they listened carefully, they thought they heard Cheryl whimpering.

One of the women called her boyfriend for advice. He dismissed her concerns and told her to go back to sleep. She tried calling Cheryl instead. They listened through the wall as the phone rang five times in Cheryl's apartment. The sound of the phone ringing sent Bundy running. The repeated sequence of the methodical sound and brief pause pulled Bundy out of his fervor once again. The ringing was her light in the dark, her savior.

On the other side of the wall, the friends dialed the police. When the Chi Omega sisters had dialed dispatch less than an hour earlier, the women had been understandably distraught and hard to understand. The dispatcher didn't anticipate mass murder at a sorority house and radioed that sorority girls were fighting over a boy. When Cheryl's friends called, the dispatcher and the responding officers knew another deadly attack had occurred.

Cheryl's friends located a hidden spare key and gave it to the officers. In her apartment, they found the battered young woman on the floor. She would wake up later at the hospital with five skull fractures, two jaw fractures, and a dislocated shoulder. The beating robbed her of her hearing in her left ear and stole her sense of equilibrium. Sheriff Katsaris sent an investigator to the scene. Even on the surface, the crime against Cheryl resembled the attacks at the Chi Omega house—sleeping women were bludgeoned by an intruder. He suspected it might be the work of one deranged man.

At that point, Katsaris knew Margaret and Lisa were dead. Cheryl, my roommate, and I were all at the hospital, and Katsaris was not optimistic about our recovery. Margaret's autopsy later showed that Bundy had beat the right side of her head so hard that the left side of her brain slammed against her skull. If we had endured the same type of attack, how were we to survive? He would later learn that our

attacks had been interrupted. My roommate and I had been graced by the light. Cheryl had been saved by the ringing.

If only there had been something to save Margaret and Lisa as well.

7

A POLICE CRUISER SPED behind the ambulance that brought me to the hospital. In the vestibule, an officer followed my stretcher and then positioned himself nearby as a team of physicians and nurses began to examine me. The police officer's presence assured me, and I began to understand that my attacker was not coming back to finish beating me to death. I realized the police officer was armed, and he was prepared to defend me. I had the sense it was the same officer who had been with me in my room at the sorority house. It might have been an entirely different person; I was only focused on his uniform and badge and how they signified a willingness to protect me. Less than twenty minutes before, I had tried to curl myself tightly into a ball in the hopes that my attacker wouldn't be able to see me and pummel me a second time. Now I had someone by my side, standing on guard as though he was my shield.

Just as the police officer's presence assured me, I felt a new surge of fear as the medical team triaged my injuries. I could hear them describe my wounds to each other, but my vision was not clear. I didn't have my glasses, and I struggled to focus on the faces surrounding the metal examination table. These disembodied voices were

frightening, and I strained to make sense of who these people were and what they were going to do to me. I knew they weren't going to maliciously harm me, but I still worried they would hurt me. My eyes fluttered back and forth as I tried to focus on the voices as they blurred into a chorus of medical directives.

The chorus began an odd recitation about rape. The attacker had violated Lisa and Margaret, and one of the police officers in the room recommended the nurses perform a rape kit. I knew I hadn't been sexually assaulted, but my nightgown was stained crimson from all my injuries and I couldn't speak to tell them my injuries. As the medical team passed the idea back and forth, a young nursing student became clear to me. She stood at my side and watched my eyes widen at the discussion of a rape examination. I was a virgin, and I was afraid of the probing, especially if it was going to occur before an audience of nurses and cops. I also didn't want my underwear removed in front of a room of people, exposing my nakedness. I was powerless to stop them, and I panicked silently as a nurse took scissors and pushed them against the hem of my yellow nightgown. I heard the progressive snipping as my nightgown slit open and my calves, and then my thighs, were bared for all to see.

The scissors cut past my pelvis and revealed my underwear. I felt the humiliation of knowing my privates were covered by a thin layer of cotton and that everyone in the room was staring at my vulva underneath, trying to assess whether a rape kit was warranted. The student nurse kindly looked into my frantic eyes, and she understood my fear. She spoke up and firmly told the other nurses to stop. She pointed out that I was still wearing my underwear and it was clean.

"There is no indication of assault," she announced.

The other nurses promptly agreed she was right. A woman with my grave injuries would not have been able to pull her panties back on after an assault. And my underwear showed no signs of blood or semen. I had been spared one of Bundy's standard actions in his murderous

routine. So many of his other victims endured injuries inflicted with metal rods or pipes. He hated women so deeply that he repeatedly rammed sharp and blunt objects into their vaginas, almost as if he was aiming to puncture their uterus. Even once the women were dead, he couldn't stop himself from wanting to rape their cold corpses. He violated several of his victims after their deaths, and in certain instances, he even returned to the mountains where he dumped their bodies so that he could apply makeup to their lifeless faces and then rape them.

Bundy was on a rampage at the Chi Omega house. Yet he still paused to ram the spray bottle into poor Lisa's vagina and anus. She was unconscious, but still alive, when he shoved the bottle into her body and then deeply bit her breast and buttock. If the light had not saved my roommate and me, it was probable that he would have strangled us both and then grabbed objects off our nightstands or the window ledge to thrust into our helpless bodies. We had been spared, and the student nurse sensed how an unnecessary rape examination would only add to my trauma. With her quick and firm announcement, the scissors were put away and the medical team returned to planning surgeries for my jaw and chin.

The student nurse leaned in close and stroked my forehead gently. I knew her. She was the bride in the wedding I had attended just hours before. She was still in nursing school, and she was doing a rotation in the emergency room. After the reception in the early afternoon, she traded her bridal gown and veil for her nursing uniform and cap. And here she was, comforting me, a guest at her wedding who had been brutally attacked. Like the sorority sister who came to my bedside and held me while we waited for the paramedics, the student nurse was loving and assuring. Her touch was masterfully healing, and her gentle fingers on my forehead released my tension and gave me a sense that I was not alone. She stayed with me as I was moved from the emergency room to the presurgical area. She was one of the last images I saw before I was sent into surgery.

The phones began ringing in the dark of night. In Saint Petersburg, Margaret's parents heard the apologetic voice of a police officer explaining their daughter had been injured. Lisa's parents received a similar call. My roommate's family was local, and her parents learned almost immediately after the attack that their daughter was injured and on her way to the hospital. The caller was vague, and her father thought perhaps she had fallen and broken a bone. He sped to the hospital and arrived before the ambulance. As he waited, he overheard nurses telling each other to prepare for two young women to come in "dead on arrival." He feared one of those women was his daughter, and he considered returning home to get his wife. A physician intervened and assured him that his daughter was alive and on her way. He sat helplessly in a plastic chair and waited.

In Miami, my parents had a similar feeling of powerlessness after the phone rang at four in the morning. They were almost five hundred miles to the south, and driving would take most of the day. They hurriedly packed suitcases and tried to control their emotions as they stood at the airport ticket counter, walked onto the tarmac, and then waited for the airplane door to close. The flight was only around ninety minutes, but hours separated them from being by my side. I was in surgery, and the hospital had limited information they could provide at that point. The police didn't have many answers either. All my parents truly understood was that something brutal had happened to me.

In the morning, radio news reports described the assault. Back in Fort Lauderdale, my friend Nora woke to the sound of her parents talking in the kitchen. They had been listening to the radio when they heard my name listed as a victim in a sorority house attack. They hesitantly explained to her that someone had broken into my sorority house, killed two women, and gravely wounded my roommate and me. Her dad tried to call FSU for more information, but no one was

able to tell him more than what the radio had reported. None of it made sense. The authorities didn't know who had attacked us or why. Updated information was promised, but all people could do was wait.

Nora's mom, Goody, had already lived through a similar situation in which people waited anxiously to learn whether loved ones had survived. In November 1942, she was a lounge singer onstage at the Cocoanut Grove nightclub in Boston, surrounded by a forest of fake palm trees. In the audience, a young GI unscrewed the light bulb above his table to give him and his date more privacy. A busboy lit a match to see better when he screwed the light bulb back into place. The match torched nearby drapes and the fire raged around the room. The club, authorities would later learn, was a death trap. The front door was a revolving entrance that took only one person at a time and jammed easily, especially in a panic. And the side doors had long been bolted shut by the club owner to stop patrons from stepping out on their bills.

People toppled out of their chairs from the smoke inhalation. Others stampeded to get through the revolving door. The palm trees around Goody ignited, and she froze in fear with her fingers hovered over the piano keys. She suppressed her terror and pulled herself up from the piano bench, warning the kitchen workers as she fled. She demanded that a hesitant cashier leave the till and follow her. She then held a wet napkin to her nose and followed others as they pushed their bodies through bar-covered windows and into the alley. In the coming days, people waited anxiously to learn if their loved one had made it out alive, was recovering in a hospital, or was one of the almost five hundred people who perished. Goody's sister, Aunt Riva, was one of those who didn't know whether her loved one had survived. She had planned to pick Goody up that night at the club and saw the hysteria as she approached. One of their cousins told Riva he saw first responders carting off an unconscious young woman wearing a red velvet dress. Goody had been wearing a red velvet dress that evening. For the next terrifying few hours, Riva feared the worst.

The fire sparked serious academic studies on anticipatory grief—the idea that a person could begin mourning the loss of someone before they were dead or even known to be dead. Aunt Riva had agonized all night about whether the woman in the red velvet dress was her sister. She avoided calling home to their mother, but finally did so the next day and learned Goody was safe. The morning after the FSU attacks, anticipatory grief was felt by many people as they waited to learn whether my roommate, I, or the other victim, Cheryl, would survive our surgeries.

Aunt Riva had always been popular among our friend group in high school, and she took on the task of calling my friend Tony in New Orleans with the bad news. Tony had been the houseboy for Chi Omega. We called him the house "sweetheart" as his official title. In exchange for free meals, he helped the cook with setup, serving, and breakdown. He had last been in our house the Thursday before the attack. In the kitchen, he had chatted with Margaret about a diorama she had made of a restaurant interior for a design class she was taking. The next day he had flown to New Orleans, where his parents had recently moved, and spent the weekend at home.

He groggily took Aunt Riva's call. "Doll," she asked him. "Are you watching the news?"

"No," he said. "I'm sleeping. Why?"

"Well," she said. "I am going to tell you what happened."

———————

The campus was shaken by the murders. The university immediately put out a statement warning students that two women had been killed at the Chi Omega house and two more were injured. They listed our names and ages, and also identified the fifth victim, Cheryl. Students gathered that evening for a candlelight vigil to honor Margaret and Lisa, and to pray for the three of us who were hospitalized. Students

were terrorized, and the school responded by requesting that all females walk in the company of a male. The men of FSU took their duties seriously. Male students slept in the hallways of the dorms, and fraternities offered to personally escort sorority members across campus.

By Sunday afternoon, my parents had arrived at the hospital and were ushered into my room in intensive care. They were with me, but they couldn't see me through the bandages that wrapped around my face. They stayed at my side and answered calls from the friends and family who phoned the room, heard a busy signal, and tried again until they got through. Mama repeated herself with each caller, pausing at times to compose herself. She told callers that I'd had surgery and that my jaw was wired shut. She spoke carefully, trying to contain herself in case I overheard her in my drug-induced state.

Tony called the room in the evening. In high school, he had been a regular with our theater group, and his mother was best friends with Nora's Aunt Riva, which gave him good status with Mama. He also had language abilities that she respected. His first language was Italian, and he learned Spanish from a Latin American nanny. He always enjoyed practicing his Spanish with Mama, and when he called the hospital, she didn't want to risk speaking in English in front of me. It was reminiscent of all those years ago when I had lupus and Mama spoke with my aunts and the physicians in Spanish. She was doing it again, and reverting to her native tongue seemed to open her emotions. She spoke too fast for Tony to understand, and he had to pass the phone for his father, an international businessman, to translate.

Sitting in a hospital room again, switching to Spanish, and not really knowing what was going to happen had to feel like she was back in the pediatric ward, wondering if her child was going to live. Back then, the physicians didn't initially know what was killing me. In Tallahassee, authorities didn't yet know who had murdered my sorority sisters and tried to kill my roommate and me. Everyone was a suspect, and men who had dated the victims, including my boyfriend

Simon, were brought in for questioning and then dismissed. The Chi Omegas submitted to fingerprinting so crime scene technicians could analyze the house and determine which prints didn't belong. In the early days, the authorities were in the dark about the attacker and his motive. They had only Nita's description of the man she saw in the foyer. But why did he do this? Why these women? And did he plan to do it again? They had to assume so.

I knew I had been attacked. My parents didn't have to hide that from me. My roommate didn't have any memory of what had happened to her, and her parents eventually had to tell her about the attack and then about Margaret and Lisa. Mama withheld news of their deaths from me, and anyone who called or visited was on strict orders to not discuss anything upsetting. I wasn't able to broach the subject on my own given that my mouth was wired shut and my tongue was split nearly in two. The surgeon had decided to allow my tongue to heal naturally and said the tissue would renew itself over time. Until then, I had to experience the disgust of feeling that shredded muscle in my mouth.

Within a few days, I moved from the intensive care unit to a private room. Nora came up to Tallahassee in the middle of that week, on the same flight as my sister. Nora waited her turn to see me, standing awkwardly in the hallway next to the police officer who guarded my room. I couldn't talk when I saw her, and my face was too bandaged for her to really see me. I felt sad for her to see me in this situation. We were so far away from those evenings we spent at her apartment, singing while she played the guitar. Those days, I realized, were never coming back, and I had a new reality to confront. Yet I felt comforted knowing that Nora was with me again as I moved forward. Nora could see my eyes and how they prickled with tears. She supposed they were from fear and frustration. She was right. I was badly wounded, swollen, and constricted by wires and gauze. None of it made sense, and it wouldn't for a long time.

8

THE MORNING AFTER the attacks, residents at the Oak apartment building were also trying to make sense of the murders. A few people gathered in one of the units and shared what they had heard from the news reports as well as secondhand information. Bundy invited himself into the conversation. The other residents knew him as "Chris Hagen," and he claimed he had left Stanford University's law school. They assumed he was some sort of graduate student at FSU, but no one had taken the time to ask and Bundy didn't offer specifics about himself other than to tell them he knew the law very well.

No one in the unit really knew anything about the murderer or his motivations. One resident, however, guessed correctly that the assailant was probably still in the area. Bundy disagreed. He suggested the killer was a "professional" who had used an untraceable weapon and fled Tallahassee after the last attack. The other men in the room let Bundy talk, mostly because they didn't care enough about him to correct him. They thought he was weird and arrogant. He had only been in the building a few days, and he had already irritated the other residents with his bragging. It wasn't only that he spoke highly about himself, it was that he boasted about odd things. Bundy told

one resident that the police were so stupid that he bet he could easily outsmart them and get away with murder.

Bundy at that point knew that three of the women he had attempted to murder the night before had survived. He never expressed any sentiment about our survival and whether that disappointed him. His focus was on the police, and his desire to outsmart them was like a game. His behavior, forensic scientists would later learn, was typical of serial killers in the days after an attack. Bundy enjoyed discussing the murders with others in his building, and he delighted in how no one had any solid leads as to who was responsible. He could have left the area and headed to a new state or even Mexico. Yet he remained in Tallahassee because he wanted to be close to his crime, and in some ways, he wanted recognition for the murders. He didn't want to be arrested or sent to prison. But he wanted acknowledgment that the crimes belonged to him.

His desire for recognition wasn't uncommon. Serial killers have been known to send notes to police or to befriend reporters covering the case so they can offer little clues. They taunt authorities and then revel in the fantasy that they are too smart to be apprehended. Yet it bothers them that no one knows they are too smart to be apprehended. It's a game to them, and they want to win, because in their disturbed minds, they think the public will admire not admonish them. Think of the BTK strangler. For almost seventeen years, he sent newspapers and police anonymous letters about his crimes. He invented the acronym BTK to signify how he murdered his victims—bind, torture, kill. He killed ten people, including a husband and wife and their two young children. The BTK killer then detailed the crime in a library book left at the Wichita Public Library.

The murder of the family was particularly horrendous. The BTK killer suffocated a nine-year-old boy with a plastic bag and hung his eleven-year-old sister from a basement pipe and masturbated while she died. He murdered children in the worst way possible, and then

tried to turn his crimes into a cat-and-mouse game between himself and the police. Did he think the public was cheering him on? As if he was some sort of heroic outlaw who challenged the authorities, and in doing so, represented a disgruntled community? In some ways, these sexually sadistic serial killers mistakenly thought the public respected their intelligence and their ability to evade authorities. Because to them, it was never about the victims. The people they murdered, or attempted to murder, didn't exist to them as actual people. To people like the BTK killer or Bundy, the victims were targets. We were necks to strangle, heads to bash, and vaginas to violate. We were parts, not people.

About a week after the attack, my dad climbed into the passenger seat of a black, unmarked police cruiser. Marilynn, Mama, and I sat in the back. A second unmarked cruiser followed us as we drove. The police still had no viable leads as to who had attacked five sleeping women or why. They wanted me on constant surveillance as we left Tallahassee, and they planned for an undercover agent to ride with us on the plane to Miami. I thought we were headed to the airport, but the cruiser drove toward campus and the Chi Omega house. The officer explained that he needed me to return to my room and look to see if anything was missing. This was important because police needed to consider whether robbery was a motive and if the attacker stole anything of value. They were also looking to see if the killer took any of my nonvaluable belongings, or what the police referred to as "souvenirs" or "trophies." Given that the killer had attacked five women in one night, the police had to assume they were dealing with a repeat offender. And some serial killers were known to take a specific item from their victims in order to later hold the object and relive the killing.

I sat in a car full of people and I felt alone. In just one week, my life had changed, and in many ways, it felt like it had regressed. I was wounded, and enduring a physical pain that no one else in the car could understand. It reminded me of all those times Mama and Marilynn drove me to my chemotherapy appointments and I rode in the backseat with a sense of dread. I was once again in the backseat, heading toward a place that I knew would cause me pain. And that in itself felt so confusing. The Chi Omega house had once been a place I loved dearly. Now it was the scene of the crime, the place where I almost died.

I think Mama had her own pain to endure in that car ride. She must have felt as though her life had regressed as well. Before the lupus diagnosis, she had fought so hard in the hospital to keep me alive and find someone who could end whatever was killing me. She again had a wounded daughter, and no idea who had tried to murder her. She had trusted the Chi Omega house would be safe for me, and that broken keypad lock had betrayed us all. She probably never wanted to see the Chi Omega house again, but there she was, parked in front of it to wait while I went inside.

The police officers helped me from the car. I had not walked since the night of the attack. The last time I had taken steps on my own was when I crossed my room in my yellow nightgown and climbed into bed. I had been immobile ever since and my muscles had weakened. I was unsteady, and the officers each put a hand under my arms to help me up the front walk. In the foyer, I was struck by the silence. The sisters had not yet been permitted back into the house. The crime scene technicians had claimed the house for themselves, and there was a layer of black fingerprint powder on every surface. Yet the house had an overpowering smell of perfume. The sisters had not lived in the house for a week, but the mix of their various perfumes and fragrant shampoos still lingered. I had never noticed the aroma before, but after being in the hospital, I found it made me nauseous.

With the officers' support, I took one step at a time and moved up the staircase slowly. At the landing, I saw there were three doorways blocked by yellow crime scene tape—Margaret's, Lisa's, and mine. I didn't know anything had happened to anyone else in the house. In the hours after I awoke from my surgery, I was foggy and under the influence of both a head injury and painkillers. I thought all the sorority houses at FSU had been attacked, and I worried for my friend Betsy, who lived in another sorority house. I had to be assured that only Chi Omega had been attacked, and I assumed it was just me and my roommate. No one told me otherwise, and it would be weeks before Mama would finally admit the devastating news about Margaret and Lisa. In the moment, I sensed that something bad had happened to them, but I was too bewildered to make the connection.

We paused in front of my room so the police officer could remove the yellow crime scene tape. I stood in the doorway and confronted the scene in front of me. Our room was a snapshot of suffering. There were blood streaks and splatters on the walls and the floor. Both of our beds were drenched in the blood that had spilled from our heads. My beloved comforter—that green and white cover with trees—was crusted in brown dried blood. I stared at the comforter and considered the massive stain. It came from the blood that had poured from my mouth and dripped from my face. I remembered the way it tasted and how my nearly severed tongue flailed in my mouth.

This really happened to me, I thought. *None of this was imagined.*

The room shocked me. This was where a man I had never met before in my life used an oak log and tried to pummel me to death. This was where he held up the log for a second time while I braced myself and waited to die. This was where the beautiful white light shone through our windows and saved us. It was horrifying, but I think I needed to see it to understand that what I experienced was true, as confirmed by the bloodstains on my comforter. I would never have to wonder what the room looked like after we were attacked;

I would never have to question myself when I revisited the attack in my mind.

The police officer brought me back into the moment. He asked me to look around the room and see if anything was missing or if there were any objects that didn't belong to me. In addition to taking "souvenirs," some serial killers were known to leave "calling cards" meant to signal they were responsible or to taunt authorities. I scanned the room, looking at my dresser with my lipsticks and my jewelry holder. A stack of books sat on my desk, and the window ledge still displayed my Chi Omega initiation paddle. Every surface was dusted with the black fingerprint detection powder. I didn't notice any missing items or any planted objects. Everything was the same, yet nothing was the same. It felt surreal to be back in the room. It was reminiscent of those stories in which a person became entrapped in a mirror and viewed his or her old life from the other side but could never go back. I could never go back to my old life.

———————

Bundy could never go back to his old life either. Before his arrest for attempted kidnapping of the teenager at the Utah mall, he was a failing law student with a fiancée he rarely saw. He hadn't built much of a life for himself, and he didn't seem keen to find his way back to the weak connections he had made. He just wanted to kill. And in order to do so, he had to find a way to pass as a normal person in Tallahassee. A student or someone with something to actually do with his time. He also needed money to buy food and pay the rent on his room at the Oak. In the coming weeks, he grabbed a couple of purses from women who had left their handbags in their shopping carts at grocery stores and then stepped away to order from the butcher or reach for an item on the top shelf. He also stole a utility van belonging to the university and swapped out the license plate with one he snatched from a student.

By this point, Bundy was wanted by the FBI for his escape from the Colorado jail, and he was on their most wanted list. But authorities assumed that Bundy had either gone back up to Washington State or down to Utah. They even contacted the teenage kidnapping victim and warned her family to be alert in case Bundy was looking for her. No one suspected that he had made his way to Florida, and local authorities weren't on the lookout for him. Thus, he wasn't suspected in the FSU attacks, because no one even knew he was in the area. To the people who met him, he was still Chris Hagen, a grad student with a high opinion of himself and a fuzzy backstory.

Time for Bundy, however, was running out. Not because the police were looking for him, but because he had no money, no proper identification, and no way of securing an income to pay his rent. His past girlfriends were being watched by the FBI, and he couldn't reach out to them for money or support like he had done in the past. He was pinballing from one meal to the next, from one stolen purse to the next. And all along, he maintained his intent to kill. During the second week of February, he drove the stolen van to Jacksonville and began hunting for a new victim. It was a Wednesday in the early afternoon, and the junior high students were just leaving school. One student, Leslie, left the schoolyard and crossed the street to wait for her older brother in the Kmart parking lot. Bundy saw Leslie waiting in the rain and pulled the van right in front of her. He opened the door and stood in front of the suspicious teenager.

Bundy tried a line about being with the fire department and began asking Leslie questions. Her father was actually a police detective, and she had been around first responders her whole life. The man in front of her wasn't in uniform and he was shifty, like he had some sort of nervous energy. He also had a dirty, scruffy look to him, and she was sure he wasn't on the job. She kept her guard up as he asked her questions about whether she was a student and if she planned to go into the Kmart. Her older brother soon pulled up and aggressively

asked Bundy what he wanted with his sister. Bundy backed off. He never messed with men, and for as much as he later bragged to people about his strength, particularly his hand strength, he wasn't a street fighter. Most young men could have knocked him out. Bundy got back in his van and left the area.

The next day, Bundy approached a victim using a different tactic that was his true modus operandi—because he consistently failed to charm women into his car. His legacy, and the movies made about him, will tell you otherwise, because it's far more exciting to think of a handsome serial killer who lives among us and switches seamlessly from law student to murderer and then back again. It also makes people feel safe to think the victims were somehow at fault for being naive and trusting. But I want to be clear—of the more than thirty-six women and girls that Bundy murdered or attempted to murder, almost all were attacked while they were sleeping, hit from behind, or dragged into his car. Of the thirty-six women and girls he admitted to attacking, twelve of us were in our beds. Sixteen were attacked from behind or were pulled unwillingly into a vehicle. Debra Kent, for example, was the Utah teenager who left the high school play to pick up her younger brother at the roller rink. Neighbors later reported they heard a woman screaming. Why? Because Debra was dragged into Bundy's car. She didn't go willingly.

How has this bizarre narrative even existed? The Bundy victims have been treated like cartoon characters who saw a handsome man, developed red hearts in their eyes, and then idiotically trailed behind him to their own deaths. He tried to make that happen, and he failed. The same night that he murdered poor Debra, he attempted to charm the theater teacher into coming into the parking lot to help him with some sort of nonsense he invented. She had no time for that. And so he made sure his next victim wouldn't be given the choice to comply.

It was the same with the last murder he was known to commit. After he failed to lure Leslie into his van, he decided to take the next

victim by force. Bundy drove the next day to Lake City, a crossroads city in northern Florida. It sits near I-75, which runs from Georgia down to Naples, and I-10, which crosses the state from east to west. He again headed to a junior high school and looked for a young victim he could easily overpower. In the morning, he saw a twelve-year-old girl dart from one school building to the next. Kimberly Leach had left her purse behind and received permission from a teacher to run and get it. Bundy grabbed her as she ran back through the rainy courtyard. One witness later testified that he saw Bundy pushing Kimberly into the passenger seat. The girl looked distraught, and the witness assumed she was being sent home from school for bad behavior and was being picked up by an angry father. He didn't initially report what he saw to authorities, and waited five months to come forward.

Kimberly's parents reported her missing, but there were no leads for months. Her remains were eventually found in a hog shed in a state park. Authorities could tell she had been sexually assaulted, beaten, and murdered. We don't know how long Kimberly lived before Bundy murdered her. But we do know that he admitted before his execution that he often kept the victims alive for days for his own sexual gratification. Then, in a fury, he would murder the victim and then regret he didn't keep her around for a few more days of enjoyment. In the same interviews, he divulged how he once picked up a fifteen-year-old hitchhiker and drove her to a state park where he forced her to strip. He made her get down on her hands and knees and then he took pictures of her with an instant camera. He put a rope around her neck and killed her.

And that is the truly terrifying aspect of the Bundy legacy. If we look at the list of victims and suspected victims, we see there were only one or two instances in which he asked a woman for help or presented himself as a police officer. There were a few instances in which he says he picked up a hitchhiker. The rest of the time, he was a crazed-eyed weirdo whom potential targets avoided. This notion of the charming

serial killer who lived among us was a myth. The real terror was that he attacked women in plain sight, and as seen in the Kimberly Leach case, witnesses looked away. The former paramedic who saw Kimberly's abduction sat just two car lengths away and admitted to the court he watched with amusement. "I got the impression the young girl was crying or had been crying. The man had a scowl on his face. And I felt like probably the girl had gotten in trouble at the school or misbehaved in some way and [the school] had called her father to come and pick her up and take her home. And as I was sitting there, watching them, I remember thinking to myself, you know, the daddy is going to take the little girl home and probably, you know, give her a spanking or something like that."

The daddy was going to take the little girl home and give her a spanking? This is the true terror. When women and girls are hurt in the US, no one believes it comes from somebody well dressed and lawyerly looking like Ted Bundy. They assume those men are in the right and the girls are in the wrong. They smirk over the thought of a well-deserved spanking and they look away.

9

MAMA POURED A cup of coffee and placed a cinnamon bun on a plate. She brought it to the police officer who was parked outside our Miami house for the morning shift. They exchanged pleasantries, as if the officer was the neighborhood beat cop and not part of a twenty-four-hour-watch. Weeks had passed since the night of the attack. Police still didn't know who was responsible, and they had exhausted all leads. They had interviewed boyfriends past and present, as well as male students whom others described as odd or concerning. The victims and witnesses underwent hypnosis, an ineffective technique that was used at the time to see if a person might have hidden or repressed memories. I also underwent hypnosis, but my injured tongue made it hard for me to talk.

My recovery was progressing slowly. About three weeks after the attack, a Miami surgeon realized my jaw had been set incorrectly. I had to endure another surgery in which my jaw was broken, reset, and wired shut. The surgeon placed a metal bar across my gumline. A wire was then wrapped down across each of my teeth, almost like a shoelace twisting between eyelets. I felt the tension and pain of the apparatus at all times. The surgeon knew the experience would be

painful and prescribed morphine to be given every four hours. Mama, however, worried that too much morphine would make me an addict. Although she filled the prescription, she only gave me morphine when the pain brought me to tears.

I was always in pain, and the torment ranged from throbbing to excruciating. At night, I consistently dreamed of eating hot dogs or popcorn. In my dreams, I opened my mouth wide to surround the hot dog bun or I tried to chomp handfuls of popcorn. This caused me to try to open my mouth while I slept, which set off intense muscle spasms. I was a long way from hot dogs and popcorn. Instead, I ate only pureed foods sipped through a straw for the next six weeks. My sister tried to make me interesting meals, and she put different ingredients into the blender. One time, she offered me blended beans. It was disgusting, and I ended up complaining through clenched teeth. She promptly took the beans off her revolving menu.

Every night, either Marilynn or Mama brought me a bottle of hydrogen peroxide, and I had to wash my mouth out to prevent an infection in my shredded tongue. My family cringed as I poured a small amount into my mouth and braced myself while my tongue burned and my teeth sizzled. It felt like my entire mouth had turned to metal and had reached a heat level so intense it seared. My family was at a loss, and they were trying their best to help me in the way they knew how. For Marilynn, that meant blending foods and standing outside the bathroom door, asking if I needed help. Dad was on standby in case I asked for anything, and Mama was building a wall. She wanted me protected from the outside world, and she thought the less that people knew of the attack, the better off I would feel. That even included my own brother, Jack. He was about ten years older than me, so he was almost thirty years old at the time. He was married, had two daughters, and lived an hour north of Miami. Mama told him I was attacked, but she made it sound like it was really no big deal, and everything was fine, just fine.

Jack didn't learn the extent of my injuries until years later, and I think it pained him greatly to be excluded. When our father died, he hugged me while I cried. He held my hand at the funeral and made it his job to protect Marilynn and me. I think that Mama's decision to not tell him the truth about the attack denied him of his instinct to comfort me. He couldn't have fixed my injuries, and he couldn't have sought revenge on the attacker. But he could have come to the house and been part of the recovery in his own way. He never had the chance because no one ever told him.

In this sense, my recovery team was small. I had my parents and my sister. I also had my good friend Nora. I was allowed to visit her in Fort Lauderdale, and Goody made me a small Italian pasta called *pastina* that I sipped through a straw. It was a welcome break from pureed foods. I was also allowed to visit Simon and his family in Boca Raton. I spent the night in his sister Sara's room,* and she had to wear a pair of wire clippers on a string around her neck in case I vomited in the middle of the night and needed the wires cut. It was a terrifying proposition to think of me choking on my own vomit while Sara fumbled to cut the wires and release my jaw. Fortunately, it never happened, but she told me years later that she was so nervous that she stayed up all night and watched me sleep.

That was it. That was my recovery support. I had no contact with the Chi Omega sisters, and I had to mourn the loss of them. I was cut off from them, and it started when I was in the hospital in Tallahassee. My mother shooed away most visitors and callers. She might have scared off some of the sisters. But no one other than my high school friend Suzy called our house in Miami to see how I was doing. The loneliness reminded me of when I underwent chemotherapy. At the time, it felt as though there was no end to the isolation. Each day had

* "Sara" is a pseudonym.

been the same; I was lifeless and alone. Again, I was ailing on my own and I wanted badly to be in touch with my peers.

I later learned the sorority's national leadership told the sisters they needed to avoid bringing attention to the attack. Having two women murdered and another two viciously beat was bad for business. And at the end of the day, Chi Omega was a business, and because I had dropped out of school to recover, I was no longer a paying customer. I tried a few times to call the sorority house phone, but I didn't recognize the women who answered. The sorority had a house phone located in a small room, and pledges were tasked with answering the phone and taking messages. I have to admit I didn't know the pledges very well, and they acted like they had never heard of me. My jaw was wired, and I frustratedly tried to repeat my name and ask for my "big sister" or my old roommate to come to the phone.

I called the sorority house about three or four times in early February. I worried they felt I had deserted them by going back to Miami to heal while they remained at the scene of the crime. Each time, I stretched the kitchen phone's long yellow cord and sat at our white Formica table. Mama and Marilynn sat with me at the table and looked concerned as I gave my phone number to the pledge who answered and pleaded for someone to call me back. I needed to hear from my sorority sisters, and I needed them to tell me that I hadn't done anything wrong. I didn't choose to be attacked in my bed by a serial killer, and I didn't choose to have injuries so extensive that I had to leave school and return home. No one ever called me back. I never spoke with my sisters again.

This was my loss. I needed them. But I now accept that the women in that sorority house suffered greatly as well. They happened on my roommate and me as we bled profusely in the minutes after the attack. They saw Lisa's and Margaret's bodies carried out, and they lived with the horrifying knowledge that it could have been any one of them if

they had forgotten to lock their door that night or if Bundy had tried their knob. They were victims too, and although I wish they hadn't cut me off, I understand there was no guidebook on how to proceed after experiencing such brutality.

I feel differently, however, about the Chi Omega leadership. I never heard from the national officers, and as adults, I think they could have done better. For months, I kept waiting for someone to reach out. I had believed in all the pledges we made about sisterhood lasting forever. I truly felt we were bonded sisters, not club members who merely paid dues. I was so honored when I was initiated, as if joining was a privilege reserved for the lucky few. That's why I resisted when my father brought me to a law firm and asked me to meet with a team of attorneys. My medical costs were mounting, and my father was looking for relief. Given that the keypad lock had been broken and the back door was open, my father and the attorneys felt Chi Omega had premise liability and should share in the expense. I cried when I learned the nature of the meeting and stomped out of the conference room, claiming that I could never turn on my sisters. I didn't realize yet that Chi Omega had long stopped thinking of me as a sister.

Despite this painful rejection, the Chi Omega alumni association always seemed to find me in the decades to come. I moved to three different states, yet the quarterly magazine and its appeals for donations always made its way to my new address. When he could, my husband stuffed the magazine into the recycling bag before I saw it. But often, I saw it come through our mail slot and I felt wounded by the reminder—mostly because I never saw any tribute to Margaret and Lisa. When we began writing this book, I sent my coauthor, Emilie, a stack of information and included several of the alumni magazines, the *Eleusis*. Emilie took issue with one particular headline in a spring edition: SISTERHOOD NEVER STOPS. She twice emailed the current national president and asked for comment, and then she sent a certified letter. She asked each time whether the sorority was finally

ready to comment on the attack and to explain why I was cut off. The president did not respond, and neither did any member of her executive board. It only confirmed that sisterhood indeed stopped for me. Bundy beat it out of me.

———————

Time was running out for Ted Bundy. The Florida authorities didn't know one of the FBI's most wanted was in their state. But they were linking one event to the next, and soon they would have a chain for Bundy to trip on. It started with the junior high girl in Jacksonville who had been waiting outside the Kmart when Bundy approached. Her father was a detective, and she relayed the incident along with the license plate number and the van's make and model. Her father ran the plate through the computer system and saw it registered to a student at FSU. He sensed something more sinister, and he asked a local sheriff's deputy to meet up with the student. The young man explained his tag had been stolen, and although he didn't report it missing, he had it replaced.

The police found the missing license plate meaningful because the young man lived near the fifth victim who was struck the same night of the Chi Omega attacks. They were neighbors, and police suspected the murderer took the license plate around the same time of the assault. Soon, deputies realized an FSU van of the same make and model as the one in the Kmart parking lot had also been stolen. Now the police had something. The killer had taken a license plate and a van from Tallahassee and had driven it east to hunt for more victims. Patrol cars were watching the FSU campus carefully in case the white van returned.

Bundy was indeed still in the area. He was living at the Oak, but he was late on his rent and trying to find excuses that would appease the landlord for a few more days. He planned to leave Tallahassee,

partly because of the late rent but also because he'd had several near misses with police. One patrol officer just eyed him as he walked late at night, but another stopped him as he fumbled with a car door in the dead of night. Bundy had ditched the white van by then but foolishly kept the license plate on the front seat of his new stolen vehicle. The officer asked Bundy about his business in the area, and Bundy claimed he was pulling an all-nighter to study and had come down to grab a book from his car. This directed the officer's attention to the front seat, where he glimpsed the license plate. While he took the tag to run the numbers, Bundy ran back to the rooming house.

Any sensible person would have left town, but Bundy still enjoyed being close to his crimes. In the second week of February, he finally boxed up his pilfered belongings and packed them into a new stolen car, an orange Volkswagen Bug that displayed a freshly snatched license plate. He drove from Tallahassee, likely thinking he was making a clean getaway and that the police would never catch up with him. But Bundy's thinking was scattered, and he zigzagged across northern Florida for the next few days. This was remarkable, because Tallahassee is only twenty-four miles from the Georgia border, or eighty miles from Alabama. In less than five hours, he could have been in Mississippi, and in six hours he could have been in Louisiana. If he had followed the roads around the Gulf of Mexico, he could have been in the Mexican state of Tamaulipas within seventeen hours.

He could have been long gone. But instead, he was like a windup toy that whizzed around in pointless loops. He drove to a hotel about 150 miles west of Tallahassee and spent the night. A few days later, a police cruiser pulled up behind him in Pensacola, a western border town near Alabama. The officer called in the license plate number and turned on his flashing blue lights when the dispatcher confirmed the tag was stolen. Bundy drove for another mile before he pulled over. Then he tried to fight the arresting officer and run from him. As the officer wrestled Bundy to the ground and restrained him in handcuffs,

Bundy cried for help. I have to wonder how many of his victims had done the same.

At the Pensacola jail, Bundy stalled to avoid answering the officers' questions. He gave them a fake name, and when they found the various driver's licenses and credit cards in his possession, he tried to pass himself off as a small-time crook. In the coming days, he admitted he was Ted Bundy, the escaped prisoner from Colorado. He joked with his interrogators and tried to act as though none of it was a big deal. It's possible he thought he could strategize his way out of custody. Despite the fact that he was incoherent and unfocused, he still considered himself a genius who was capable of outsmarting even the most talented detective. He vacillated between trying to entertain the officers with stories of his hijinks and crying and saying, "I can't talk about that."

Police in Colorado, Oregon, Utah, and Washington all suspected Bundy of murdering dozens of women and girls. All these cases were unsolved, but they now understood Bundy was a serial killer with a clear target—young women and teenage girls he could easily over-power. In the years to come, media accounts claimed Bundy preferred to kill women with long dark hair that was parted in the middle. Supposedly, one of his ex-girlfriends had long dark hair, and this nar-rative suggested that Bundy's murders were a type of revenge against his former lover. But he attacked so many of us in our beds while we were sleeping. He didn't really know whose head he was bashing or whose throat he was strangling. My roommate was actually blond, as was Lisa Levy. And I had Mama's tight, dark Cuban curls. We didn't fit "the profile."

Bundy was now the prime suspect in the Chi Omega attacks, as well as the assault on the fifth woman that night. Tallahassee police

strongly believed he was the driver of the white van, and they suspected he had abducted Kimberly Leach, whose body they had yet to find. Investigators had evidence to work with, but the technicians needed time to conduct their analysis. The stolen van had been recovered near campus, and forensic investigators were scouring the inside for clues. Bundy prided himself on wearing gloves and not leaving behind fingerprints, but Bundy didn't know what he didn't know.

One thing Bundy didn't yet recognize was that he had a new adversary in Sheriff Ken Katsaris of the Leon County Sheriff's Office. Katsaris was a younger man, just thirty-nine, and filled with energy and determination. He wasn't stuck in old ways, and he openly embraced new evidence technology that Bundy didn't realize existed. Even more importantly, Katsaris took this case personally. He had been at the Chi Omega house within minutes of the attack. He saw both my roommate and me carried out on stretchers, and he winced at our bleeding faces and ripped flesh. Our injuries were so profound that he thought I would soon die. He was glad I proved him wrong, but he was haunted by the murders of Lisa and Margaret. Katsaris believed Bundy was the culprit, and he knew the evidence would soon prove him correct. Until then, they were holding Bundy on charges of auto theft and credit card fraud. Katsaris made his firm grip on Bundy well known. The prisoner was shackled during transfers, and Katsaris made him wear a leg brace so he couldn't try to run away like he had done so many times in the past. Bundy didn't realize it, but he had finally met his match.

Learning my attacker had been arrested was a relief. For a month, we had lived in fear that he would read one of the newspaper articles that listed my parents' address and then find our house in the middle of the night. Bundy's arrest meant we no longer required constant police

protection, and it was one more step toward normalcy. Mama craved normalcy, and she focused on my physical healing and my outward appearance, as if restoring both would make all the pain and trauma disappear. I was starting to realize how much my mind also needed healing. I had endured a vicious beating in which I had braced myself to die. I needed to process all that had happened to me, but mental health treatment wasn't anything that Mama acknowledged.

Mental health treatment simply wasn't the old Cuban way. In Mama's view, talk therapy was for crazy people and it risked shaming the family. She thought she was protecting me by keeping me out of a therapist's office. And I think, in some ways, she thought the removal of my wires from my jaw would signal my healing was complete. But that process was terribly traumatic. The surgeon didn't anesthetize me for the procedure, and it was punishing to feel him pulling the wire from my mouth. He didn't simply snip the wire and let it fall off in pieces. He pulled it with one long yank, and I felt the agony of the tight wire unwrapping from each tooth.

On the day my wire was removed, I hadn't stretched my jaw in nine weeks. The muscles were slack and painful, and I wasn't prepared for the humiliation that came with trying to eat a meal with an atrophied jaw. My parents had taken me to Howard Johnson's after the appointment, and I had hoped to enjoy a meal of ham and eggs. My jaw was too weak to properly make quick chewing movements, and I had to do long, slow chomps. I likely looked like a person without teeth or dentures trying to use her gums to eat a meal. It was humiliating, like so much of this process had been for the victims. But to Mama, the scars on my jawbone would fade, and anyone who looked at me standing in line at the grocery store would never have guessed that I had been attacked by a madman just months prior. If I looked good, then I was good, and everything was fine.

Except it wasn't. I was traumatized. I wanted to be better, and so I came up with my own form of mental health treatment. I started

with a technique that is now referred to as visualizations. To help my anxiety, I imagined a small island in the ocean. It was a tranquil, sandy island and it had a single palm tree dotted with coconuts and a beach chair underneath. I visualized the island, and every day I imagined myself moving closer to the island. The island represented healing, and it also represented the idea that I was creating distance between myself and my past trauma. All I had to do was live my daily life and then I could move closer to the island the next day. At first, the island was a speck in the distance. It was so far away, and I had a long way to go. I referred to my progress toward the island as "baby steps." Every few days, I would go into a relaxed state and I would picture myself taking baby steps toward the island. Sometimes I would turn back and look behind me, and I'd see a swirling, dark mass. I knew that black mass had once surrounded me like a fog, but I was able to slowly step away from it and put the darkness behind me. The visualization was soothing for me, and it also gave me a sense of hope, as if I had something to look forward to. One day, I would reach that island. In my mind, I would sit on that sandy beach with my toes in the sand and I would look back at the ocean I had crossed to get there, and the darkness would be gone.

I also began my own version of exposure therapy. I worried I might be developing an aversion to unfamiliar men, and I saw that as a hindrance. How would I grocery shop or step into an elevator if I was afraid of strangers? In late March, I took a cashier job at a lumberyard where most of the customers were male. I figured it was the most men I would see in the shortest amount of time. It was almost like they would come at me rapid fire. My expectations were correct, and one by one, men of all ages came up to the register. I had to ring up their purchase by typing in the product number. I had to add each item individually, and the transaction took a few minutes. During this time, I needed to look each customer in the eye, ask about his day, and thank him for his purchase. There were a few times I panicked,

and I have to admit I ducked underneath the counter and let another clerk handle the customer. When the customer left, I stood up and realized all was fine. Another challenge had passed, and I baby-stepped closer to my sandy island.

Mama was opposed to me taking this job at the lumberyard, but I knew it was something I had to do for myself. It wasn't often that I stood up for myself, and I didn't tell her that I was taking the job to force myself to face my fears. I actually only worked at the lumber yard for a month, and once my aversion to men had passed, I handed in my notice. In the coming years, I had to repeat my exposure therapy with hospitals. I had endured a monthslong hospitalization during lupus, and then I woke up in a hospital after Bundy attacked me. Add in my multiple jaw surgeries, and I saw hospitals as a place of pain. I didn't want to visit for any reason, even when my close friends had babies. I recognized once again that I was developing an aversion that had the potential to hold me back. I returned to my own form of exposure therapy, and I took a job as a buyer for a hospital. Every day, I had to park in the hospital parking lot and face my fear as I walked into the lobby, up to the administrative offices, and to my desk. I was determined. I was going to survive this attack.

10

MY BOYFRIEND, SIMON, never returned to FSU after I was attacked. He returned to his family's home in the south of Florida and began working for his father's successful building supply company. Simon always knew he had a sales job awaiting him at his father's business, and I'm not sure he cared much for school. In hindsight, the attack might have been his excuse to withdraw. He lacked direction, and I think both our parents thought that I needed to be reorientated on a new path as well. His twin brother began talking to him about proposing to me, and Mama began telling me that I should accept if he asked.

In the early spring, Simon and I went one evening to a shopping plaza. He surprised me when he led me near a fountain, got down on one knee, held up an engagement ring, and proposed. I said yes. Our parents were thrilled and desperate to plan the wedding for as soon as possible. They booked a ballroom at his parents' country club for late June and began charging at the wedding date. For them, June 24 could not arrive fast enough, and they moved through the planning at turbo speed. Simon's parents arranged for us to have an afternoon wedding at their Lutheran church followed by a three-hundred-person

reception at their country club. We compiled the guest lists, ordered invitations, and selected the menu and the band. Simon and I went to various stores and picked items for our gift registry. We also went to a cake tasting, and we were able to try samples of all the frostings, fillings, and flavors the bakery had to offer.

The tight time frame made Mama feel like decisions had to be made in an instant, including the selection of my wedding dress. Mama decided that I would wear a high-necked, long-sleeved white dress despite the South Florida heat in late June. She took me to a bridal shop that she knew would have the type of dress she and Dad wanted for me. Dad and Aunt Grace came along. She had the attendants select a few dresses for me, and I tried them on and stood in front of the three-panel mirror and looked at myself from several angles. The dresses were pretty, but they were heavy and not necessarily something I would have picked for myself. My family, however, was in charge, and after just a few dresses, Mama told the attendant that they had found the one they wanted. A seamstress came to take measurements for alterations and the decision was done. Not surprisingly, I became a fan decades later of the program *Say Yes to the Dress*. I never got to choose my own wedding dress, and I loved watching the brides express their opinions and then find the dress of their dreams.

I was passive about the wedding planning. It was such a sharp contrast to the young woman I had been just a few months prior when I had dragged Mama to all those home goods stores so I could find the perfect bedspread. She had tolerated my pickiness and willingly inched up and down the aisles with me as I felt fabrics and pondered patterns. Now I stood submissively in my underwear as I changed out of the wedding dress that Mama had selected for me and prepared to marry a man based on the encouragement from our parents.

I think Mama thought that getting married would give meaning to my life. It would fix me, as though the attack had never happened and I didn't have a slew of depositions and court testimonies in my

near future. Simon came from a very good family, and his parents were both well-to-do and loving. I think in my future Mama saw safety, and she believed that nothing as bad as Bundy would ever happen to me again. She also saw an opportunity for an easier life. Simon's mother filled her days with auxiliary board meetings and country club lunches. She didn't have to work like Mama did for all those years at her and Dad's industrial painting business. Mama saw me moving into a starter home, and then one day, a big Boca Raton house with professional landscaping and a backyard pool. In hindsight, I realize Simon and I didn't know each other well, and that meant we were only in love with the idea of each other. We met toward the end of 1976 and we hung out in a group for most of 1977. We had only been exclusive for about six months when he proposed. And yet, we were about to take our vows.

I shouldn't have been getting married. It wasn't the right time in my life, and I had so much from the attack that I still needed to process. I was just beginning to understand that I had been attacked by a serial killer and survived. But I didn't yet know what it meant. I didn't even know which questions needed answers. I did understand that I needed closure, and I returned to the Chi Omega house for the first and last time since the police had brought me back weeks after the attack. I was in Tallahassee with Simon, his twin brother, and his brother's girlfriend to attend a football game.

I asked the group if we could stop by the Chi Omega house. I hadn't seen it since the day the police brought me back and I saw my bloody comforter cover. Simon pulled up to the sorority house, waited until I took a few steps onto the sidewalk, and then drove away. The three of them went to a nearby bar to have a beer and a sandwich while I went inside by myself. It was hard for me to approach the house. I had to walk slowly, taking actual baby steps, to reach the front

door. The house was quiet, and the sisters were likely at a tailgate or enjoying a pregame beer special at one of the bars near campus. I only saw one sister as she passed through the foyer and asked if I needed help. We didn't know each other, and as I declined, she kept walking. I went up the stairs, thinking of the last time I had been there and two policemen had to hold my arms as I took each step carefully. At the landing, I turned and went past Margaret's old bedroom. Each door had the occupants' names spelled out on little paper owls—the owl was the sorority's mascot. Margaret's name was no longer on the door, and at room 8, there were two new owls where mine and my old roommate's names used to be.

I looked in the room. The place where I almost died. The space where my life changed. There were no remnants of the violence. The walls had been repainted and new carpet laid down. The room was light, bright, and airy. It was nice, actually. Everything seemed so normal, and yet, these halls had seen a madman walk through just months before. In a few short minutes, our worlds had been tipped over. As I stood in the hallway, I sensed that some of the sisters had been able to reestablish their lives and move on. I had not fully healed, physically or emotionally, from what Bundy had done to us. I found myself feeling like I did that day the police brought me back to my room. Once again, I was standing on the other side of a looking glass, in another dimension, staring at a life I could never return to. I left the house and sat on the curb for about an hour and waited for Simon and the others to return. They didn't ask me about the house or how I felt returning for the first time in months. And honestly, I wouldn't have known how to answer even if they had.

My good friend Nora agreed to be a bridesmaid even though she secretly had her concerns about the wedding. She sensed that my

parents, as well as his parents, were pushing us into this wedding as a way to solve bigger problems. He risked aimlessness; I had been battered by Bundy and my mother feared I was damaged goods. If we married, our parents seemed to think we would somehow level up into adulthood and start living focused lives that resembled their own. Most importantly, no one would be able to hurt me again. They had good intentions, but we were headed toward disastrous results. At least, everything looked perfect on paper. The invitations were sent out with beautifully embossed letters, and everyone smiled in the wedding photographs. For my wedding party, I chose Marilynn as my maid of honor and Simon's sister as one of my bridesmaids. I also had Nora and my high school friend Betsy as my other bridesmaids. I had my bridesmaids wear long, light blue dresses with a sheer shawl, and the groomsmen wore light blue tuxedos. Simon wore a white tuxedo, which was very fashionable at the time.

We posed for pictures at the church and then again at the country club. The ballroom faced an expansive, green golf course and it was picturesque. We smiled for the camera as we sat with our wedding party at the head table and then again as we fed each other bites of our wedding cake. We danced together, and then he danced alone with his mother, and I danced alone with my father. We had more than three hundred guests, and although many of my high school friends attended, none of the Chi Omegas came except for Suzy White, but she was also a high school friend. I had sent an invitation to the sorority house, and I was later told it was hung in the telephone room. I had hoped that sisters would RSVP and then road trip down to Boca Raton to attend. But no one even acknowledged the invitation. I didn't let their absence ruin my day, and I was very happy at the reception.

11

SOON AFTER THE honeymoon, I went to Tallahassee to testify before the grand jury. I saw my roommate for the first time since we had gone to bed that night in January. We gave each other a long hug, and it felt good to see her. Like mine, her external wounds were healing, and I'm sure she was addressing her own emotional recovery. The prosecutors had warned us not to talk about the case. Any exchange of information would be seen as prejudicial, so we limited ourselves to remembering the hours before she packed up her sewing and I put my books away. Before everything changed.

When it was time to testify, I waited in a small room behind the judge's chambers. In Florida, a grand jury heard the prosecutors' evidence against a suspect and determined whether the charges should advance. The proceedings were held in secret, and the media was kept out. The setup was also different. The jury sat on one side of the room and observed the proceedings. The attorneys, defendant, and witnesses sat at a large conference table. Bundy sat at the head of the table on one end, and I sat opposite at the other end. It was my first time seeing Bundy. In the moment, I wasn't much focused on who he was or what he looked like. I had seen photographs in the paper

and I knew that people considered him to be an average-looking man. I was more focused on how I wanted him to see me. I stared at him the whole time and my gaze never broke. I wanted to be the person in power. I wanted to communicate to Bundy that I wasn't afraid of him. He didn't scare me anymore because he couldn't get me. I, however, could get him with my testimony.

I was cautious with my answers. The attorneys began a set of questions that I would have to answer again at a deposition, and then later at the actual trial. I explained my activities on the night in question leading up to the attack: the afternoon wedding, the early dinner with friends, and the attempt to study for my math exam while my roommate sewed. The defense asked me about the attack and whether I saw my attacker. They knew it was too dark in the room for me to see his face. I remembered that the silhouette of my attacker was male and slender, and I distinctly remembered him raising his arm with the log in his hand. But I couldn't describe him further. The defense pushed a no-face-no-case type of approach, and they later argued that if my roommate and I couldn't identify our attacker, then it could have been anyone.

But Sheriff Ken Katsaris had planned for this defense. Before the grand jury convened, he received a warrant to have a dentist take an impression of Bundy's teeth and compare it to the bite wounds on Lisa's buttock. Katsaris had pulled Bundy from his cell in the middle of the night and told him they were going on an outing. He led Bundy from the jail to the back entrance of a dentist's office. The inside walls were decorated with black-and-white photos, almost like a restaurant that put up headshots of celebrities to suggest they were regulars. It didn't seem like a medical building, and it wasn't until Bundy reached the office that he realized he was at a dentist. He was furious and announced he wouldn't cooperate without a warrant. Katsaris gladly waved the paper in his face. Bundy was surrounded by armed guards and he had no choice but to comply.

Dental impressions were uncomfortable. A nonflexible material, typically plaster, was poured into a mold and then placed into the person's mouth. The person had to wait for the plaster to form around his teeth, and the mold often gagged him and gave him a sensation of choking. Bundy sat in the dental chair, slightly gagging on the mold, and later complained that he had been mistreated and his rights were violated. That dental mold was nothing compared to what his victims went through. And when we went to court to testify, the lawyers asked little about the agony we had endured. The questions were clinical and required me to give simple, unemotional answers about the number of surgeries I had had to date and how long my jaw had been wired. They failed to ask how torturous it was to have my jaw wired shut for nine weeks.

Thus, the grand jury knew nothing about my or the other victims' suffering. They didn't know how Mama held on tight to the morphine prescription until my tears made her give me a half dose. I wasn't able to tell them about my tongue and how it was grotesquely split and had to heal slowly on its own. No one heard about the hydrogen peroxide I had to swish around my mouth and the way it burned my wounds. Nor did the lawyers ask me what it was like to finally have the wires yanked from my mouth.

We victims had had our bodies scrutinized by medical professionals and our lives investigated by police and attorneys. The police had looked into the victims' lives and created a profile on each of us. It included my admissions essay to FSU that I had written years ago in my bubbly cursive. It also included a transcript of my grades at FSU, which listed my attempt at taking meteorology with the hope of becoming a TV weather reporter. There was a sinister feel to the investigation, and the police noted that I wasn't known to have "lesbian activity." That comment seemed intrusive and unnecessary. It also seemed like they were building a case to prove that we were worthy victims, as if only certain women deserved sympathy.

The report also claimed I was religious and did not drink. Obviously, the police were oblivious to my regular attendance at fraternity parties. Many times, I had cheered for guys doing keg stands and then filled up my own cup with beer. The report also missed how hungover I felt on the Saturday morning before the attack because I had spent the night boozing with Betsy. That was the reason I skipped drinking Saturday night and went to bed early—not because I had some great desire to go to church on Sunday morning. Clearly, these profiles weren't complete assessments of who the victims were as people. They were victim caricatures, and it was worse for the dead. They were no longer people; they were evidence.

The grand jury experience also made it clear the process wasn't about the victims. It was about Bundy. And on the day of his indictment, he demonstrated that his focus was on the police and prosecutors. The grand jury handed down its indictment around three o'clock on a Friday. Katsaris kept the indictment sealed and thought about his next move. A judge had previously gagged Bundy from speaking to the press, and some reporters threatened to file an injunction if they didn't have access to the prisoner. Katsaris arranged for the media to meet in the lobby of the Leon County Jail that evening after nine o'clock. Videographers set up lights, sound technicians ran microphone wires, and journalists stood with their notepads out.

Bundy stepped off the elevator and seemed stunned by the press conference. His surprise quickly turned to anger. He assumed Katsaris had called the press conference to humiliate him in public. Part of this might have been true. Katsaris might have wanted a spectacle when he read the indictment in front of reporters. But it was truly Bundy who made a scene. He was infuriated by the indictment, as if it were a loss in his personal battle against the sheriff. Bundy pointed his finger in Katsaris's face.

"You told me you were going to get me," Bundy said. He turned his attention to the cameras. "He told me he was going to get me."

Bundy looked back at Katsaris. "You got the indictment. That's all you're going to get."

Katsaris remained calm and read the indictment to the press. But Bundy couldn't contain himself. He paced until another lawman stopped him and made him turn back toward the sheriff. And then he stood and looked over Katsaris's shoulder as he read. At times, he raised his head toward the news cameras and blinked with a wild look in his eyes. He then paced forward, spoke to the press, and griped that this was his only chance to address them. He pledged to plead not guilty and held up his hand, as if he were a Boy Scout taking an oath.

When Katsaris read the charge against Bundy for beating me in the head, he said my name and the alleged crime of attempted murder. Bundy smiled as Katsaris said "Kleiner" and then he chuckled a bit when he heard "knowingly cause great bodily harm." It was evident the victims didn't exist as people to Bundy. He wasn't sorry for those he murdered or attempted to kill. In his mind, he was the true victim and Katsaris was his captor. Katsaris knew all of this, and he was determined to not let Bundy escape like he had done in the past. He told me decades later that as he read that indictment he thought, *There's no way he's escaping from **my** jail.*

—————

I moved on with my new life as the summer of 1978 progressed. Simon and I were living in a lovely two-bedroom house in Boca Raton that we purchased with my in-laws' help before the wedding. He was working for his father's company, but he was just starting out and his pay wasn't significant. I was working as a bank teller at a credit union geared toward retirees. Simon and I took a paper route to make extra money. We woke at four thirty each morning to pick up the newspapers. They were given to us as separate sections, so we had to assemble the papers in a specific order and then add whatever coupon

books or supermarket flyers were offered that day. We slipped it all inside a tight plastic bag and began our delivery route. Part of our route included high-rise apartments with open-air hallways. I realized that I could do two floors at one time by dropping the newspapers over the ledge below and aiming for the intended doorstep. I prided myself on my accuracy and speed. Each day, I wanted to see if I could be better and faster than the day before.

I headed to the bank after the papers were delivered. I had to be at the counter by 8:30 AM. In a typical day, I waited on customers who approached with withdrawal or deposit slips. We were located near a retirement community, and almost all our customers were senior citizens who were depositing their pension or social security checks. When a handsome young man came in, my fellow tellers and I took immediate notice of him. He wore a brown suit and carried a briefcase, and he lingered by the convenience table as if he might fill out a deposit slip. He picked up one of the pens chained to the table, and then he put it back. I think he could sense he was being watched and he abruptly left.

A few days later, I had just returned from lunch and opened up my teller window and motioned over the next person in line. It was him. He was dressed nicely, like a businessman, yet there was no reasonable business he might have at a credit union meant for retirees. I knew something was amiss, and I opened my drawer in anticipation of being robbed. What did robbers want in this moment? Was I meant to hand him the hundred-dollar or twenty-dollar bills as opposed to the singles? During training, the head teller didn't tell me how to proceed during an armed robbery. The robber held a dark leather pouch in his hand and then put it on the counter so I could see the gun inside. Behind me, the head teller realized we were being robbed. She quietly notified the police as I fumbled with the cash in my drawer.

Before I could take cash from the drawer, the robber looked over my shoulder. The drive-through window was positioned almost

directly behind my spot at the counter. He saw a police car pull through, and he ran from the building. I didn't realize he had spotted the squad car. I thought perhaps I had handled the situation so well that it scared him away. I was feeling quite proud of myself, and I turned around to boast to the other tellers. That's when I saw the police vehicle through the window. It hadn't been me after all that scared away the robber. A moment later, we heard a shot being fired in the parking lot. I huddled with four other women under the head teller's desk until a police officer came into the bank and told us the threat had passed.

The police didn't apprehend the robber right away. They found him later in the day, and they asked me to ride with an officer to identify the suspect. They drove me to a parking lot behind an apartment complex. The suspect stood with his arms behind his back, and they ordered him to face the squad car. He couldn't see me as I sat behind the tinted glass in the backseat but I could see him. He was young and handsome. Why did he need to be so violent? And why did people seem like they were one thing when they were really another? It was an experience I just didn't need. I didn't need to be another witness in another criminal trial of a dangerous man who had no regard for the lives of others. But I had to do what was being asked of me. I studied his face and I confirmed this was indeed the man who had shown me the gun and demanded the cash from my drawer.

Oddly, the police never followed up in the weeks to come. I had given my statement and made the identification, and then I never had to go to court or give a deposition. The robber simply vanished from my life. He might have taken a plea deal from prosecutors and avoided a trial. Or he might have had a really good lawyer and powerfully connected family members who made the matter go away. I never knew the outcome, because it no longer involved me. The other case involving a dangerous man, however, I could not and would never escape.

Kathy on the first Christmas after the attack, 1978.

12

MY ALARM WENT off the morning after the armed rob-
bery at 4:30 AM. I went with Simon to pick up and organize
the newspapers for our delivery route. After all the newspapers were
delivered, I returned home to shower and dress in my nice teller
clothes. Then I headed to the bank and went to my window like usual.
Part of me understood that the bank was a safe place to be because of
the police presence. One officer was stationed in the lobby for a few
days in case the robber had an accomplice who planned to return and
finish the job. But part of me was also unnerved. I knew I couldn't let
my fears control my life. I was still baby-stepping toward my peaceful
island, and the robbery was part of that dark, swirling cloud of evil
that I was putting behind me. I had to address my anxieties, because
I knew I would soon have to confront Ted Bundy.

The grand jury indictment ensured that Sheriff Katsaris would
see Bundy in court. Until then, Katsaris kept Bundy on close guard
and forced him to wear a leg brace during transports so that Bundy
couldn't run away like he had in Colorado. Bundy didn't realize it,
but his defense was doomed from the start. The indictment had been
his first piece of bad news, and it was followed by a judge ruling that

he couldn't employ his attorney of choice. Bundy wanted a Georgia attorney who had made headlines two years prior when he defended five young Black men accused of robbing and murdering an older White man. The attorney quickly realized his clients were innocent, set up by the police, and the victims of racial injustice. He fought successfully to have their coerced confessions thrown out in court. The prosecution's case crumpled and the five men were released. Bundy tried to cast a similarity between himself and those five innocent men. He wanted people to see *him* as the victim of Sheriff Katsaris and the legal system. His victims? We were inconsequential.

The judge refused Bundy's request to have the Georgia attorney represent him on the grounds the attorney was not licensed to practice law in Florida. Bundy wanted a special privilege, and the judge denied him. During the hearing, Bundy pouted when he didn't get his way and refused to answer the judge's questions. The trial was set for October 3. At that point, Bundy's focus was on fighting Katsaris. He had the Georgia attorney file a $300,000 lawsuit against Leon County and Sheriff Katsaris for supposedly depriving him of his rights as a prisoner. It was a ridiculous lawsuit that went nowhere, except the court ordered Katsaris to allow Bundy outdoor exercise. The sheriff wasn't taking chances, and he arranged for Bundy to have his workout high on the jail's roof. Bundy had few supporters, but he confided his complaints in them through letters and phone calls. He hated the food and the lack of natural light. I found that ironic, given that I had spent nine weeks earlier that year slurping food, even pureed beans, through a straw.

I tried to ignore the proceedings in the coming months. I had a full work schedule, which helpfully made me think about each day as it came, and not what lay in front of me. Mama, meanwhile, continued to clip every news article she came across about Bundy and the Chi Omega trial. She knew Bundy had a public defender, Mike Minerva, and he had been successful in pushing the trial from October

to November, and then eventually into the new year. What she didn't know was that Minerva had negotiated a plea deal with prosecutors for the Chi Omega attacks. In exchange for admitting to murdering Margaret and Lisa and then attacking my roommate and me, Bundy would receive seventy-five years in prison. Minerva, like most defense attorneys who handled capital cases, considered anything other than the electric chair a win. Bundy refused it. He wanted to go to trial. He wanted the attention, and he seemed to believe he would find himself in the public's favor. He didn't realize he was fighting a losing battle.

Someone else was fighting a losing battle, and it's one she never should have had to endure. One of my sorority sisters, Valerie Duke, was coping with a crushing depression after the murders. She had lived in room 7, which was right next to my room. Valerie had gone home the weekend of the murders, and she heard of the attack the next morning. In the coming weeks, she would also learn that Ted Bundy had gone into her room but found the beds empty. She realized that Bundy had entered room 9 (Margaret's), room 8 (mine), and room 7 (hers). The rooms were in a row, and her absence saved her. Bundy would have murdered her too if she was home that night.

It was a terrifying realization that she would have died that night if her plans had been different. She began struggling emotionally after the attacks, and it's likely she developed an undiagnosed case of post-traumatic stress disorder (PTSD). At the time, the manual used by mental health professionals, the *Diagnostic and Statistical Manual of Mental Disorders*, known as the DSM, didn't even include PTSD. The condition was added in 1987, but even then, psychologists and psychiatrists didn't quite acknowledge that a person didn't need to witness the event in order to be severely traumatized. Learning the traumatic event happened to a loved one was enough to trigger the condition.

The medical community knows that now. They know that PTSD occurs when a person has been exposed to—or hears about—a situation in which he or she believes he or she might be killed or endure bodily injury. PTSD can also be triggered by hearing the traumatic event happened to a loved one. This is why we acknowledge that nurses can get PTSD from seeing patients suffer or police officers can develop the condition after investigating child abuse cases. Valerie didn't need to be at the Chi Omega house on the night of the attacks to be shocked and traumatized. She was highly stressed by the attack, and she ended up dropping out of school on the one-year anniversary of the attacks. In May 1979, she sat in her car near a Florida river and pointed a gun at her temple. When she pulled the trigger, it was another life claimed by Ted Bundy.

Valerie was lovely. She had long, glossy brown hair and a beautiful smile with perfect teeth. She needed medical care, but it didn't exist at the time. I want to stress that she shouldn't be remembered as a troubled young woman who couldn't control her emotions. She was a victim of Ted Bundy who needed medical treatment for PTSD. Her suffering was legitimate, and her death could have been prevented if Ted Bundy had controlled *his* emotions and *his* drive to kill. There was only one person to blame for her death, and that was Bundy.

In the spring of 1979, I saw the man who was responsible for three of my sorority sisters' deaths as well as my and my roommate's suffering. I had to go to Tallahassee so that Bundy's defense attorney could take my deposition. We met in a conference room as if we were having a corporate meeting. Bundy sat at the head of the table like a bored middle manager, not a vicious serial killer being confronted by a victim. I sat at the head of the other table. It was a smaller conference table than the one we sat at for the grand jury. For the first time, we

were so close. I could have yelled at him and damned him to hell for murdering my sisters and brutalizing me and my roommate. I also could have told him he was doomed and then laughed at his future pain. But I did neither. I controlled my emotions, because he needed to know that *I* was in control.

The victims, we meant nothing to him. But we were going to be the ones who sent him to the electric chair. A dentist was going to testify against Bundy and say he left the bite marks in Lisa's buttocks. Nita, the sister who saw him in the foyer, would identify him in court. And my roommate and I were going to be very compelling and credible witnesses who captured the jury's sympathy. My job in that moment was not to hiss curses or tell him of my agony. It was to remain calm so he could be held accountable. No one had to tell me that. I didn't need a lecture from the prosecutor or the sheriff on how to act in the deposition. I knew what the situation asked of me and I was prepared to deliver.

Not surprisingly, Minerva asked me little about the attack. He spent most of the deposition asking me small, seemingly meaningless questions in the hopes of having me stumble and give the wrong answer. He wanted to discredit me and to take away my power to sit in front of the jury and make them believe me over him. He asked me multiple questions about the staircases in the house, and which I took upstairs when I got home. If I answered differently on the witness stand, he would move to strike me as a witness based on a lack of credibility. I listened carefully and answered respectfully. I also hedged my answers with "I think" or "I believe" so he couldn't later claim I gave an exact answer as to when I went to bed or who turned off the light in the room.

Minerva danced his way around the attack. He asked me if I woke up prior to my injuries, but I didn't wake until Bundy entered the room so I had to say I didn't. After that, he was mostly concerned with whether anyone had told me what happened, and in doing so, put

ideas inside my head. He wanted to know my state of consciousness in the hospital, what the police told me, and what contact I had with the sorority sisters. He must have been disappointed to realize that the Sisterhood That Never Stops had indeed ended for me. I hadn't talked about the case with any of the other victims, and my memories were my own. And soon, I would share them with a jury who would determine Bundy's fate.

Kathy with Chester in her first house, Boca Raton, 1979.

13

WHEN I STILL lived at home with my parents, reading the newspaper became challenging. Mama cut out every article related to Bundy and the trial. Dad, Marilynn, or I would try to look at the paper only to find entire sections missing. Sometimes, she cut out an article and an empty square remained on the page. Other times, she took the entire section, which was typically the front part of the *Miami Herald*, and the rest of us had to make do with the remaining paper. For a long time, I thought Mama was trying to keep upsetting news away from me. But she saved these newspaper clippings for the rest of her life. They were important to her, and she preserved them in a stack, which I inherited in a box along with other mementos.

I sent boxes of the newspaper clippings to Emilie, starting with the ones Mama clipped in Tallahassee after the attack. The newspaper had printed the pictures of the victims and listed our names. After that, Mama clipped every article about the hunt for the then-unknown killer, and then eventually, about Bundy and the trial. No story was too small. She carefully cut out a story from November 1978, "No Cake for Bundy," about how the Leon County Sheriff's Office did not have plans to bring Bundy a cake in jail for his thirty-second birthday.

Of course they didn't! What jailer or warden celebrates an inmate's birthday? It was a stupid story, but Mama cut it out anyway. Another story she saved, "Bundy Seeks Dental Care," was about Bundy needing two fillings. He wrote to legal services to demand that he receive dental treatment. The story also noted how officials didn't want any changes made to his teeth, because of the bite mark evidence from Lisa's buttock.

Starting in April of 1979, the stories Mama clipped were mostly about Bundy's combative attempts to delay or avoid the trial. At that point, he had demoted his public defender, Mike Minerva, to advising counsel, and decided to represent himself. He didn't have a law degree, and he had done poorly in the few semesters he spent in law school. From the start, he came across as an amateur. He motioned for the court to block the press from attending any depositions or interviews related to the discovery process. The judge, Edward Cowart, refused and said there wasn't a "clear and present danger" that would warrant the exclusion of the press.

Bundy exploded at Cowart's response. "Showing clear and present danger is clearly impossible," he snapped. "You're imposing an impossible burden on us."

"That's the law," the judge said.

Bundy then wanted his attorneys to stop all depositions until the judge's order could be reviewed by a higher court. That didn't happen. Cowart also ignored Bundy's complaint about the leg brace Katsaris forced him to wear. Katsaris knew Bundy had run from the Colorado courthouse during his second escape attempt, and he made Bundy wear the leg brace so he couldn't move fast if he indeed slipped away from his jailers. Bundy took issue with how the brace made him look in media photographs.

"I object to being portrayed as a dangerous person, as a guilty person, when I am not. But one can't help but to believe—when they

see me pulled in chains—that there's some justification for portrayal," Bundy griped.

The resistance continued. Mama saved multiple stories in which Bundy wanted Cowart to quash the warrant from the dental impressions. The impressions had been taken the previous July, and Bundy was fighting to have them excluded as evidence. The prosecution brought in several experts who testified that Bundy's bite pattern was unique and he was most likely the person who bit poor Lisa's buttock. A few days later, Mama had to flip to section B of the *Miami Herald* to learn the judge's decision. He was allowing the dental testimony.

The trial in Tallahassee began in May 1979 but didn't get far. The jurors all admitted they knew about the case and had formed strong opinions. Cowart ended the juror interviews and announced the case was moving to another jurisdiction where the jury might be more impartial. Around that time, Bundy's defense attorney, Mike Minerva, petitioned for the court to relieve him of his duties. He said that he and Bundy had "irreconcilable conflict." Bundy had also complained to the court and called Minerva "incompetent." Cowart eventually granted Bundy's request, and three new public defenders were assigned. At that point, the trial was meant to start in June in Miami, and the news stories were longer and started on one page and then continued on another. Mama began saving entire sections.

Looking back at these entire sections makes for interesting reading. On the day Bundy's trial finally began, there was a story about a flight attendant who sued for, as the headline put it, a "fat payoff." The picture showed a perfectly slender woman who was fired for being "obese" and was suing for wrongful termination. Her attorney claimed she was just "big-boned." The section also had advertisements for newly released movies and advertisements for vehicles at "prices you can afford!" It reminded me of those days when I was recovering from lupus and I sat bald-headed at our kitchen table, cut out those little green stamps, and placed them in the coupon book so that we

could redeem them for prizes, like a hair dryer, that had no bearing on my current situation. At that time I was trapped in an alternative reality, and it felt that way again with the Bundy trial. It might have felt the same way to Mama. She was focused on the murder trial of the man who had beat her daughter's skull, and she must have felt like an outsider to the normal rhythms of life. It would feel like that for a while, because the trial dragged on for weeks.

The trial resumed in Courtroom 4-1 at the Metropolitan Justice Building in Miami. Just two months before, the Florida Supreme Court had ruled that recording devices were permissible in courtrooms. More than two hundred journalists from around the globe received press passes to report on the trial, and the case was one of the first to be nationally televised in the United States. Most of the reporters spent their days on the ninth floor of the courthouse, which had become a designated workspace for members of the media. Only one camera was in the courtroom, and it broadcast the trial live in the media room. The three main news networks had feeds running to this camera so they could record or broadcast the trial as they saw fit. However, the first day, June 25, was quite dull for members of the media. The trial resumed by interviewing a new pool of potential jurors. One headline called it "tedious." The slow pace was mostly the fault of Bundy's new defense team. They were young, still in their twenties, and slow with screening prospective jurors. After eight hours of the attorneys painfully asking jurors what they knew about the case, Cowart scolded the team and told them to speed it up.

The newspapers Mama saved captured the numbed nature of the early proceedings. The lawyers could not address Bundy's alleged crimes or past crimes during the jury selection. In turn, if the jurors wanted to be selected, they had to act like they were ready to be impartial or barely knew anything. One juror claimed she paid more attention to soap operas than the news. Another said she only watched Spanish-language media. One man admitted he heard Bundy had

"previous troubles" with acts of violence on other college campuses, and Cowart dismissed him. Interestingly, the newspaper printed his name and occupation, as well as the names of the jurors who were eventually selected. (Many criminal courts now protect jurors' privacy by referring to them by a designated number.) These jurors were about to be thrust into chaos. They would be sequestered for the next few months, and their eventual decision would be scrutinized publicly.

It took five days for both sides to decide on a jury. Then, before the trial could begin, Bundy's team filed several pretrial motions about evidence they wanted excluded from the jury. They claimed the real killer was a man who committed suicide and left behind a confession that he scribbled on a bathroom wall in a printing company in Tallahassee. They also demanded to see other "material evidence" they complained was withheld by the sheriff's office, like a letter that was wrapped in tin foil and then addressed to Katsaris. These were ridiculous motions and Cowart dismissed them swiftly.

Several of the motions, however, mattered. In early July, Bundy's team challenged Nita's eyewitness testimony. They claimed she hadn't seen Bundy in the foyer, and instead glimpsed one of the houseboys, Ronnie. Similar to my high school friend, Tony, Ronnie helped around the house in exchange for free meals. Ronnie was compelled to come to the courtroom to stand next to Bundy so the judge could consider their profiles. Nita said she saw a man with a sharp, prominent nose. Was that Ronnie? The *Miami Herald* photographer captured a photograph of the two men standing in the courtroom for comparison purposes. The reporter opined that the two men didn't look alike. Ronnie was a bit shorter, his profile was different, and he was a decade younger than Bundy. The judge dismissed the motion.

The next day focused on the eight-hour taped interview Bundy gave the Pensacola police after his arrest. The defense wanted it excluded from the trial. Bundy, despite representing himself during the questioning of witnesses, casually wore a Seattle Mariners T-shirt under a

blazer. On tape he questioned one of the Pensacola officers, and likely regretted how he said in the interview that his "fantasies" were taking over his life. The judge also heard how the police asked Bundy what he knew about the Chi Omega murders and he responded, "The evidence is there. Go find it." In the end, the judge ruled the jury would not hear the tapes. Much of the interrogation was not related to the Chi Omega case, and instead focused on the reasons why Bundy was wanted at the time by the FBI. He had escaped from a Colorado jail, and the interrogators had questions about how he escaped, made his way to Tallahassee, and then supported himself on stolen credit cards and fake IDs. Including the tapes risked exposing the defendant to past crimes, which an appeals court might one day find prejudicial.

Bundy still had more pretrial motions, and Cowart was losing his patience. Almost two weeks had passed and opening arguments had yet to begin. The jury had been sequestered in a hotel, and Bundy was wasting the court's time by motioning for better exercise time. He complained the jail's gym closed each day at three o'clock while he was still in court. He requested a special privilege to have personal access to the weights and punching bag. Cowart wasn't having it.

"I'll tell you now the court's not going to try this case all summer," Cowart warned. He ordered the opening statements to begin the next day.

"My attorneys are entirely unprepared," Bundy protested.

"Proceed without them," the judge responded.

———

Opening statements began on a Saturday, and the media were once again bored by the proceedings. Mama clipped a story that explained how prosecutor Larry Simpson calmly described the crimes at both the Chi Omega house and the duplex on Dunwoody Street a few blocks away. He outlined the case against the defendant and assured

the jury the evidence was going to prove beyond a reasonable doubt that Ted Bundy was responsible for the violence. Robert Haggard, a young attorney with blond hair that almost reached his shoulders, delivered the opening statement for the defense. He struggled greatly.

"No one disputes the two young ladies were murdered in Tallahassee," Haggard said, without much force to his voice. "No one disputes the other two ladies were assaulted. Nobody disputes the other young lady was assaulted on Dunwoody Street. But there is a true issue in this case. Who committed these crimes? And that is what this jury has been impaneled to find. The issue is did Ted Bundy commit this crime and no other man? The issue is, will the state prove that Ted Bundy and no other man committed this crime beyond and to the exclusion of every reasonable doubt?"

Simpson spoke up. "Objection, argument."

The judge gave Haggard a warning. "Don't argue."

Haggard continued, but he stumbled into another argumentative statement. He spoke for twenty-six minutes, and Simpson objected twenty-nine times. The judge sided with Simpson almost every time, which meant Haggard had to withdraw his statement or rephrase it. Mama cut out the article that explained Haggard's clumsiness in the courtroom, but she might not have understood what it meant for an objection to be sustained or overruled. We didn't have anyone to explain the process to us, and we didn't understand why certain evidence was admitted into the trial and other parts were excluded. We weren't assigned a victim advocate to interpret this very foreign world for us. We were only told what was needed of us, and I was due at the courthouse on Monday morning to testify.

I came down from Boca Raton to spend Sunday with my parents and Marilynn. They planned on taking me to the courthouse the next day. I know that my mother-in-law and sister-in-law planned on attending each day of the trial, but I can't remember whether Simon came with me to Miami that weekend. I have no memories of him

being with me, although I vividly remember being with my parents and sister. I know my parents felt uncomfortable by the media presence at the courthouse. And I think they had concerns that Bundy might not be held accountable for his crimes.

We were quiet that night at dinner. Mama made a beautiful arroz con pollo, and we each focused on our food. I think a lot of our apprehension came from not understanding the court process. There was so much unpredictability, and we understood that the situation was out of our control. All I could do was present myself calmly in court, answer the prosecutor's questions, and keep my composure if the defense cross-examined me. The prosecutors, in their own way, would protect me from inappropriate questions by objecting on my behalf. I knew I just needed to listen to the questions, consider my answer, and take my time with my response.

I wasn't afraid of seeing Bundy the next day. I knew he couldn't hurt me, and I also knew he was never going to be a free man. Even if the prosecutors' efforts failed, and Bundy was acquitted in the Chi Omega murders and the attack on Dunwoody, he still had to stand trial for the murder of Kimberly Leach. He would then have to return to Colorado to stand trial for the murder of the nurse. He still had a prison sentence to serve in Utah, as well as one in Colorado for escaping custody. Then, there were the charges in Florida for stealing vehicles, license plate tags, credit cards, and driver's licenses. Ted Bundy, I understood, would never be free. He could never again find me while I slept and brutally beat me.

But I wanted him to see justice for what he had done to Margaret and Lisa, and in turn, Valerie Duke. I wanted him to be punished for attempting to murder me, my roommate, and the victim on Dunwoody. I wanted him to be held accountable for the trauma my sorority sisters, as well as the Dunwoody housemates, endured by witnessing the aftermath of inhumane savagery. I believed Bundy was responsible for murdering young Kimberly Leach, and I wanted him to

hurt for that too. In July 1979, we didn't yet know the extent of Bundy's brutality and that he had senselessly murdered more than three dozen women and girls. If I had been aware, I would have wanted him found guilty for wrongfully taking away their beautiful lives. He murdered their dreams, their hopes, and everything they loved. He had no right. And what bothered me was how much he thought he had the right. That's why he was fighting to be a free man. He had no remorse for his violence; he only wanted to be free so he could do it again. A guilty verdict would prove to him that he didn't have the right to murder women and girls.

I didn't want him to win his case on some legal technicality. An acquittal would make him think that he got away with murder because he indeed had the right to strangle, beat, and rape women as he pleased. Bundy had been successful in having a few of his pretrial motions granted, and the prosecution was relying on the testimony from witnesses and experts. The defense planned on attacking the credibility of each person who took the stand, and I had to assume I would be one of the people who the defense would claim was not a worthy witness. And that was a disturbing possibility. The next day when I was on the stand, there was a possibility the defense would diminish what happened to me and the other victims in an attempt to prove their client innocent. It would be hard enough to live with an acquittal. But it would be even worse if it came after a lengthy trial in which all of us victims were told we didn't know what we were talking about.

14

———————

MAMA WAS TENSE the morning of my testimony, but she kept her emotions to herself. Ever since Bundy had tried to murder me, Mama had been concealing a deep rage. She never articulated to any of us how she felt about the attack or the trial. But we saw small flare-ups when she slammed doors too hard or answered questions too sharply. She never apologized. She never cooled down and then approached Marilynn or Dad and said, "I'm sorry about earlier." She just brought her boil down to a simmer until eventually her anger once again became too heated and caused another explosion.

Marilynn was back living at my parents' house after dropping out of college, and I think she was an easy target for Mama to criticize. Mama, if given the chance, would have taken off her high-heeled shoe and beat Bundy with the sharp point. But it would take her years to even admit that much. In the moment, she kept quiet about her desire to impale Bundy. Of course, that wasn't an option. The judge wasn't going to grant the victims' mothers a collective opportunity in which they could take their weapon of choice and harm the man that hurt their daughters. And so, Mama silently seethed. She snapped at Marilynn when she got underfoot or failed to do something exactly

the way she expected. She stomped around the house and then tersely answered, "I'm fine," whenever anyone asked what was wrong.

I could feel the tension as we took our seats in the family car. We weren't going to talk about the attack or the trial during the car ride, although we all would have benefited greatly from expressing our emotions. Mama had set a standard of acting like everything was fine, even when it was not, and we rode in silence. Mama rode in the front seat with that simmering anger we all knew was just beneath the surface and ready to erupt at the slightest provocation. Dad kept his eyes on the road and his worries to himself. Marilynn sat next to me in the backseat and looked out the window, likely wondering what a person could expect at a murder trial.

Traffic from my parents' house to the courthouse was tight, and it seemed like everyone was headed in the same direction. Dad parked the car, and we began walking toward the main entrance. There was a swarm of reporters out front. Some had their television cameras set up to do live reports, and there were large vans with satellite dishes high in the air. We hesitated when we saw the reporters. I had avoided giving interviews for several reasons. Mama wanted us to maintain our privacy, and the prosecutor had asked us to hold off on answering questions. If a reporter misquoted us or got something wrong, the defense might use it against us if it conflicted, even in the smallest way, with our testimony. We felt relieved when a security guard saw us and waved us to a side entrance.

I had to say goodbye to my family at that point. They were going to the courtroom, and I was told to wait with the other witnesses in a conference room. I know Mama wished she could go with me, and I have no doubt she would have taken my place on the witness stand if given the chance. My parents, however, knew I was a strong person and I could handle what I had been asked to do. I had known ever since I was a child that bad things happened to good people. I had seen my mother endure the sudden loss of my father and then the

greediness of his family as they tried to claim his insurance policy and navy benefits. I had watched those young women in the lupus support group grieve the end of their lives and worry for the families they would soon leave behind. I had survived Ted Bundy on that fateful night in January, and then learned two innocent women had not. These things didn't make me bitter, but they did make me strong. As I stood at the elevator bay, I knew I was stronger than the young attorneys who might ask me unfair or inappropriate questions. I knew I was stronger than Ted Bundy.

I was escorted to the conference room, and I was delighted to see several Chi Omega sisters. My roommate was there, and she looked beautiful. Her long blond hair was thick and healthy. She had chosen a long-sleeved, high-collared white dress with a belted waist. I also saw Melanie, the sister who was close to Margaret Bowman and had talked to her about her blind date. A fourth sister, Carol, was also called to testify. In addition to us, there were two other women from FSU. They were the roommates of the woman, Cheryl, who had been attacked on Dunwoody Street. They had been the ones to call her phone, and the rings from that call had scared Bundy and sent him running into the night.

I was also happy to meet several of the police officers and paramedics who had responded that night. It was an opportunity to hug them and thank them for their kindness and protection. I think it was a relief for them to see my roommate and me doing so well. We both had our lingering pain, but we had survived and we had a full life ahead of us. In this sense, the atmosphere in the conference room was pretty light. There were about a dozen people in the room, and we shared a sense of excitement that the trial was finally going to happen. And although we didn't articulate it, there was also a sense of comradery. We were part of a select group of people who were going to testify against Ted Bundy. And although none of us ever asked for this tragedy to enter our lives, I think we all had a sense of gratitude

that we *could* testify against Bundy. There had been a growing under-standing that Bundy was responsible for more than the attacks at Chi Omega, the Dunwoody duplex, and the murder of Kimberly Leach. Officials in Colorado, Idaho, Oregon, Utah, and Washington were now considering Bundy their top suspect in dozens of cases of missing or murdered young women. These victims, we understood, would never have a chance to confront Bundy in court. Neither would the police or paramedics who found their bodies.

At the time, I didn't know much about the other victims. Bundy wouldn't confess for another decade, and we knew there might be others, but we didn't know there would be dozens of others. I did have an understanding that the other victims were young women, like me. I knew that some were younger than me when they were viciously murdered. I also knew that if that white light hadn't saved me, I would have been just like them—unable to testify against Bundy in the hopes the jury would give him the ultimate punishment.

The plan that day was for us to remain in the conference room. We were witnesses for the prosecution, and they would call us down to the courtroom as needed. We would then face cross-examination and return to the conference room when we were done. We were meant to stay until the end of the day in case we were recalled to the stand for further questioning. In our conference room, we had no sense of how packed the courtroom had become. There was a metal detector set up outside the door that each person had to walk through before entering the diamond-shaped courtroom.

The room was set up so the judge sat at the back wall, which had wood paneling and a stand for the witnesses. The jury box was on a side wall next to the witness stand. The front walls near the entrance were angled, and each side had rows of seats for audience members. There were thirty-three spots reserved for members of the press. The other seats went to family members, like my parents and my in-laws,

and other interested parties. The remaining seats went to people who just wanted to see the proceedings.

I'd learn later about some of the people who took the remaining seats. They were young women who were Bundy fans. A few of them admitted to television reporters that they found Bundy good looking. They believed he was innocent, and although they knew he was troubled, they fantasized that their love could fix him. These young women stared angrily at the witnesses for the prosecution. They had fabricated a persona in their minds as to who Bundy was as a person, and they agreed with his claims that he was being wrongfully prosecuted. To these delusional young women, Bundy was the only true victim.

There were other young women in the courtroom who were there to thrill seek. They realized that Bundy targeted teen girls and women in their early twenties, and they also fit the profile of the type of person Bundy would attack. For them, being in the courtroom was like seeing a monster up close. It was exciting, especially because they knew Bundy would have strangled and beat them if given the chance. He was surrounded by guards and he wore the leg brace, which meant he wouldn't be selecting any new victims in the courtroom. The possibility, however, was delightful enough to entice them to attend the trial. These women were also detached from reality. They were attending a murder trial—in which two women were dead and three were badly wounded—for pleasure. They were treating actual human suffering like it was a horror film designed to scare and entertain them.

This was the crowd my family had to sit among when they went into the courtroom that day. Mama was already seething underneath her calm demeanor, and Dad was emotionally wounded and drained. Marilynn had been picking up the pieces for the past year and a half. She had been the one to sit in the hospital waiting rooms and puree my food. She had been the one to dodge Mama's outbursts. There had been many times when she got snapped at for not doing

something the way Mama wanted it done. Her life, through mine, had also been negatively impacted by Bundy, and now she was stuck in a courtroom with young women who fantasized about teaching him how to love or who were delighted by the goosebumps they felt in his presence. My family sat rigidly among these people, waiting to hear the prosecutor announce to the courtroom that he was calling Kathy Kleiner to the stand.

———

My roommate went first. She kept her chin up as she walked briskly through the gallery and up to the witness stand. Her voice was soft and clear, and she was sure of herself and her answers. She established that she went to bed around midnight, and then the prosecutor asked her what she remembered next.

"Being lifted into the ambulance," she said. She pursed her lips together and made the slightest frown. The memory was painful for her, but she remained focused on the prosecutor.

"What's the next thing you remember after that?"

"Being sick," she admitted. She broke into a big, beautiful smile.

"Where was that?"

"At the hospital."

"How long were you at the hospital?"

"From that Saturday night until Friday afternoon of the next week."

"Were you injured?"

"Yes, sir."

"Can you tell us what your injuries were?"

"Well, I was hit on the head and I had cuts on my head." She motioned across her forehead. "I had a broken jaw. Some of my teeth were knocked out. I had broken facial bones. I had a broken arm and a crushed finger."

"Do you know who did that to you?"

"No, sir."

"Were you awake or asleep at the time?"

"I was asleep."

The prosecutor had no further questions. The defense declined to cross-examine, and my roommate was excused from the witness stand. The prosecutor called for me next.

I wore a cap-sleeved red dress that had white trim around the neck and cuffs. It also had a white belt, and I paired it with white high heels. I faced the court clerk and raised my right hand and swore to tell the truth. Bundy was in my line of vision. He was sitting with his attorneys at the defense table, which was covered with overflowing file folders. I didn't care about Bundy. I wasn't intimidated by him, and it wasn't the first time I had seen him in a courtroom setting. What I cared about was my family, and I wondered where they were sitting. There were hundreds of people in the courtroom, and the prosecutor was directing my attention to him. I didn't have a moment to pause and look for Mama.

The prosecutor began with the basics. He wanted my full name and where I was currently living in Florida.

"Boca Raton." I smiled. I was ready for this moment.

"Where were you living back in January of 1978?"

"At the Chi Omega sorority house."

"And in what city is that?"

"Tallahassee, Florida."

"How long did you live at the Chi Omega sorority house?"

I paused. I looked at the ceiling while I tried to get my dates in line. "Since . . . um . . . September of '77," I said with a nod.

He reviewed who my roommate was at the time and my major in school.

"Are you finished with school now?"

"No, sir."

I wished I could add *why* I wasn't finished with school: I was attacked in the first few weeks of the quarter and I had to leave so I could heal from multiple surgeries.

"Are you married?"

"Yes, sir, I am."

"When did you get married?"

I stumbled on the date. I said June 1978, then I corrected myself with a laugh and said 1979, which was the wrong answer. Fortunately, the defense missed it. We moved on to the night in question. I repeated how I had gone to the wedding Saturday afternoon, had dinner at a friend's house, and then went to bed early.

"Did you hear any noises or were you aroused that night?"

I paused. I had heard our bedroom door open. I wasn't fully cognizant the first time Bundy hit me, but I knew after he pounded my skull that I was in the process of dying. I had seen him come back to me the second time and raise his arm in preparation to beat me again. And then that beautiful white light saved me.

I never saw his face, and the prosecution wanted me to focus on my injuries, not how dark it was in the room and how my attacker could have been anyone. I gave an edited version, which was what we had rehearsed.

"I was awoken after I was attacked," I said. "I remember a commotion but I didn't have my glasses on. I don't remember anything that was going on. Just a lot of commotion."

My answer was simple and the prosecutor didn't probe. My job at the moment was to represent the victims and our injuries, not identify the man in the darkness whom I couldn't see.

"Can you tell us the first thing you remember?"

"Sorority sisters."

I then gave the line that everyone had taught me and the newspapers had published. "I was asking for my pastor . . . and my boyfriend. I remember paramedics being there."

"Was this still in the sorority house?"

"Yes, sir, it was."

"What was the next thing that you remember?"

"Being taken downstairs on the stretcher and being taken out to the ambulance."

I left out my hallucination from my concussion and how I saw a very vivid carnival scene.

"How long were you in the hospital?"

"About a week."

"Can you tell us about the injuries you had at that time?"

This was my moment. This was what I was representing—Bundy's brutality. I was one of the few living witnesses who would ever be able to speak to how much damage he had inflicted on a helpless woman.

"I had my jaw broken in three places," I said, and I pointed to my right jaw joint, my chin, and then my left joint. I put my hand on my right shoulder. "I had lacerations on my shoulder and whiplash on my neck."

He asked me about my teeth. "Yes, sir, my teeth are still loose on the bottom." I pointed to my chin. I then pointed to one of my jaw joints. Each one had a pin. "I have a pin in my jaw."

One of the jurors shook her head sadly when I described my teeth and jaw pin. Another asked the bailiff for a glass of water. This was what I had come for! My roommate, the victim on Dunwoody, and I were three of the few living survivors of Ted Bundy, and we were there to make the injuries real for the jury and to speak about the brutality for all the victims who could not speak for themselves. Perhaps they were there. Maybe in the courtroom, scattered among the Bundy fans and the thrill seekers, there were dozens of shadow figures. These were the women and girls whose lives Bundy had stolen, and in testifying against Bundy, we were speaking not just for ourselves but for them.

Margaret. Lisa. Kimberly Leach. And the dozens of women and girls whose names I did not yet know. We were embodying their

stories on the stand so that the jury saw not just a photograph of a victim lying on the morgue table but a reminder that these victims once lived beautiful lives that Bundy had no right to end.

"Kathy, do you know who did this to you?" the prosecutor asked.

"No, sir," I answered truthfully.

Bundy knew. He sat at the defense table and knew he was to blame.

The prosecutor had no more questions for me. I looked at the defense table as they told the judge they declined to cross-examine me. The judge thanked me for my time, and I left the stand. I looked at Bundy as I passed him. I was discreet and I didn't rudely stare at him. My purpose was to be the victim, not show hostility in front of the jury. But I had experienced what I had wanted from the moment—an opportunity to make the jury see how this demon deserved not just a guilty verdict but the ultimate penalty.

The testimony continued throughout the day. Melanie, who was Margaret's good friend, described how the keypad lock was broken. I think it must have been hard for Mama to hear that testimony. She had believed I was much safer in the sorority house, and that lock was part of her sense of security. Another sister, Carol, testified how she had come home just moments before Nita. She confirmed that the light was on in the foyer, and the newspapers made note that this was damning testimony for the defense. In the coming days, they were going to try to discredit Nita and say that she didn't have a good look at the perpetrator when he fled through the front door. But Carol had established the light was on, which killed any opportunity for the defense to claim it was too dark for Nita to make a clear observation.

The jury also heard from four police officers and three paramedics. Bundy was still insisting on representing himself, and he took

the cross-examination for one of the police officers. He pressed the officer for details. Mama later saved the news article in which the reporter found the line of questioning to be suspicious. Bundy wanted to hear about Margaret's and Lisa's dead bodies and what they looked like when the officer found them. How were the bodies positioned when they were dead? How were their arms twisted? Were the rooms smattered in blood? It was as though Bundy delighted in reliving the murders and he wanted to know what he missed after he fled. I hope neither woman's parents saw the same news article.

Bundy wanted the details about the aftermath of room 8. I think this testimony must have been terrible for my parents to hear. The officer described how he was the first one into our room. I was sitting on the edge of the bed, and blood was spilling out of my mouth. A sorority sister was holding up a bowl to catch all the blood draining from my body. At that point, a juror shifted uncomfortably and the defense objected to the testimony. Haggard, the young attorney who had delivered the opening statements, called the testimony "too gruesome." The judge allowed it and said it was relevant because it related to the severity of the crimes.

In the coming moments I hoped that Lisa's parents weren't in the courtroom. I hoped they never saw the newspaper articles that detailed the police officer's testimony. He told the court how he found Lisa. Her skin was pale and her lips were turning blue. One of her eyelids was raised and revealed a glassy eye beneath. She was in the final moments of her life. A paramedic later testified about her wounds, and he said the bite mark on her breast—the one in which Bundy almost bit off her nipple—had left her skin so shredded that he thought Lisa had been pierced by a bullet. No parents should ever have to see those words in newsprint about their child. They should never have to hear them spoken in a courtroom. I hoped Lisa's parents were spared the agony.

After each of us testified, we were escorted back to the conference room. At the end of the day, we were all guided out of the building.

We would never be needed again to testify against Bundy. We had each gone through a grand jury hearing, a deposition, and then the criminal trial. Our portion was over. All we could do was follow the news along with everyone else and hope the jury found Bundy guilty. It was the end of a journey that none of us had ever asked to take, and for me, it was a journey that I went through without the support of my sorority sisters. As we all stood in the elevator, I had a flicker of hope that our paths would finally cross. The other Chi Omegas were hinting that they might meet up that evening in Miami. Part of me wanted to suggest joining them, but I felt it was better to wait to be invited. No one offered for me to come along, and I went home to Boca Raton feeling disappointed. I later learned they thought I would make the offer because I was from Miami, and when I didn't, they felt a bit rejected. It was a missed opportunity for me to be with women who had endured the same trauma. Clearly, this journey was one that I had to endure on my own.

15

AFTER MY TESTIMONY, I immediately sank into self-doubt. I didn't tell Mama or Simon how I worried my statement wasn't good enough. I kept quiet about my anxiety and how I feared Bundy would be acquitted because neither my roommate nor I had seen his face. It had been too dark in our room, and I was facing away from him when the light shone through our windows. Not being able to identify him made me feel like a failure. I wanted to honor Margaret's and Lisa's memories by helping convict their murderer. What if all I did with my testimony was make a jury feel sorry for me? What if it wasn't enough to make them believe Bundy was responsible?

There was nothing more I could do at this point but watch from afar like everyone else. I went home to Boca Raton and back to my spot at the teller window. In Miami, Mama continued to disrupt Dad's and Marilynn's attempts to read the newspaper by clipping related stories for her collection. The day after my court appearance was a Tuesday. Mama clipped the stories that described my testimony, which included photographs of me on the witness stand. The court, however, did not meet that Tuesday, because one of the jurors was ill. This

meant journalists didn't have anything for Wednesday's reports. The *Miami Herald* reporter was creative. He listened to the tapes from Bundy's Pensacola arrest, the ones the jury weren't allowed to hear, and he gave readers the highlights.

Bundy had been casual in those tapes. The Pensacola detectives had been curious how Bundy escaped the Colorado jail, and Bundy was pleased for the opportunity to brag. He referred to the Colorado warden by his first name, as if they were once friends, and described climbing into the ceiling, crawling through the air vent, and descending into the warden's empty apartment. He detailed stealing a car and making it partway to Denver before the car broke down and he had to hitch a ride. By January 2, he was at a bar in Ann Arbor, watching the University of Michigan play the University of Washington in the Rose Bowl. Bundy, a Washington alum, was cheering for the Huskies and was pleased to see them win by seven points. "Whipped the pants off of them," he exulted. "It was just beautiful. I sat in the bar and got, uh, bleary-eyed, surrounded by Michigan fanatics."

In Ann Arbor, he consulted a Florida map. He thought about going to the University of Florida, but he saw Gainesville was in the center of the state. He told investigators he wanted to be near the Gulf or the Atlantic ocean, and he chose FSU instead. This was another example of Bundy's nonsensical thinking. Tallahassee was an hour to the Gulf, almost the same distance as Gainesville. Florida actually had dozens of public and private universities in places like Boca Raton, Fort Myers, Jacksonville, and Miami. Tallahassee was one of the few state schools that wasn't near the coastline. Bundy never knew what he was talking about, and yet he talked so freely.

This might seem like a small detail, but it proves a larger point. In the days to come, witnesses for the prosecution would be interrogated on the stand. Their memory and credibility would come into question. As a defendant, Bundy didn't have to prove himself. His team only had to stomp on the evidence and discredit the prosecution's case.

They had been successful in keeping the Pensacola tapes away from the jury, which was too bad, because the tapes demonstrated his tendency to blabber on with mistaken authority—and inaccuracy—on even the simplest topics. He didn't know anything about the school system in Florida or the geography of the state. Yet he spoke about Tallahassee as if it were positioned blocks away from white sand beaches. He wasn't a credible witness, but he didn't have to be. The defense team only had to discredit whatever the prosecution introduced to the jury.

On the tapes, Bundy refused to speak about Kimberly Leach. When detectives brought up the attacks at Chi Omega and the duplex on Dunwoody, he cryptically told them the evidence was there if they looked. Of course, when court resumed on Wednesday, Bundy and his team were committed to pretending none of the evidence was viable. The prosecution began by displaying twenty-eight enlarged photographs of Margaret and Lisa at the hospital morgue. Jurors saw images of Margaret lying lifeless with a shattered skull and a strangled neck. They viewed close-ups of Lisa's shredded flesh. Bundy watched the presentation intently. His attorneys immediately launched their stomp-and-discredit defense.

One of Bundy's attorneys, Margaret Good, objected to the judge. "These photographs, particularly the one of Margaret Bowman shown lying on the morgue slab with the blood being drained from her body, are so indescribably gruesome that they have absolutely no purpose but to inflame the minds of the jury," she complained.

The judge allowed the prosecution to continue, because the photographs were related to the crime in question. This was how it would be for the rest of the trial. The prosecution would introduce an expert, an eyewitness, or a piece of evidence, and the defense would just try to stomp all over its relevance. After the morgue photos were shown, the prosecution called a forensic serologist to testify. A forensic serologist, I learned, was an expert in crime scene bodily fluids such as blood, semen, sweat, saliva, or breast milk. The expert testified that

the oak log was indeed the murder weapon used to bash Margaret and Lisa, and then me and my roommate. There were also some questions regarding semen found on the Dunwoody victim's bedsheets. This mattered because the prosecution suggested Bundy was a sexually sadistic serial killer who ejaculated when he attacked women. In response, the defense tried to stomp all over the prosecution's theory and then discredit the Dunwoody victim. The defense claimed the semen must have belonged to another man—perhaps someone the victim had invited into her bed. It was a disgraceful character attack.

The Dunwoody victim, Cheryl, walked with a limp up to the witness stand and into this battle. She had been a dance major prior to the attack, but she now suffered from hearing loss and unsteady equilibrium. During her testimony, the prosecutor asked her similar questions that both my roommate and I fielded. She described her evening leading up to the attack, and she detailed her injuries. She had five skull fractures. The prosecutor then asked her about the pantyhose mask that police had found at the crime scene. She denied the pantyhose were hers, and she testified she had never seen them before. In the coming days, an expert for the prosecution would testify there were hairs found in the pantyhose that were consistent with Bundy's follicular profile. The defense wanted to squash any association with Bundy.

Good stood up to cross-examine Cheryl. Good's intentions were clearly to discredit, and I think shame, Cheryl. She started by asking Cheryl how many men had ever been in her bedroom at that apartment. The insinuation was clear. Good was attempting to suggest the witness was promiscuous and the semen could have come from one of her liaisons. Cheryl remained calm, and she steadily named five men who had been in her room, including the landlord for maintenance purposes. Good then asked if Cheryl had had sex in her room on the night of the attack. The question was meant to embarrass Cheryl and to poison the jury's opinion of her. Cheryl simply stated she had not had sex in her room that evening.

Larry Simpson handled the prosecution's response. He named each man that Cheryl had listed as a visitor to her room. He then asked if any of them had a tendency to bring a pair of pantyhose to the house. Did her landlord, for example, have the habit of bringing a pantyhose mask into her room while he performed maintenance tasks? Cheryl smiled. She knew what Simpson was doing. He was discrediting Margaret Good and making her look like a desperate fool for trying to imply the pantyhose and the semen were unrelated to her client. Cheryl was soon excused from the witness stand, but a reporter noted that she was tearful in the hallway.

The prosecution began introducing evidence to the court. They brought forward bloodstained sheets, including my comforter with the trees. They submitted the clothes we had been wearing that night, as well as the Clairol spray bottle that had been rammed into Lisa's anus. An expert testified that the bottle had fecal material on it, and it had been used to sodomize her as she lay dying. And then the prosecution entered the morgue photographs as evidentiary exhibits. The chilling accounts, however, weren't over. A pathologist testified the next day about the autopsies. Bundy had pulled Lisa's panties off so forcefully that she had an abrasion on her thigh, almost like a rope burn. Margaret's skull had been so violently smashed that it had a four-centimeter depression. And the pantyhose had been so tightly wound around her neck that the pathologist had to use scissors to cut them off.

The next week for the prosecution was devoted to proving Bundy was the one who caused these injuries, while the defense responded with their stomp-and-discredit routine. The prosecution called an expert who testified about the hair found in the pantyhose left behind in Cheryl's apartment. The strands were consistent with Bundy's hair. While the expert testified, Bundy acted bored and read from an FBI pamphlet called "Don't Miss a Hair." Unfortunately, the defense had been successful in excluding testimony about Bundy's Utah arrest in

which police had found pantyhose masks in his car as well as tools they initially thought were used for burglarizing.

The jury wouldn't know about Bundy's past with pantyhose masks, but they did hear from three FSU students who had seen Bundy at Sherrod's right before the Chi Omega attack. This was helpful for placing Bundy in the vicinity of the crime and establishing his mental state as pathological. The young women all used words like *uncomfortable, strange,* and *scared* to describe their interactions with him. The defense responded with their stomp-and-discredit routine. Good handled the cross-examination, and she tried to suggest that perhaps one of the women had anxiety about men. Perhaps the problem was her?

"I can handle it," the young woman said about men approaching her in bars. But Bundy was creepy and she felt unnerved. She remembered thinking, *I couldn't handle **this**.*

With his case weakened, Bundy responded by throwing a temper tantrum the next morning and refusing to come to court. He chucked an orange at a guard and stuffed the lock to his cell with toilet paper. He claimed he was protesting jail conditions. The judge cited him with contempt of court and forced a furious Bundy to appear before him.

The jury wasn't present when Bundy was brought into the courtroom. He was belligerent, and he suggested the judge would have regrets if he didn't make him happy. "I have a great deal of potential to deal with the situation. And I've only exerted that part of my potential which is non-violent," Bundy said.

Cowart stopped him. "You're indicating to the court your potential is violence? Seek and ye shall find, and knock and it shall be opened unto you. Remember that."

"Praise the Lord, hallelujah, amen," Bundy responded sarcastically. He immediately realized he had gone too far. He apologized and said it was time to pause and say "whoa."

The judge and Bundy then descended into a nonsensical back-and-forth using cowboy clichés. The judge said he was going to use "the spurs" to keep the proceedings moving.

"Giddy up," Bundy replied.

The judge indeed used his spurs, and the prosecution called a new series of witnesses. They questioned two young men who lived in the Oak and described their interactions with Bundy on the day after the attack. Interestingly, Bundy had derided the Oak to the Pensacola investigators and referred to it as a "rathole." He couldn't even pay rent on this so-called rathole, and he made several excuses to his landlord before he stole a new car and left town. It was an insight into his sense of entitlement.

Nita came to testify that afternoon. She was remarkably steeled, which was impressive given how badly the defense wanted to stomp on her testimony and discredit her. I can only imagine how she felt that morning when she looked at herself in the mirror and prepared herself for court. If she did well on the stand, the man who murdered her sorority sisters would be held accountable and brought to justice. If she became flustered or inarticulate, the jury might acquit him. She carried a heavy weight, but she did it well. In the end, it was the defense who were rattled and clumsy. They kept her on the stand for an hour and forty-seven minutes doing their stomp-and-discredit routine. During that time, Haggard fumbled to form proper questions. His approach was too argumentative, and Simpson kept objecting. The judge continuously agreed with the prosecution. Haggard was the one who was stomped and discredited.

Nita succeeded in identifying Bundy as the man she saw in the Chi Omega foyer. She avoided the defense's traps in which they wanted to trick her into saying she actually saw the houseboy. They also tried

to bring up statements that she made during hypnosis a few weeks after the attack. At the time, psychologists thought that with the right questions, a person might retrieve memories under hypnosis that he or she had suppressed. The problem was the police kept transcripts of the hypnosis, and what was meant to be used as a memory trigger was recorded and used against the witness if there was any discrepancy with other statements. Within the coming decades, courts would hear many challenges to whether hypnosis was credible and should be allowed as evidence. Nita remained steady. Bundy was the man she saw in the foyer. Not the houseboy.

The prosecution's witnesses succeeded in placing Bundy at both crime scenes. The three students had testified he was at Sherrod's next door to the Chi Omega house. Carol told the court the keypad lock was broken, which gave Bundy access, and the light in the foyer was on, which gave Nita an opportunity to see Bundy's profile well. And then, Nita identified him as the man she saw leaving with the log in his hand. The prosecution still wasn't done. They wanted to use forensic evidence to prove Bundy left identifiable traces of himself behind. They called a dental expert to explain to the jury how the impressions of Bundy's teeth indicated a distinct dental pattern that matched the bite mark on Lisa's buttocks. The expert actually became so enthusiastic about the science that he referred to it as "excellent." The defense delivered their stomp-and-discredit response. The killer, they asserted, had crooked teeth and so did Bundy. But that didn't mean they were one and the same. Stomp, discredit, stomp, discredit.

———————

More than two weeks after I testified, the prosecutors and defense gave their final statements. Prosecutor Simpson concluded by asking the jury to send Bundy to the electric chair. Around 3:00 PM, the court emptied and reporters saw Bundy's mother, Louise, crying in

the hallway. Using a very poor choice of words, she said she would like to wring Simpson's neck. About seven hours later, the packed courtroom waited anxiously as the jury filed back into the jury box and passed the papers containing their verdict to the clerk.

Bundy stared straight ahead as the clerk read the first charge, first-degree murder of Margaret Bowman.

"Guilty as charged, so say we all," the clerk announced.

She announced the second charge for the first-degree murder of Lisa Levy.

"Guilty as charged, so say we all."

First-degree attempted murder against my roommate.

"Guilty as charged, so say we all."

First-degree attempted murder against me, Kathy Kleiner. When Sheriff Katsaris had read the indictment the previous July, Bundy had laughed when he heard my name and the charge against me. He wasn't laughing now.

"Guilty as charged, so say we all."

First-degree attempted murder against Cheryl.

"Guilty as charged, so say we all."

One count of burglary to the Chi Omega house.

"Guilty as charged, so say we all."

One count of burglary to the duplex on Dunwoody.

"Guilty as charged, so say we all."

Two guards blocked the main entrance and another two stood by the back entrance. Bundy maintained a neutral look on his face as a team of guards surrounded him and led him from the courtroom. Near the door, he looked back at his mother and girlfriend, smiled at them, and winked. Louise Bundy left the courtroom in tears. She kept repeating to reporters that she couldn't believe it. In the hallway, she gained a sense of resolve and told the media the Bundy family believed in their son's innocence and they were going to appeal and fight for his freedom.

Simpson told reporters he wasn't surprised by the verdict. Bundy was guilty and the jury found him guilty. Four days later, the court reconvened for the penalty hearing. Simpson assured reporters he would ask the jury to send Bundy to the electric chair. Reporters in the coming days weren't allowed to speak to the jury—the judge had sternly warned them not to even think about it—but they had access to Bundy. He gave jailhouse interviews in which he smiled and said he was innocent and already planning an appeal. "I haven't lost any sleep over the verdict," he said with a grin.

The court reconvened on Saturday, July 28, for mitigation. In this phase, the jury heard from witnesses who either spoke to the defendant's character or provided a rationale as to why he should receive a more lenient sentence. After hearing from witnesses, the jury would recommend whether Ted Bundy should go to prison for life or to the electric chair. Once their recommendation was entered, the judge would be responsible for upholding it or enforcing his own penalty. The defense called Louise Bundy to the stand to try to depict Bundy as an innocent man who was wrongfully convicted and not deserving of the electric chair.

Louise Bundy portrayed her son as the very best boy a mother could have. He mowed lawns, did well in school, and never forgot her on Mother's Day. He was her "pride and joy" who always had a part-time job in high school. She claimed hers was a Christian household, and she shuddered at the thought of the death penalty. She said it was "barbaric" to take another person's life. The jury was not convinced. They met the following Monday and deliberated for two hours before they recommended the judge send Bundy to the electric chair. Bundy was stone-faced when he heard the recommendation, and then he acted oddly dismissive. As he was led from the courtroom, he smiled at a reporter and said, "See you at the next trial."

This was the lack of remorse I expected from Bundy. It was why I wanted so very much to see him brought to justice. He would never

be sorry for what he did to Margaret and Lisa. He would never be sorry for the other lives he ended or damaged. He made this clear the next day when the judge gave him an opportunity to address the court prior to announcing his verdict. Bundy spoke for thirty minutes. He expressed great hostility for the media, and he compared his indictment and the trial to a Greek tragedy. The judge listened quietly to Bundy, but he was unmoved by Bundy's profession of persecution. Before he gave his verdict, Judge Cowart explained his reasoning: The attacks on January 15, 1978, had been "extremely vicious and shockingly evil." He noted that they were meant to inflict a high degree of pain. I can assure you that they indeed inflicted a high degree of pain.

Cowart gave Bundy the death sentence for the murders of Margaret and Lisa. He gave him 198 years for burglarizing the Chi Omega and Dunwoody properties. Cowart rolled the attempted murder charges of my roommate, me, and Cheryl into the burglary charges.

When Bundy had the chance to respond, he denied culpability. "I'm innocent of the charges of which I've been convicted," he said with a shaky voice. He declined to say more.

The judge had parting words for Bundy. In his final words to Bundy, Cowart seemed to forget all the young lives that Bundy had ended. He addressed Bundy as if he himself was the final victim on his list of lives ruined.

"It's a tragedy for this court to see you as such a total waste of humanity I've experienced," he said. "You're a bright young man. You'd have made a good lawyer. I'd love to have had you practice in this court. But you went another way, pardner. Take care of yourself. I don't have any animosity to you, I want you to know that."

Bundy and Cowart looked at each other.

"You shall be taken by proper authorities to Florida State Prison and there be kept and closely confined until the date of your execution is set. It is further ordered that on such scheduled date you be put to death by a current of electricity sufficient to cause your

immediate death and that such current of electricity shall continue to pass through your body until you are dead."

It's time to correct history. Judge Cowart was terribly wrong when he said Bundy was a bright young man who could have been a great lawyer. Bundy wasn't a bright young man. He struggled in law school and he simply didn't have the aptitude. He demonstrated his poor legal skills in Cowart's courtroom, and he was so impulsive that he used his cross-examination of witnesses to learn more about the crime scenes he had left behind. And yet, Cowart suggested that Bundy had victimized himself by not using his intellectual gifts to pursue greatness.

It wasn't a tragedy that Bundy never fulfilled his greatness, because he was never destined for greatness. His victims, however, had wonderful lives in front of them. Margaret and Lisa were just starting their adult lives, and on January 15, 1978, Bundy murdered them while they slept in their beds. He didn't know them. He couldn't even *see* them in the dark. They were silhouettes tucked under the covers, and he beat the life out of them. I want to correct this wrongfully recorded part of history. It's time that Bundy's legend diminishes and people stop thinking of him as charming and smart when he was neither. It's time to stop considering what his life could have been if he hadn't "gone another way." The total waste of humanity was not Bundy's death sentence. The waste of humanity was the loss of Margaret and Lisa.

Margaret Bowman was a nice person who remembered kindness shown to her. She made the people in her life feel important. She wrote her grandparents thank-you notes for the smallest of gifts and let them know she put their presents to good use. It was her way of telling them they were woven into the daily rhythm of her life, even when they weren't there. Margaret was studying interior design, and she had so many options in life. I'd like to think that Margaret might

have taken a job with a design firm after graduation. She would have traveled from one state to the next, advising restaurants and businesses on how to achieve the ambience they craved. She might have married and had a family. And maybe now, she would be a grandmother, and her own grandchildren would be sending her thank-you notes and letting her know she was a part of their lives, even when she wasn't present.

Lisa Levy was confident, energetic, and generous. She helped the new pledges by serving as an adviser. She was approachable and laughed easily. When she was at home, she worked as a salesclerk, and she consistently ranked as her store's top seller. I imagine that corporations would have been eager to hire her to their sales force after graduation. She was the type to rise through the ranks. By now, she could have been a vice president, leading a sales division and motivating younger employees. She had always been so relatable. If she had married and had children, I think she would have been the type of mother who gave her adult children sound advice. She would have been that mentor that so many of her Chi Omega sisters once knew her to be.

These were the terrible tragedies of lives wasted. And there was still so much more that we didn't know. Bundy had indeed been shockingly evil.

In August, Mama cut out a newspaper article that I think made her burn on the inside with rage. The state was paying more than $120,000 in Bundy's legal bills. Mike Minerva, the original public defender, had sent the state a hefty bill and he expected to be paid. Meanwhile, my dad had covered my medical expenses. He received a small reimbursement from the state's newly created victim's fund. But I'd had two surgeries within six weeks, and then more in the years to come

when the scar tissue on my jaw expanded and grew to be unbearable. I think Mama saved the news story because it felt like an injustice. Why should Bundy be relieved of his legal bills? Of course, we know he was never going to pay. At thirty-two years old, he was prison bound and he had no assets the court could seize. He had spent most of his adulthood as a perpetual student. He didn't own property or have investments. The state had to pay his defenders. And yet, they didn't have to pay for his victims' hospital bills or funeral expenses.

Mama kept this all from me, just like she never told me the expense of FSU tuition or the sorority membership. She never let me know what something cost. I didn't know until decades later when I saw a news clipping in which a reporter wrote how he told my dad about the victims' fund and Dad expressed gratitude for any bit of monetary help. It made me think. I knew Mama wasn't perfect—she snapped when she felt stressed, she didn't let us express our feelings, and she was judgmental to pretty much everyone she met outside of our family. But she never held me back. She let me find my way in life, and she paid every dime she could to support me in doing so. All the while, she never wanted me to worry about what the cost might mean for her and Dad. Seeing these news articles about the victims' funds and the medical bills only added to the appreciation and love I had for my parents.

In the coming months, Mama had a new set of articles to clip. In early 1980, Bundy faced another criminal trial for the murder of Kimberly Leach. As in the Chi Omega case, Bundy tried to claim that he wasn't the one who murdered young Kimberly. The prosecutors set up a similar case as Simpson and his team had done. They established Bundy had been in the area, hunting for victims. The young middle school student whom Bundy approached in the Kmart parking lot testified and identified him as the man who had come up to her. A witness who had been near Kimberly's school on the morning she was kidnapped told the jury he saw her being dragged into a car. Crime

scene technologists told the jury about the van, which Bundy stole from FSU and then abandoned in Tallahassee, saying it contained fibers from his coat. And credit card receipts from stolen charge cards placed him in the area on the day Kimberly disappeared.

The defense tried to impress reasonable doubt on the jury, and stomp and discredit, but the jury didn't buy their routine. They found Bundy guilty. During the mitigation hearing, Bundy demonstrated how little he cared about the life he had taken. He told the jury that the person who had truly murdered Kimberly wasn't in the courtroom. Then, acting as his own attorney, he called his girlfriend, Carole Ann Boone, as a character witness. Bundy took the line of questioning, and he veered into a direction that no one anticipated. For a marriage to be legal in Florida, a couple only needed to consent in front of a judge in a court of law. No wedding license or proper vows required. Bundy steered the questioning so that both he and Boone made a marriage declaration in front of the unsuspecting judge.

The jury and judge would soon have their own response, however, as to the gravity of the conviction. The jury recommended the judge sentence Bundy to die in the electric chair. Bundy refused to stand when the clerk read the verdict, and then he hotly spat, "Tell the jury they were wrong," as they left the courtroom.

The judge, Wallace M. Jopling, gave his verdict on a different day. He agreed with the jury that Bundy deserved the death penalty. He also agreed with Judge Cowart that Bundy was wasted potential. "As I look upon you, a young man with great ability, a personality, with intelligence—you make splendid arguments. You conduct yourself with decorum. You have evidenced every ability a young man can have been expected to succeed in life."

And then he said something that I wish he had directed instead at the victims. "Where a life like yours is as wasted as this, it's a terrible circumstance for this court to face."

————————

After the sentencing of both the Chi Omega and Kimberly Leach trials, reporters reached out to the survivors as well as the victims' parents for comment. I gave one interview in which I was asked to reflect on the fact that Ted Bundy was due to die in the electric chair. I had never given the death penalty much thought until then, but with Bundy, I felt it was appropriate. Bundy had taken so many lives. To me, he was like a rabid animal. What was the purpose in keeping him alive? He would never be rehabilitated. He wasn't capable of remorse. Kimberly Leach's father also gave an interview in which he said he wished he could be the one to carry out the death sentence. He said he had his own idea on how to kill Bundy, which he declined to share with reporters.

At the time, it seemed reasonable to us that Bundy would go to the electric chair for either the Chi Omega or Kimberly Leach murders. What we didn't realize was that Bundy and his legal team were able to pit each case against the other. When an execution date was set for the Chi Omega conviction, he used an appeal in the Leach trial to receive a stay of execution. When that appeal was exhausted, he then used an appeal in the Chi Omega trial to stay the execution from the Leach trial. He successfully volleyed between the two verdicts for another nine years. The survivors and victims' families didn't know that we had another nine years of waiting before we would see the sentence upheld. These nine years would include multiple instances in which the prison began preparing for the execution only to have a judge issue a last-minute stay. We'd receive phone calls from the prosecutor as the preparations began, only to receive a midnight phone call announcing that it was off. That meant Bundy was a problem of both my past and my future.

16

I ACTIVELY TRIED TO become pregnant toward the end of 1980. I have to admit, I wasn't doing it for the right reasons. Simon and I were realizing that we weren't right for each other, but I wasn't ready to admit it. I was just twenty-two years old and I believed I loved him. I also wanted our marriage to work because it seemed like so many people had invested in us. Both our parents had spent money on our huge wedding, and his parents helped us buy our house. I had joined his family, and I loved them. I didn't want to walk away from it all. Having a baby seemed like a way to solidify us as a family.

When I found out I was pregnant, we decided to tell both sets of parents at once. We had them all over for dinner, and then for dessert we presented a sheet cake with CONGRATULATIONS: YOU'RE GOING TO BE GRANDPARENTS written on top. Mama read it at almost the exact same speed as Simon's mother.

"Oh my God! This is great!" Simon's mother announced.

"Oh my God! You're going to kill yourself!" Mama blurted.

Mama had fear, not joy, in her eyes. I understood why, and I knew I was taking a risk. My doctors had long warned me that pregnancy could be fatal for women with lupus. When I was diagnosed a decade

prior, I had been told I wouldn't be able to have children. It wasn't that I wouldn't be capable of conceiving, it was that my pregnancy was considered too dangerous. I had already gone into organ failure once with lupus, and my doctors thought I was at great risk of experiencing it again. But I thought the risk was worth it, and I had a sense that everything was going to be fine and that both my baby and I would be healthy.

Whereas Mama was worried I'd go into kidney failure or develop preeclampsia, Simon's dad only had one major concern about my pregnancy: What were we going to name our baby? He worried that because of my Cuban heritage, I would insist on a Spanish name for our child. I found this to be very funny. Both my parents came from families that opted for Anglo names. My mother was Rosemary, and her parents went by Julian and Clara. My grandparents didn't even speak English, and yet they had anglicized names. My mother continued the tradition by naming her children Jack, Marilynn, and Katherine. I wasn't exactly considering Ydalia Adelaida for a girl or José Antonio for a boy. But just to give my father-in-law a well-deserved ribbing, I told him I wanted to name the baby Juan Jesús. It became a running joke, and he was good humored whenever I brought it up.

I liked Michael for a boy, mostly because I had a celebrity crush on the actor Michael Landon, who was starring in the TV show *Little House on the Prairie*. Simon agreed to the name, and I progressed through my pregnancy without any notable health issues or a lupus flare-up. I did, however, gain almost fifty pounds. I had started my pregnancy at ninety-nine pounds, and I was near 150 pounds in my last week. I felt heavy and uncomfortable, especially on the hot days of summer in South Florida. My discomfort came to an end in August 1981 when I went into labor around three o'clock in the morning.

I called Mama in Miami to let her know my labor had started, because she was about an hour's drive away from us. When I called, neither of us realized that we would both barely make it to the hospital

Kathy, pregnant with Michael, at her baby shower, July 1981.

in time. My labor was progressing so quickly that by the time I got to the hospital, I was past the eligibility for receiving pain management. From the time my water broke to the moment Michael was born, I was in labor for a total of only three hours. I had to start pushing almost the moment the nurses put my legs into the stirrups.

To no one's surprise, Mama moved at turbo speed as soon as she hung up the phone. She rushed up from Miami and navigated her way to the maternity ward in time to see Michael being born. She wasn't actually in the delivery room with me, but the operating room had huge windows on the door that were not curtained. Anyone could

have looked through and seen me panting and pushing. Fortunately, it was Mama who stood at the windows, not some random stranger.

After a few days in the hospital, we were sent home and I began my life as a mother. At that point, I had left my job at the bank and I was staying home with my son. Prior to leaving the bank, I had been promoted from teller to loan adviser, which was nice because I didn't have to stand all day while pregnant. But it was a daytime job, and I needed to be home with my son. I still wanted to bring in an income, so I took an evening job as a server in a local pizza parlor. My mother-in-law and sister-in-law kindly agreed to watch Michael while I was at work because Simon often had to work evenings as well.

I had to be at the pizzeria by five o'clock, but Simon wasn't off work by then and sometimes neither his mother nor his sister was available to take Michael. I had received a referral to a woman who provided childcare in her home. I went to the house and met with her. It seemed like a safe environment to leave my son in for an hour or so. I was wrong. One day when Michael was seven months old, I was due at the pizza parlor by five o'clock. I had spent the day with Mama and Michael and then dropped him off with the sitter for a few hours. The plan was for my mother-in-law to pick up Michael from the sitter and bring him to her house for an overnight visit. That night before bed, my mother-in-law saw a huge red handprint on little Michael's back. Someone had beaten my baby.

It was a terrible situation that got worse. My mother-in-law didn't call me, mostly because she didn't know what to think. She trusted me as a mother, but she also couldn't explain the handprint on her grandson's back. She casually asked me about it the next morning when I came to pick up Michael.

"Did you get mad at Michael yesterday?" she asked.

I told her I was with my mother and Michael all day, and Mama could attest that I did not discipline my son. That's when she revealed the handprint. I was livid. I called Mama right away, left Michael with

Kathy and Michael, 1982.

my mother-in-law, and went to the police station to file a report. I had intentions to press charges against the babysitter for child abuse. But first, the police made me take a lie detector test to prove it wasn't me who had hit my son. The test took an hour, and they asked me repeatedly, "Did you beat your son?" I was in tears by the end. The full ordeal was exhausting and intimidating, and I believe the police thought I was the one who had made the handprint. Even though I passed the lie detector test, they weren't convinced enough to investigate further. They said the sitter lived with multiple people in the house and they couldn't be sure which one of them had struck my child.

I was furious with the sitter, who I made sure never saw my baby again. Mostly, I was devastated. Of all the things I had sustained and survived in my life, seeing my baby abused was one of the most

traumatic. It was an absolute low point for me. I had been bedridden with lupus and mutilated by Ted Bundy. But those were things that happened to *me*. I could cope with my own pain and humiliation. I couldn't cope with my son enduring the same.

––––––––––––

Not long after the sitter struck Michael, Simon and I were hit with the realization that our marriage wasn't working. I moved into an apartment with Michael while I worked with a real estate agent to find a townhome or condominium. I was a single parent for the next five years, and not just a single parent, but a single parent to a young child during the most demanding years of parenthood. These were the years when my son was in diapers, when he couldn't play unsupervised, and he easily got ear infections and other colds from the other kids at day care. I had no one to lean on in those moments, not financially or emotionally. There were days when I felt I didn't have any opportunity to take a break. I had to get up in the middle of the night when Michael needed me, or I had to deal with an explosive diaper just as I thought we were ready to leave the house. I often felt stressed, as if the day just wouldn't let up. But I never wanted Michael to see me struggle. It was important to me that he think I was excited about each day that lay ahead of us. So whenever I had a bad day, I treated us to McDonald's so he could enjoy a Happy Meal and the indoor playground. He thought he was having a fun night with McNuggets, but really I was just at my limit and I didn't have the capacity to cook or entertain a small child.

We started our new life together in a small apartment I found in Boca Raton for us to rent while I went through divorce proceedings. Only then did I tell my parents I was getting a divorce. I didn't want to give them yet another reason to worry about me. Dad didn't say much when I told him. Mama worried I was walking away from a

good family with a successful business and the possibility for a comfortable life. She gasped when she saw my new apartment. It was dirty no matter how much I cleaned, and cockroaches scattered whenever I turned on the lights. I must have killed ten roaches a day, but it was just for the short term and I wanted her to understand that I just needed to find my way on my own. Mama responded by joining my search for a place to purchase.

Mama, as one could imagine, was an ideal person to help with house hunting. She approached each property with a sour look on her face. She frowned her way through small kitchens, raised her eyebrows at jammed windows, and made criticisms phrased as questions, like "Oh, so *that's* where the laundry is?" or "*This* is the master bedroom?" She really wasn't impressed until we started looking at newly constructed units.

I eventually found a town house in a newly constructed community. There were two bedrooms and two bathrooms upstairs as well as a balcony overlooking the front walk. The downstairs had the living room, dining room, kitchen, and a half bath. It was everything I needed, and a new life was opening in front of me, including my new job as a buyer for a hospital. I initially pursued the position because I realized I had come to see hospitals as places of pain, and I avoided them whenever possible. Even if a friend had a baby, I couldn't bring myself to visit her in the maternity ward. Taking a job at the hospital was revisiting the exposure therapy I put myself through at the lumberyard in the months after the Bundy attack because I had become fearful of men. What started as a job turned into a delightful career for the next eighteen years. I found I had a knack for purchasing. I negotiated the price on everything from tongue depressors to surgical sutures. In some ways, it felt like a game to me, one that I was good at winning because I wanted to get the best price possible, and I wasn't afraid to tell suppliers to make me a better offer.

I was not yet twenty-five years old, and I had a town house with a mortgage, and a young son to raise on my own. I could have felt overwhelmed, and I often did. But I was also excited and optimistic for the future. The town house was mine, and I could decorate it any way I liked. I still had an interest in interior design, and as the first owner of the unit, I was able to select the furnishings. I chose eggshell-colored kitchen cabinets that matched the eggshell paint on the walls. I had a grayish rug running throughout, and I chose a clean, art deco style for the downstairs. In the living room, I added teak furniture and a fake plant to add greenery. I mounted a TV to the wall, put up shelves, and lined them with 1920s-inspired knickknacks. In the downstairs bathroom, I hung black wallpaper that was designed to resemble the universe. It was like walking through the cosmos. There were comets streaking across the paper and star points forming Orion. Everyone, except for Mama, considered the wallpaper beautiful. She said it was like looking into the "devil's den" and she refused to use that bathroom. She always trudged upstairs to use the bathroom in Michael's room.

Michael's room was decorated in a dinosaur motif. In his closet, I organized his toys into clear plastic boxes meant for shoe storage. Each box was labeled and designated for a specific toy. He had one bin for his Matchbox cars, another for his building blocks, and separate ones for his various action figures. I made him responsible for putting his toys back in the bin before he could take another bin from the closet. I hoped to teach him how to read the labels and how to be organized. In that regard, I think I was also trying to organize my own life.

As Michael grew to be a toddler and then preschool age, I started telling him he was the big boy of the house. Each night, he would follow me as I walked around our home and made sure all the windows and doors were locked. When I tucked him into bed, I gave him "butterfly kisses" by blinking my eyelashes around his face. One night, Michael put his hands on my face while I gave him his butterfly kisses and he felt the scar on my cheek from one of my jaw surgeries.

Kathy and Michael, Christmas 1983.

Kathy walking Michael to school, October 1984.

"How did you get this?" he asked, pressing his little fingers on the scar.

"A long time ago," I told him. "An evil man came into my house and hurt me. That's why we make sure all the windows are locked at night."

Michael cupped my face in his small hands. His voice was serious, and I could tell he was trying to sound like an adult. "I won't let anyone hit you in the face again," he promised.

I looked down at my precious boy, whom I wasn't even supposed to have because of my lupus. All I wanted to do was protect him from the world, and here he was saying that he was going to protect me. It was clear we were going to take care of each other.

I left the conversation at that. In the years to come, I never hid what happened to me from my son. But I also never brought it up. I tried to keep Bundy from inserting himself into our daily lives, so I tended to keep quiet, even when my memory was triggered by the sight of an oak log in the fireplace or a keypad lock. I was trying to keep the attack in my past, but I know that for others, the night of January 15, 1978, still felt painfully fresh.

———————

Suzy White had been one of my first friends at Fort Lauderdale High School. She was with the group of theater kids my drama teacher asked to befriend me. To know Suzy, in my opinion, was to love her. She was soft-spoken, and her delicate persona let others know she was sweet. Some of her kindness was her personality, and some of it was because of the roles she had to take on in life. Her mother had been an alcoholic, and her brother had both cognitive and physical disabilities. She was so kind and patient with him, and I know he depended on her to provide in ways that her mother could not.

Suzy was one of the main reasons I joined Chi Omega. She had been a year ahead of me in school, and I followed the path that she had already trod: enroll at FSU and pledge Chi Omega. In the sorority house, she lived just two doors down from me in room 6. On the night of the Bundy attack, Suzy had received a call from a friend. She left her room in the early hours, around the time Bundy began walking toward the duplex on Dunwoody. As he walked behind the Chi Omega house, he saw sorority sisters opening the back door without having to pause at the keypad lock. He realized it was broken, and he grabbed the oak log from the woodpile.

Suzy blamed herself. She had exited the door before Bundy had entered, and she wrongly assumed she hadn't shut the door properly. She thought her actions were responsible for Bundy being able to access the door and attack the four of us. This was not true. First, the only one responsible for the murders that evening was Ted Bundy. He was the vicious serial killer with no regard for human lives. Second, if we wanted to blame anyone else, then we would look no further than his multiple girlfriends. They sent him money while he was in prison, and he used those funds to buy a plane ticket to Chicago, a train ticket to Ann Arbor, and then a bus ticket down to Atlanta. They assisted him, and if anyone had bloodstains on their hands, it was them.

For years, Suzy thought it was her fault, and she carried this heavy burden with her. In November 1986, she met up with one of the Chi Omegas to talk about what had happened that night, and she expressed concern it was her fault that Bundy had access to the house. If only, she reasoned, she had better shut the door, then Bundy wouldn't have had access. I don't know the details of their conversation, but I'm sure the sorority sister assured Suzy like we all would have. The keypad lock was broken, so what was she supposed to do? And who could have predicted that Ted Bundy lurked nearby?

The guilt continued to gnaw at Suzy. Two days after the conversation, Suzy went to Disney World in Orlando with her boyfriend. They rode Space Mountain, an outer space–themed roller coaster where riders zipped around in the dark past flashing lights. After her ride ended, Suzy climbed out of her seat and onto the platform. She took several steps and then dropped dead from a cardiac episode. She wasn't yet thirty years old. I think the burdens she carried created a stress on her heart. To me, Suzy White died from a sick heart that was further weakened by a guilt and shame that Ted Bundy should have felt but never even acknowledged. In this sense, to me, Suzy was another Bundy victim. His violence injured her.

I was living in Boca Raton in November 1986 with my five-year-old son. I received a call from one of our high school friends in the theater group that Suzy was gone. It was devastating to hear that yet another beautiful young life was gone too soon. We took solace in each other and made plans to meet up and attend the wake and the funeral together. On the day of the services, we were in disbelief, and it was hard to reconcile that we were about to attend our good friend's wake. I think I was so focused on my high school friends that I failed to realize that Chi Omegas would also be present. Suzy was the only woman from the sorority that I had contact with, and I still struggled with how they had cut me off all those years ago.

When our group walked into the wake, I was surprised to see a group of Chi Omegas bunched together. They came over to me and began asking me how I was feeling. It felt very personal, but we didn't know each other anymore, and that made their concern seem fake. I hadn't seen these women in almost eight years, and now they were talking to me like we had kept up for all this time. I scoffed. They weren't entitled to such familiarity with me. It wasn't fair that when I needed them the most, they cut me off. They had each other, and I felt like I had no one. I didn't need them now, eight years later, and I told them as much. The damage was done, and they couldn't try to mend the burned bridge, especially because it felt like it was for their benefit, not mine.

I do have an understanding of why the Chi Omegas as frightened, twenty-year-old victims didn't reach out to me. I wanted to have empathy for what they had endured, and I understood how it limited the compassion they had available for me. They were traumatized too. But I had far less tolerance for thirty-year-old women expecting a person they cut off years prior to act as though nothing was wrong. They wanted me to ease their guilt and make them feel better about the situation. I think they should have approached me more cautiously, and not pretended that everything was fine between us. I wasn't one of them, and Chi Omega made it clear that the Sisterhood That Never Stops had ended long ago for me. It wasn't fair for them to try to force me to make them feel comfortable.

I remember telling one of the sisters, "I needed you then, but I don't need you now."

It was somewhat true. I still hurt terribly from the loss, and part of me wished they were still my friends. I also knew I had built a life for myself and my son in which we could feel happiness every day. I didn't need to revisit the past, especially the attack and its aftermath, for the benefit of these women with forced smiles. I'd had to grieve their loss years earlier and realize that the friendships we had were

not the true ones I believed them to be. Mama had been right. In the months after the attack, she watched me hopefully wait for any one of the Chi Omegas to call our phone. After a while, she began telling me I had been naive to think they were my "sisters." They were young women who chose the same sorority as me and paid dues like I did. We weren't family. We weren't bonded.

I felt devastated by Mama's words at the time. I don't think she was trying to be unkind; I think she was trying to protect me by getting me to reject them like they rejected me. It took almost eight years for me to do so. I can't say I felt freed when I acted cold to the Chi Omega sisters at the wake and redirected my attention to my high school friends. The rejection still didn't feel mutual. It just meant that I no longer had a place in my life for these women, and I wasn't going to open myself up to them, and so I kept my distance at both the wake and the funeral. I had enough to grieve in those days, and I didn't have the energy to make the Chi Omega sisters feel better. There was something major adding to my stress that week, and I'm sure the same was true for the Chi Omega sisters. Just days after we buried Suzy, Ted Bundy was scheduled to die in the electric chair. It was a day I had been waiting for years to see.

17

TED BUNDY DIDN'T want to die. He wasn't ready to accept guilt for his crimes, and he wasn't ready to let Sheriff Katsaris win. The victims didn't matter to Bundy. We never did and we never would. The only thing that mattered to Bundy was not being defeated by Katsaris and the prosecutors from either the Chi Omega or Kimberly Leach cases. Bundy had been convicted in the Chi Omega murders in July 1979 and was then sent to Orlando to stand trial for the murder of Kimberly Leach in early 1980. Once both trials were complete, he turned his attention to appealing both verdicts while trying to portray himself as a victim of a broken system.

Bundy, of course, was no victim. The system gave him far more privileges than most inmates ever knew were available. The State of Florida paid his legal bills to his public defenders, and the prison system supplied him with the law books and materials he needed to serve as his own attorney in the appeals. As Bundy tried to manage his appeals, the old adage about "a lawyer who represents himself has a fool for a client" rang true. Although he wasn't an attorney, he insisted on fighting the courts on his own, and by February 1986, he was about to finally lose. The Supreme Court had rejected a writ of

certiorari he had filed regarding supposed errors in the Chi Omega case. The governor of Florida immediately signed his death warrant.

A writ of certiorari, or a cert, is when a person brings specific issues to the attention of a higher court and asks it to require a lower court to revisit the items in question. Bundy had a list of errors he claimed denied him justice in the Chi Omega trial. He still contended that he should have been allowed to have that Atlanta attorney serve as his defense lawyer. He also believed the judge misled him as to when he would be able to have a hearing on the effectiveness of his public defenders, and he felt he unfairly missed the opportunity. The Supreme Court declined to review his cert and recommended he find himself an attorney.

Bundy soon had a new attorney, Polly Nelson. She was a former social worker who had returned to law school and had just started with a big Washington, DC, law firm that was taking on Bundy's case pro bono. Nelson wrote in her 1994 memoir that another attorney approached her about representing Bundy and she confused him with Richard Speck, the mass murderer who broke into a Chicago town house in 1966 and savagely massacred eight nursing students. The other attorney corrected Nelson. Bundy was the one who broke into the sorority house in 1978 in Tallahassee and brutally attacked four women. Nelson was immediately enamored. She wrote in her memoir that she "bonded instantly" with the idea of him alone in his cell, "his inner child trembling in complete terror."

Nelson threw herself into the case. Bundy was weeks away from the electric chair and she wasn't going to let anyone harm "her baby," as she called him. She motioned the Florida Supreme Court for a stay of execution, which they swiftly denied. The US Supreme Court, however, gave her until the end of March to make her next move. Nelson came up with her own list of supposed errors from the Chi Omega trial that included attacking Nita's credibility and blocking jurors opposed to the death penalty from serving. Interestingly, Nelson admitted in

her memoir that Nita's testimony was consistent and would be far more difficult to challenge than the eyewitness testimony in the Leach murder trial. Nelson forged ahead with the cert anyway. It was the same moves we saw during the trial—stomp, discredit.

The Supreme Court declined to review the cert in May. Nelson rebounded almost immediately with a cert in the Leach murder. While that was under review, she also filed three petitions in Judge Cowart's court to evaluate Bundy's competency during the Chi Omega trial. Cowart approved two of the petitions but denied the one that asked the state to pay for the cost of the expert analysis. Nelson expressed her disappointment in her memoir, suggesting it was unfair the state did not pick up yet another expense related to Ted Bundy. At this point, she had lost all perspective. She was also upset that summer when a made-for-TV movie portrayed Bundy as an actual serial killer, and she referred to the network as "heartless."

Nelson was ruthless in her attempts to save Ted Bundy. She volleyed between the Leach and Chi Omega cases, using a petition or a writ for one of the cases as the excuse as to why the other's execution date should be delayed. And over time, she seemed to agree with Bundy that he was the true victim. She wrote in her memoir that "death row inmates were human beings in the worst trouble imaginable." She also revealed that Bundy admitted to her how he had murdered a fifteen-year-old hitchhiker after he forced her to strip, get down on all fours, and suffer the humiliation of him taking photos of her naked body. He tied a noose around her neck, raped her, and strangled her. That young hitchhiker—just fifteen years old—was a human being in the worst trouble imaginable. So was Margaret when Bundy entered her room, and so was Lisa when he rammed the spray bottle into her anus.

Nelson did have to admit Bundy was a complainer. He pestered her about wanting better food or exercise time. In Nelson, Bundy had found someone who was sympathetic to his imaginary status as a

victim, and he was looking to exploit her assistance on all levels. She also had to admit that he wasn't intelligent. The notion that he was a brilliant legal mind was pure fiction. She found that while he could speak and write well, he had little ability to process information and respond. She also noted he had "real deficits" in judgment, awareness, and deep thinking. Perhaps this was why she felt so protective of him, and she spent most of 1986 hopping from one petition to the next. But by November, it seemed their opportunities had run out.

Bundy was scheduled to die the week we buried Suzy White. The execution was for the Leach murder, but the victims and their families from the Chi Omega case were also included in the formalities. The prosecutor in our case served as our contact point. He was the one who called our homes and asked if we wanted to attend the execution as witnesses. On the day of the execution, he was tasked with keeping us updated. We would receive a series of calls throughout the night about the status of the execution. We would then receive a final call after Bundy was pronounced dead. At that point, Bundy had received several stays of execution, and that had taught me to be cautious with my emotions. That November execution, however, was tormenting. We had just lost Suzy and it felt like Bundy should be buried six feet under, not her. The execution proceeded as planned, which made me think it was actually happening. But seven hours before Bundy was to be strapped into the chair, a judge issued yet another stay of execution.

By that time, Nelson was regularly being interviewed by reporters. She came into the habit of ending the interview when they asked her, "But what about the victims?" It was a fair question. Margaret's, Lisa's, and Kimberly Leach's families had been suffering for almost nine years without their daughters. My roommate, the victim on Dunwoody, and I had all tried to move on with our lives, and our healing was constantly interrupted by the legal games that Nelson played on behalf of "her baby." I can't speak for the other victims or the families of the women and girls killed by Ted Bundy. But I can

say that for me, Bundy's execution was meant to be a closing chapter to this horror story. I would always be a Bundy victim, but there was something healing in knowing that his story was stopping and mine was continuing—without him in this world.

I also still had a concern that Bundy would somehow play the courts to his advantage and win an acquittal. I couldn't bear to see that kind of injustice. The victims deserved so much more, and now we had to contend with an attorney who believed it was Bundy who deserved better. It was exhausting, and on the advice of my sister, I wrote a letter to the local newspaper to express my distress over the delay of execution. My words then served as a reminder that the legacy of Bundy's violence lived on: "Crime cannot be undone," I wrote. "Life cannot be restored, sometimes, even if the victim lives through the nightmare."

———————————

November 1986 was a hard time for me. I didn't realize that in a few short months, my life would change forever and for the better. In the spring of 1987, my high school friend Betsy was at a bar when she ran into Scott Rubin from high school. Scott had been in theater and the mime troupe with me, but he gravitated toward the popular girls and I thought of myself as a bit of a nerd. I always had a quiet crush on him, and because he was one of Betsy's older brother's friends I got to see him often at their house. Scott was now in a master's program for communication disorders at Florida Atlantic University in Boca Raton. Knowing that I was in the area, Betsy took Scott's phone number and told him she was giving it to me. I didn't call right away, but when I did, we had such a nice phone call that I invited him to lunch at my place.

My parents had recently moved to Boca Raton, and they were able to take Michael for the day. I was standing on my balcony when Scott walked up to the town house for our date. By then, my hair

was long and curly and I was no longer the teeny little girl that Nora easily picked up during our mime performances.

Scott looked up at me and thought, *Wow, she's not little Kathy anymore.*

And he was no longer just one of Betsy's older brother's friends. I learned that Scott was studying neurogenic disorders for cognition and language, and he planned to one day earn his doctorate and teach at the college level. He learned about my new life with Michael and my job as a buyer. We enjoyed our lunch so much that we decided he should stay for dinner. I had shrimp and steak for us to grill. I admitted to Scott, somewhat embarrassed, that I liked my steaks cooked well done. I thought it stemmed from when the lupus drugs made me so ravenous that I made Mama pull raw steaks out of the broiler because I was howling with hunger. I half expected Scott to think I was unsophisticated for liking well-done steaks, but he admitted he liked them the same way I did.

It was love from the beginning. At the time, two other men had taken me on dates in the previous weeks. I called up each man and sang out, "I can't date you anymore, because I'm in love!"

I soon introduced my parents to Scott. For Easter, Scott agreed to join our family for church services. Mama saw Scott for the first time in his suit and tie. She took note of his tall height, brown beard, and longish brown hair. She gasped with delight.

"Oh my goodness. He looks just like Jesus!" she exclaimed.

Mama approved of the relationship. Scott was funny and laid-back. I suppose in that regard, I had finally inherited Mama's ability to select tall and kind men. Scott was also extremely tolerant. He appreciated Mama for who she was and accepted her for who she wasn't. His family, for example, was Jewish. Mama on more than one occasion told him with sincere sadness that she would miss seeing him in heaven because he wasn't Christian. Scott always just took it in stride, nodded, and said he'd miss her too.

Michael also loved Scott from the start. Whereas I had rules about Michael only pulling out one toy bin at a time, Scott was relaxed and attentive. They loved being together. One time, Scott took Michael to McDonald's for lunch. They were at a table enjoying their meal when an elderly woman approached them and complimented father and son for looking exactly alike. Michael was pleased that people thought Scott was his dad, and they didn't correct her. As I felt growing up with Dad Kleiner, we saw no reason to delineate between stepdad and dad, especially because Scott naturally fit into the role. He cheerfully tossed Michael around in our condo association's pool. He intently watched as Michael showed him how his Transformers toys shifted from semitrucks and cars to crime-fighting robots. Scott complimented the robot through the full demonstration and made Michael feel as though he had something special.

Our new family bonded over our mutual dislike for frogs. In South Florida, we had little lizards that scurried across sidewalks, snakes that slithered up walls, and green frogs that showed up in the most unexpected places. We each had our reasons for not liking these little frogs. One time, I went to put my shoe on and felt a frog inside. I shrieked and flung the shoe away. The frog soared high in the air and landed on Michael's chest. The frog was gripping poor Michael with its four legs, clinging on for dear life. Michael screamed. I screamed. Somehow, we got the frog outside. Another time a frog landed on Scott as he was walking along the row of town houses in our complex. Most disturbing, I think, was the time I woke up in the middle of the night to use the bathroom. I had just sat down on the toilet when I saw a small green hand come up from the bowl and touch the toilet seat between my legs. I woke up Scott with my screaming, and he rushed into the bathroom to help me deal with the little intruder.

I had come a long way from ducking under the lumberyard's counter because a strange man approached the register. I now had a kind and attentive partner, and my son had a devoted father. This

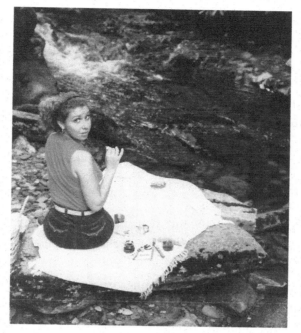

Kathy in the Smokies, 1988.

was the love I had waited to experience. Scott was affectionate, and he focused on what I needed. He wasn't just my boyfriend; he was my best friend. Finding a partner like Scott meant I could really confide my emotions about the attack and the trial. We knew at that point that Bundy was responsible for dozens of murders, although it was still only suspicions at that point. I thought about the victims often and how they had been robbed of having an adult life. They weren't able to have a child, buy a town house, or meet their soulmate. It was infuriating, because Bundy still wasn't admitting to his crimes, and his appeals were maddening. I was lucky to have Scott for emotional support. I was going to need it.

For the rest of 1987 and all of 1988, Bundy's lawyer volleyed between the two cases. One more time, he came close to being strapped into the electric chair. Again, the guards transferred him from his cell on death row to one near the death chamber. He was fifteen hours away from execution when the court issued a stay. The cycle of coming so close to the execution date was exhausting for the victims' families and the few of us who survived. Three times we learned the governor had signed a death warrant and an execution date had been set. Three times we learned a higher court had granted a stay of execution while an appeal was in process.

But by the end of 1988, Bundy had played out his latest attempt. His attorney had attempted to convince the courts that he was incompetent at the time of the murders. A roster of psychiatrists evaluated Bundy and tried to determine whether he was insane when he murdered young Kimberly. Bundy conveniently developed a new life story that involved an abusive grandfather whose violence made the family live in fear. The psychiatrists supposed such daily terror impacted the way Bundy related and bonded with others. The courts weren't impressed. There were whispers by the end of the year that Bundy had reached the end of his appeals. I remained cautious in January 1989. Something felt different when the governor signed the fourth death warrant. It seemed the execution might finally happen.

18

THE LIGHTS FLICKERED and then darkened at the Florida State Prison. The prison superintendent had ordered a test of the electric chair. The generators that powered the electric chair demanded all the building's energy. Within a few minutes, the check was complete and the lights came back on. The death chamber was ready for inmate 069063. The day before, the Supreme Court had denied Bundy's latest appeal, and the Florida governor signed the death warrant the same afternoon. His execution was scheduled for Tuesday, January 24, 1989, before dawn. But would yet another stay of execution keep Bundy alive?

At work, I requested Monday and Tuesday off. I hadn't bothered asking for time off with the previous execution dates, even the two occasions he came close to dying. This time, I sensed, was the end. Bundy also seemed to understand his impending death. The Friday before the execution, he began confessing to an investigator from Washington State. He admitted he had buried five women at Taylor Mountain, including Georgann Hawkins, the University of Washington student who had been prepping for her Spanish final in June 1974. She had taken a study break to go out with friends and then

visited her boyfriend at his fraternity house. Her sorority house was only a few doors down and her walk home should have taken mere minutes. Instead, Bundy appeared in the dark with a crowbar, thrashed her skull, and stuffed her unconscious body into the car. She was confused when she regained consciousness and asked Bundy if he was her Spanish tutor meant to help her study for her final. During his confession, Bundy described her confusion as "funny."

Authorities, Bundy said, would find Georgann's bones along with two other women at Taylor Mountain. Investigators had known two of the women were buried together. They didn't realize there was a third victim. Almost fifteen years after her disappearance, Georgann's family finally had an understanding of what had happened to her. They could collect her bones from the state authorities and finally put them to rest. But Bundy didn't tell the Washington investigator about the murder because he thought he might bring the Hawkins family some peace. Once again, he was using the cases against each other. He thought the confessions might give him leverage with the courts.

The Washington investigator, eager to close so many cold cases, contacted a victim advocate and asked her to call the families of Bundy's suspected victims. Over the weekend, phones rang in the homes of the parents whose daughters had disappeared so many years earlier. Several still kept their daughters' rooms exactly as they had been the day they went missing. The advocate explained her intentions and asked if they would be willing to petition the court to delay the execution in exchange for the truth. The families refused. Their daughters were long dead, and the man they knew was responsible—Bundy—was about to finally receive justice.

I have long thought of those families being called over the weekend. They were asked to save the life of the man who showed no mercy toward their helpless daughters. I couldn't imagine their own pain. I understood my pain to be different, and I had benefited from a sense of justice. I had stared Bundy down in a courtroom from the

witness stand, and my testimony helped jurors sentence him to death for the murders of Margaret and Lisa. The verdict and death sentence had vindicated me. But the families of all those girls never had that vindication. They lived with the stories, as Kimberly Leach's parents did, of how a witness saw her crying as she was dragged to Bundy's car. That one witness thought Bundy was her father and she was a preteen who had gotten in trouble at school. The witness later admitted he had been amused by the situation. He didn't realize Kimberly had been crying in terror.

The victims' families had lived with the sense that their loved one had suffered in some way. Some knew their daughters' skulls had been cracked with a crowbar. Others, like Margaret's family, understood that her windpipe had been squeezed tight. Several, including Lisa's family, learned their daughters' bodies were violated around the time of death. Bundy wasn't offering a *why* these innocent women and girls died. He only had a *how*, and sometimes he couldn't even remember the details. He had killed so many times in his life.

The numbers surprised me. As the weekend progressed, Bundy admitted to murdering thirty women and girls. Yes, he said, he had killed college student Lynda Healy, who voiced the morning ski report on the radio. And he had indeed murdered Susan Rancourt, who was studying hard with dreams of medical school. All these beautiful lives were stopped short—and that's what made the execution even more important to me. My life had been interrupted, and it would have been cut short if that light hadn't poured into our bedroom window during the attack. I healed and my life began again. Now it was time for the murdered women and girls to have justice.

———————

There was no easy way to tell a second grader that his mother had been attacked by a serial killer a decade earlier and now the state planned

to put that man to death. The execution was intended for Tuesday around seven in the morning, which would be in the middle of his getting-ready-for-school routine. I didn't want my boy standing in his backpack by the front door, watching me cry on Scott's shoulder. He needed to be away from the town house, away from the intensity of a tragedy coming to a close. I contacted the school and let them know he was taking a four-day weekend. He would spend the night before the execution at my parents' house. His morning would involve splashing in my parents' backyard pool.

I remained concerned that Bundy might receive yet another stay. Almost three years had passed since the first death warrant was signed and then suspended. Each time the judges had ordered a stay, I wondered how they would feel if their own daughters crossed Bundy. But the judges stayed silent that Monday morning. The news didn't report a stay of execution pending an appeal. In twenty-four hours, I hoped, this would all be over.

I didn't want to spend the day before the execution thinking about it, so I instead preoccupied myself with a day off. Michael thought his absence from school was a reward. All the other kids were settling into their desks while he slept later than usual. We went through our typical morning routine as if it were a Saturday. While the other kids opened their workbooks and picked up their pencils, we headed for the pool across the street. I found a chair where I could watch Michael as he played and I paged through a stack of magazines. I occasionally jumped in to join him, and there were times we had the full pool area to ourselves. After several hours, we tired of the sun and returned home. Michael watched cartoons and played with our tiny new rottweiler puppy. I ran a load of laundry and waited for Scott to finish his afternoon class. We followed the normal rhythm of our routines, as if prisoner 069063 never existed.

Michael packed his overnight bag, and we went to my parents' house for an early dinner. My mother still never spoke of the attack,

the trial, or the pending execution. I think she felt her silence was healing and helpful. My parents have both passed on, and now I look back and I wonder what they must have been experiencing. All those years ago, they had been woken in the middle of the night and told their daughter had been attacked in her bed. They saw my bloodied room in the Chi Omega house. And then they supported me through all those surgeries. Now the man who tried to kill their daughter was finally scheduled to die for killing other parents' daughters. Their emotions must have been intense, but they gave no indication when we came into their house.

Mama was in the kitchen, casually browning chicken drumsticks in a frying pan. Mama said nothing of the execution. She had been disappointed the other two times, and I know she felt bad for me. She concealed her feelings as she cooked, and we followed her lead. We chatted in the kitchen as she sautéed garlic, onion, and pepper. She poured in a can of crushed tomatoes and brought the pan to a simmer. At the table, we heaped rice onto our plates and then ladled the chicken on top. In a way, it resembled the arroz con pollo she made the night before I testified against Bundy. We had been quiet then, so uncertain. I think we had been afraid of what was to come. Now we didn't have to be afraid anymore. The end was almost near.

It was a scene far removed from the Florida State Prison, where the execution proceeded as planned. In the afternoon, Bundy sat down for a lengthy interview with religious broadcaster James Dobson. I saw parts of the interview later. Bundy wore a peach-colored shirt with long sleeves underneath. He was in his early forties by then and he still had his hair. But he had aged in prison, and deep lines creased his forehead. The interview was odd, because Bundy wasn't used to admitting his cruelty, and he clearly wasn't comfortable discussing his sick tendencies with a man of the cloth.

Criminologists were beginning to use the term *serial killer*, and one of the psychiatrists who evaluated Bundy called him a "classic

case" of a sexually sadistic serial killer. Like most sexually sadistic serial killers, he was a White male from a middle-class background, and he followed the same crime scene behaviors identified in others who killed for their own sexual pleasure. He often selected his victims in advance, for example, and determined where he was going to take them after the abduction. When possible, he kept them alive and subjected them to hours or days of mental, physical, and sexual anguish. He enjoyed watching them fear for their lives, and he loved watching them die. Claiming control over the lives and deaths of girls and women was for his sexual pleasure. To investigators, he had admitted returning to Taylor Mountain and other remote spots to sexually assault his victims' corpses. He did not reveal such facts to Reverend Dobson, and he emphasized that he had been raised in a good Christian household. He also didn't disclose how he applied cosmetics to the dead women's faces or engaged in necrophilia. He instead blamed his actions on pornography and argued it was a great societal ill. Bundy failed to look at the reverend as he claimed he was corrupted by erotic photos as an adolescent. He described how he eyed pornographic magazines in drugstore aisles and on bookshop racks—places in the community, he said, where he should have felt safe. He drew a clear connection from these early glimpses at erotic magazines to his insatiable desire for pornography to his inhumane attacks on women and girls. Reverend Dobson listened politely as Bundy blamed pornography. In the coming days, the national news shows hosted psychologists and psychiatrists who debunked the claim. Only Bundy was to blame.

Bundy's wrists were in handcuffs during the interview. He often used his bound hands to rub his face or shield his eyes when asked difficult questions. Reverend Dobson brought up the kidnapping, rape, and murder of young Kimberly Leach. He asked if Bundy had any "normal emotions" in the days following the vicious attack. Bundy looked away and refused to talk about Kimberly. He said it was "too

painful." Later, Reverend Dobson described Bundy as expressing regret for the lives he took and the pain he caused. I found Bundy's remorse to be doubtful—he was still fighting for his life. As he sat with Reverend Dobson, he was still hoping the phone would ring in the warden's office with news that one of his appeals had won him yet another stay of execution.

The sky was still light when I kissed Michael goodbye and made him promise to behave for his grandparents. Scott and I returned to my town house with the full night ahead of us. We decided not to turn on the news or listen to any execution coverage. Instead, we put on some of our favorite records and sat on the living room couch. I had a nice collection with Billie Holiday, Sammy Davis Jr., and Judy Garland. These records were the perfect soundtrack to the many other topics we had to discuss. Scott was months away from graduating with his master's in communication disorders. We planned our wedding for shortly after his graduation. The summer would be busy. I had to put my town house up for rent and plan our move to Athens, Georgia, where Scott would start his PhD program at the University of Georgia. As we talked, I forgot the next day would be a pivotal turning point in my life. In the moment, I had my fiancé, a son sleeping happily at his grandparents' house, and a new life to plan in Georgia.

As the night progressed, Scott and I grew tired. I lifted the needle from the spinning record and switched off the downstairs lights. For the past few years, we had told my mother that Scott slept on the living room sofa when he spent the night. Even though we were both divorced adults in our thirties, my mother thought it was improper if we shared a bed before taking vows. We even went so far as to have Scott creep down the stairs with blankets early in the morning so he would be on the couch when Michael woke up to watch his Saturday-morning cartoons. That way, Michael would answer "the couch" if my mother ever asked him where Scott slept during overnight visits. We felt it was worth the effort if it meant avoiding an argument with my

still-strict mother. Even on that important night, my mother assumed Scott was on the couch and I was in the master bedroom. Scott, of course, was in the dark, cool room with me. We were able to relax and drift to sleep.

———————

There was a phone call for prisoner 069063. One of his attorneys was on the other line calling with an update about the pending appeals. Bundy's team of attorneys had filed three new appeals the previous week. All had been denied. The Supreme Court was Bundy's last chance at a court-ordered stay of execution. Late on Monday night, they voted against all three appeals. It was over. Bundy was heading to the death chamber at sunrise. A prison employee watched Bundy through the window. He said Bundy's face changed as he learned his life was ending. He described him as being "visibly distraught."

My phone rang around the same time. I fumbled for the light as I answered. Larry Simpson, the district attorney who prosecuted the Chi Omega murders, was calling me with an update. Simpson had a deep voice with a southern drawl. He had been impassioned when he delivered the closing statement and told the jury to give Bundy the same amount of mercy he gave Margaret and Lisa—none. On the phone, however, Simpson's voice revealed no emotion. He told me simply that all appeals had been exhausted and the execution was proceeding as planned. He said he would call again in a few hours with another update.

I hung up the phone and repeated the conversation for Scott. The time was coming, and all we could do was wait and try to sleep. I turned off the light and we wrapped our arms around each other. In the dark, my mind went to places I had not thought of in years. So much of my survival had been about taking those baby steps forward. I trained my mind to think about the present and the future. But the

execution meant the past had become the present, and the tragedy revisited me. I remembered the flashing red and blue lights from the parking lot as I was carried out on the stretcher. Then, the scissors cutting off my nightgown before surgery. Weeks later, the officers slowly walking me past the yellow crime scene tape on Margaret's and Lisa's doors. And how seeing my bloodied bedspread made it all seem real. These were the moments I lived with but tried to forget.

The layers of grief pushed me into a light sleep. I later learned that Bundy could not sleep. He prayed with a Methodist minister and then asked to call his mother around 2:45 AM. His mother told reporters in Tacoma that he sounded "wonderful" and at peace with himself. I later learned that his calm demeanor on the call was short-lived. The hours were slipping away and there was still no call from the governor ordering a stay of execution. He realized the call was not coming—he was in the final hours of his life. He became emotional and tearfully begged the people around him not to kill him. Witnesses later described him as pleading for his life. I was stunned when I learned of his hysterics. I imagined that many of his victims said the exact same words to him when he was attacking them. *Please, please don't kill me.*

Bundy typically knocked his victims unconscious with a blunt object before he stole their lives. Many did not realize they were going to die. But we know from his own admissions that some regained consciousness. Others were fully awake when they realized in terror that Bundy wanted them dead. I'm sure they experienced a surge of panic as they feared the violence to come. For some, the horror dragged on for hours, and in a few instances, days. Bundy did not relent when they begged for their lives. And now he was pleading for mercy.

My phone rang again around 3:30 AM, and I realized I had fallen asleep. Simpson was on the line once more. The execution, he said, was

continuing. In the coming hours the prison would begin prepping the condemned for the death chamber. Simpson's voice was serious, yet neutral. He gave me the information as calmly as if he were reading an instruction manual. I was groggy and I thanked him for the update. Scott and I realized there was no point in trying to sleep anymore. I put on my glasses, grabbed a blanket, and went downstairs to turn on the news coverage. Reporters were already broadcasting updates, even at that early hour. Scott and I curled up on the couch with the puppy and dozed in front of the news.

"I'll believe it when I see it," I told Scott.

Many people were also up at that early hour. Bundy called his mother for the last time. She told him, "You'll always be my precious son." Around 4:45 AM, prison officials brought Bundy his last meal. Condemned prisoners were allowed to request a specific menu, but Bundy made no such request, and the guard brought the standard last meal of steak, eggs, toast, and hash browns. Bundy refused the tray.

Sometime after five o'clock, Scott made a pot of coffee and we began watching the news coverage. We learned that witnesses had arrived at the prison. Forty-two witnesses were scheduled to watch Bundy die. Three, including Simpson, were prosecutors. Other witnesses included reporters, investigators connected to the Chi Omega and Leach cases, and forensic medical witnesses for the prosecution. Years earlier, officials asked whether my parents and I wanted to attend the execution. I had no interest. I didn't want to give Bundy any more time from my life. I felt as though he had already taken so much. And seeing him, even if he was strapped into the electric chair, would be a painful reminder of the attack and my sorority sisters who did not survive. My parents also declined the offer. Dad was too sensitive to witness a man dying in the electric chair. And most Cuban mothers would agree with Mama when she said she didn't want to attend the execution but wished Bundy could be on the receiving end of her most pointed high-heeled shoe.

"Put me in a room with him. All I need is ten minutes," she promised repeatedly.

There were many others, however, who wanted to see Bundy in the electric chair. Their careers had been devoted to upholding the law and seeing people like Bundy brought to the death chamber. They were told to report to the prison several hours before sunrise. Oddly, they were first brought to the cafeteria. I later learned that prison procedure included inmates serving breakfast to the witnesses prior to their transport to Q wing, where the death chamber was housed. The witnesses sat in the cafeteria as inmates brought them coffee, grits, and pancakes. Several witnesses later said they didn't have an appetite. Others had been up all night and needed the fuel. As the morning continued, many witnesses made note of how the procedures made the process seem clinical and almost devoid of emotion.

The only one who showed emotion was Bundy. He was tearful and afraid of the painful death he faced. At six o'clock, the bars to Bundy's prison cell clanked open. His hands were shackled as guards pulled him into the hallway. It was time to prep the prisoner for the electric chair, because electrodes worked best on smooth, hair-free skin. Bundy cried as the guards shaved his head and clumps of his brown hair fell to the floor. At one point, the guard tilted Bundy's head forward in order to get the back of the head and his neck. With his head low and tears streaming down his face, Bundy was pushed into a position of shame. It had been a position he was unwilling to assume on his own. The guard next rolled up Bundy's right pant leg and shaved the hair off his calf. Two electrodes, one on his head and the other on his leg, would soon kill him.

Guards ordered the whimpering prisoner to strip. Bundy had to be bathed prior to dressing in the clothes he would wear to the electric chair. Later descriptions stated that Bundy "was bathed" or "was showered," which suggested he did not do the washing himself. It seemed a guard took control of the water and the soap, and Bundy

was forced to comply with directions to raise his arms or turn around. He was naked and exposed, and out of instinct, he tried to cover his genitals with his hands. How many of his victims, like the fifteen-year-old hitchhiker, had he forced to strip? How many of them tried to use their hands to cover their naked bodies?

After Bundy was clean and dry, guards dressed him in blue slacks and a blue button-down shirt. He also might have put on an adult diaper. In the past, prisoners were forced to bend over while guards packed their rectums with cloth or cotton. Guards then twisted the condemned man's penis into a rubber band. These measures were taken because witnesses found the smell of burning feces to be offensive, and efforts were made to limit the mess for when the prisoner inevitably lost command of his bowels and bladder. In a short time, Bundy would lose the same control. It was more than he could bear. The court system had long been a game he tried to outmaneuver, and the prosecutors and investigators had been his antagonists. The women and girls he had killed remained nothing to him. The shame came not from his evil actions but from being forced into submission.

Around that time, the prison established a connection with the governor's office. This was part of the procedure. A moment before the execution, the prison superintendent would pick up the phone on the back wall of the execution chamber and ask a representative in the governor's office whether there was a stay. Given the eagerness with which the governor had signed the death warrant, a stay was not expected. Bundy was becoming increasingly desperate. One guard later described him as a "coward" in the final hour. He had murdered so many women and girls, and now he bleated, "Please don't kill me."

Guards smeared a gel onto Bundy's naked scalp. The gel was intended to limit the burns caused by the electrodes. The gel must have felt cool and uncomfortable on his bare scalp. The end was so very near, and Bundy panicked. He announced he had more murders to confess. The superintendent brought a tape recorder. Bundy told

them where to find a body in Colorado. Authorities believed the body was the remains of Denise Oliverson. She was twenty-four in 1975, and she was riding her bicycle on a Sunday to visit her parents. She was never seen again. Bundy then gave the location for a Utah victim, possibly Susan Curtis, age fifteen. Susan had been attending a youth conference at Brigham Young University in the summer of 1975. She was walking from a banquet to her dormitory when she disappeared. Bundy drew maps to show investigators where to find the bodies. Neither victim was ever located.

The confession was another attempt to delay death. Bundy begged for "thirty more" or "sixty more" days to reveal the details of all the lives he silenced. He claimed he didn't want clemency, only a chance to be helpful and allow the families to know the truth. But that day, a reporter covering the execution connected with one of the victims' fathers and asked if Bundy should be kept alive in exchange for information. The victim, Janice Ott, was a newlywed sunbathing at a popular Washington state park to pass the time while her husband was away on business. Bundy had approached her and asked for help with his sailboat. He had picked her out of the crowd with the intent to end her. Her father, Donald Blackburn, resented the confessions and wished Bundy had gone silently to the death chamber.

"Would you like to hear the story of what happened to your daughter?" he asked the reporter. "Would you like to hear those details?"

The crowd outside the Florida State Prison knew the time was near. The news televised the swarm as they reveled in Bundy's demise. Some wore T-shirts that read BURN BUNDY BURN or held signs exclaiming TODAY IS FRY-DAY. Scott and I didn't have much to say as we watched the news. Occasionally we read a sign aloud or pointed out a T-shirt slogan to one another. The camera panned past hundreds of people

who seemed as joyous as if they were at a carnival or a state fair. There had been rumors that Kimberly Leach's father had planned to join the crowd, but he did not show. There was nothing to celebrate for those of us close to the case. Lives had been lost and tremendous pain had been inflicted. Bundy's execution closed a chapter, but the grief remained.

Another crowd formed inside the prison. The witnesses finished their breakfast and were transported in vans to Q wing. One of the witnesses was the dentist who helped match Bundy's teeth to the bite marks on Lisa's body. The dentist later described how one of the prosecutors and a state trooper hustled into the viewing area and claimed front-row seats to the execution. The gallery was separated from the death chamber by a partition. The bottom was wainscotting and the top was glass so that both sides could see through. The eager witnesses would soon be face-to-face with prisoner 069063.

Many in the gallery wanted to see Bundy suffer. The dentist later recalled how some of the lawmen said they wished they could have killed Bundy themselves. Others wanted the execution to be as painful as possible to avenge the dozens of women and girls whom Bundy tortured. I had never thought much about the death penalty until I was thrust into this ordeal. I supported this death sentence. News reporters later quoted me as feeling "sorry" for Bundy, and the author Ann Rule described me as having a "measure of forgiveness" for him. That was not a full description of my complex emotions. Reporters asked me narrow questions and I gave tapered answers. A decade of my emotions was fit into a two-line quote or a thirty-second sound bite. On a few occasions, I opened the paper to see myself misquoted. I told one reporter that executing Bundy was like putting down a sick dog—it had to happen. "Sick dog" was misquoted as "dead duck." I did feel that Bundy needed to die for his crimes. And honestly, I did want him to suffer like his victims did. He had pounded me fiercely with that oak log. When paramedics had found me, my jaw was barely

attached to my face and I had bitten through my tongue. And I was the lucky one. All those women and girls had died painful, humiliating, and frightening deaths. I wanted Bundy to also experience the same pain, the same humiliation, and the same fear that they did.

There were witnesses in the gallery who felt even more strongly than I did. They looked at the empty electric chair and waited for the guards to bring in the condemned. The electric chair was made of oak, which was the same wood as the log Bundy had grabbed from the stack of firewood outside the Chi Omega house. In the coming moments, he would be strapped into a chair made of the same material he used to strike Margaret, Lisa, me, and my roommate. The chair had been built by inmates in the 1920s, and the prison had taken good care of it. A reporter for the *Los Angeles Times* described the chair as "shiny."

Two guards brought the condemned into the death chamber at 7:01 AM. Bundy's hands were shackled in front of him. Witnesses described Bundy as passive and resigned. He knew he was overpowered. His face was still, but his eyes were fearful as he looked around the death chamber and then processed the stern faces on the other side of the glass. The guards strapped him into the electric chair and swiftly attached the electrical components. They first placed a large, lead electrode on Bundy's right calf. They next situated a sponge soaked in saline solution near the electrode. Then, they fit the leather headpiece onto Bundy's bald scalp. Inside, a crown with a brass screen was secured to a high-voltage wire. There was another saline-soaked sponge tucked inside.

The prison superintendent had begun soaking the sponges in saline solution the previous morning. The sponges had to be a precise saturation. A dry sponge resisted the current, and a wet sponge risked short-circuiting the electricity. Officials had learned from mistakes in past electrocutions. Condemned men had survived weak electric shocks and then been burned when the electrodes ignited. Six years earlier, the execution of an Alabama inmate took fourteen long

minutes and left the prisoner's skin seared and smoking. In another Alabama execution, prison officials connected the cables incorrectly and it took two shocks, nine painful minutes apart, to kill the man. As Bundy looked at the witnesses in the gallery, he was looking at the faces of men who hoped one of these errors would bring him suffering. They wanted to see his body smolder.

There were only a few friendly faces Bundy could look to for comfort in the gallery. The prison superintendent asked Bundy if he had any last words. Bundy acknowledged the two ministers in the gallery who had prayed with him in the days leading up to this moment. He asked them to give his love to his family and friends. A guard promptly crossed a leather strap across Bundy's chin. Then, the guards stretched the leather mask across Bundy's face. One witness later said they put on the mask with such great force that his head tilted to the left. Bundy likely realized in that moment that the presence of forty-two witnesses did not mean the guards would be gentle.

The mask was actually a courtesy to the witnesses so they would be spared from seeing the electricity's grotesque force on the dying man's face. In some situations, the force popped the prisoner's eyeballs from his skull. In rare instances, the scalp caught on fire. Almost always, the prisoner's face hideously contorted. The mouth opened in agony. The nostrils flared. The veins in the face and neck bulged and seemed like they might explode. The skin stretched to the point of splitting. Witnesses often reported they were disturbed by the smell of burning flesh and the sound of the skin searing. They often heard a popping noise, like bacon frying.

As the guards secured the mask, the prison superintendent called the representative in the governor's office. He quickly hung up the phone and leaned into the microphone that addressed both the death chamber and the witnesses. "There are no stays," he announced. "On behalf of the countless victims of Theodore Bundy, both dead and

living, across Florida and the nation, I direct you to carry out the court ordered sentence."

In the moments to come, Ted Bundy was going to die on behalf of the names read in the Florida courtrooms—Margaret Bowman, Lisa Levy, Kimberly Leach, my roommate, the victim on Dunwoody, and me. These were the names that were acknowledged in court and associated with the death sentence. We now know there were many more, and we don't know all their names. In addition to the nameless women never identified by law enforcement, the electricity was being activated on behalf of Anonymous hitchhiker (age fifteen), Brenda Ball, Caryn Campbell, Debra Kent, Denise Naslund, Denise Nicholson-Oliverson, Donna Manson, Georgann Hawkins, Janice Ott, Julie Cunningham, Laura Aime, Lynda Healy, Lynette Culver, Melanie "Suzy" Cooley, Melissa Smith, Nancy Baird, Nancy Wilcox, Roberta "Kathy" Parks, Shelley Robertson, Susan Curtis, and Susan Rancourt.

There were others too, and although Bundy claimed he was innocent in these cases, he also proved he was a liar. In that sense, the fatal electrical current was also for the murders of eight-year-old Ann Marie Burr, Brenda Baker, Carol Platt Valenzuela, Elizabeth Perry, Joyce LePage, Lonnie Trumbell, Rita Jolly, Sandra Weaver, Susan Davis, and Vicki Hollar.

In this list of lost women, I also include my sorority sister Valerie Duke, whose survivor's guilt pushed her to suicide, and Suzy White, whose kind heart could not sustain the violence she knew her friends had suffered. So many lives ruined before they were ever lived. The average Bundy victim was just nineteen years old. Most were college aged, but some were much younger. Two were in early high school. Two were in middle school. One was just in elementary school. There were at least thirty-six women and girls standing in the shadows waiting to be acknowledged.

The executioner pulled the lever at 7:06 AM, and two thousand volts of electricity hit Ted Bundy. His body thrust against the restraints.

Several witnesses said they saw a small cloud of smoke puff from his right leg. His skin was searing. Others reported that prisoner 069063 clenched his hands as he endured the powerful current. His brain temperature soared and would reach more than 140 degrees. After a minute, the shrouded executioner issued shorter durations of lower voltage. Witnesses in the gallery wondered about the executioner under the black hood. Executioners were always hooded, and their identities were kept anonymous for their own protection. They typically weren't prison employees, but they had agreed to train for the job and work the control panel in exchange for $150. Only the executioner's eyes were visible, and several news reporters said they saw eye shadow. They suspected the executioner was a woman, which they deemed to be fitting.

Bundy had once said his favorite color was a purplish blue, similar to the blue tint seen in his victims' fingers as circulation slowed in their dying bodies. Now witnesses saw Bundy's fingernails and fingertips turning the same bluish color. Prison officials waited for the electricity to clear and the body to cool. At 7:10 AM, a paramedic stepped forward and unbuttoned the prisoner's shirt. He listened for a heartbeat and then stood back. At 7:16 AM, guards removed part of the mask and revealed Bundy's still, unblinking eyes. A physician flashed a light into the prisoner's eyes to gauge a response. Nothing.

A lieutenant with the Department of Corrections announced to the gallery, "The sentence of Florida against Theodore Bundy has been carried out at 7:16 AM."

The witnesses filed out of the gallery. Most went to the telephones. The reporters called their editors. The lawmen called their commanders. And the prosecutors went down a list of phone numbers for victims' families and the few survivors. The phone rang in my kitchen, and I heard Simpson on the other line. He calmly informed me that the execution had been completed and Ted Bundy was dead. I numbly thanked him and returned to my spot on the couch.

"It's over," I told Scott. "He's gone."

I burst into tears. Scott pulled me into a tight embrace and held me while I cried. He later told me that I sobbed with uncontrollable wails that would muffle momentarily only to return in full force. All I could think about was the women and girls who had not survived. I wasn't crying for myself; I knew I was fine. I wept for the victims who had died. In my mind, I saw their naked and abandoned corpses covered with leaves and left in the cold. I imagined my sorority sisters lifeless in their beds.

To reporters and the public who followed the case, these women and girls were numbers on a kill list. They were "that girl who was riding her bike" or "the one who was walking home from her boyfriend's fraternity house." They were narrowed down from whole people with relationships and responsibilities to one-line victim biographies. But to those of us who lived through the trauma and loss, the other victims were so much more. We knew these women had once been a crucial part of so many people's lives, and that was missing from the coverage.

I don't know how long I sobbed, perhaps five or ten minutes. I do remember I calmed down and returned to the television news. Bundy's death had yet to be publicly announced, and the crowd was anxious. The cameras focused through the barbed wire and across the prison yard on Q wing. Someone emerged with a white towel and waved it at the crowd. It was the signal that Bundy was dead. The crowd erupted into cheers. I remained tearful. Soon the news showed the white hearse transporting Bundy's body from the prison. The hearse was driving to the county medical examiner's office, where the body would be autopsied and photographed. Bundy's remains would be cremated and sent to a friend who planned to scatter his ashes in the Cascade Mountains, where several of his victims' undiscovered bodies had decayed among the fallen leaves.

The revelers cheered as the hearse passed. Nearby a group of about thirty people who opposed the death penalty were holding a

candlelight vigil for the executed prisoner. Several made a point to tell the news media that they weren't Bundy supporters, more so opponents of the death penalty. It seemed rather pointless. The sun had risen and their candles did not give out much light. I was still tearful as the hearse left the camera frame. I was also exhausted from the morning's emotions. I was ready to move on. I needed to move on with my day. It's how I survived.

"I'm hungry," I told Scott plainly. "Let's go to breakfast."

———————

Scott found several reporters clanging on the gate to the townhome complex and asking for an interview. He sent them on their way. In a few days' time, we obliged a local television news reporter and sat outside in the courtyard at a picnic table to describe how I felt about the execution. The brief words I spoke into the microphone never conveyed how I truly felt. The questions were posed so that I would say that the execution brought me relief and the audience could feel there was some sense of justice in the world.

At the county morgue, the medical examiner's staff lifted Bundy's body onto an examination table. A photographer took pictures of his corpse. I later saw the photos of his lifeless body and vacant blue eyes staring at the ceiling. I thought, *He didn't have a soul anyway.* I was disturbed the first time I saw the image, but not enough to never look again. Several times I have looked at the image of Bundy's shaved head with burn marks across his forehead. Some people have said he looks like he is smiling in the picture, as if to say he smiled when he died. I don't think he had any reason to smile when he passed from this world. I doubt he liked where he was headed.

As the medical examiner took pictures, Scott and I stood in line at our favorite deli and considered the menu board. I always had a cup of coffee with the everything bagel smeared in cream cheese. Scott

ordered his usual bagel with cream cheese and lox. We took our table and made our plans for the day. My parents had Michael until the evening. We thought it would be nice to spend the morning at the pool. After lunch, we needed to visit a few used car dealerships to replace my old Toyota Corolla. And then we wanted to treat ourselves to a nice dinner. The day had been a long time coming, and although we didn't want to celebrate, we did want to mark the milestone.

We looked like any other couple as we went through our day. We basked side by side in the sun on the pool deck. We wandered through the used car lot and answered with a distant "just looking" when the sales agents approached us. We called my mother and checked in to see how the day was going in her house. And then we dressed up and went to an oceanfront restaurant. I remember we started with the escargot. We dipped our bread into the small pools of butter and used the miniature forks to scoop out the snails. Scott later told me that he wasn't sure how to act, and he followed my lead. I had always been so strong, and my fragility after the execution saddened him. He had been surprised when I burst into tears after the final phone call. It wasn't like me. I realize now that Scott had concealed his own worries throughout the day. He braced himself for bad news every time the phone rang. He feared a stay of execution would defeat me, and he didn't want to see me disappointed. He also had his own desire to see the execution completed. Ted Bundy had tried to kill his fiancée. Scott had great sadness for the women and girls Bundy had killed, and he shuddered to think that I was almost one of them.

We drank wine and I ordered the sea scallops. We didn't clink glasses or make a toast to the electric chair. But we were marking a day on which a new chapter was beginning. Bundy was dead. There would be no more appeals. No more begging. No more psychiatrists analyzing whether his murderous ways were due to living with a mean grandfather as a small child or to looking at nude centerfolds as an adolescent. His story had ended. But mine was continuing. I had so

much life ahead of me, and I wanted to live it intentionally as a way to honor the women and girls who didn't have the same second chance. I wasn't going to live under the burden of Bundy, especially when so many families were stricken with that sadness for the rest of their lives. For years, Eleanor Rose, the mother of Denise Naslund, kept her daughter's room the same as it had been the day she disappeared. In her most sorrowful moments, she told reporters that she held her daughter's sweaters close and tried to see if she could smell her one more time. I sensed that Mrs. Rose had probably been in Denise's room that day, sitting among the teddy bears and tightly hugging a sweater.

Later in the year, another mother gave a chilling interview. Belva Kent had lost her seventeen-year-old daughter, Debra, in November 1974 in Utah. They had wondered for the last fifteen years how their daughter had suddenly vanished. The family had been at a high school production and Debra volunteered to pick up her brother at a roller rink. Bundy got to her as she walked across the parking lot to the family car. After the show ended, her family panicked when they found the car in the parking lot and learned their son was still waiting at the roller rink. Mrs. Kent told the Associated Press that she had kept her porch light on for Debra. The family had been in the habit of burning the light until all their children were safe at home. The porch light now burned day and night, because she was still waiting for Debra to come home.

Bundy's light had finally been extinguished. But mine still burned, and I was going to make sure it burned brightly.

19

WE MOVED TO Athens, Georgia, the summer after Bundy died in the electric chair. There was nothing from the ordeal that I took with me. Mama was the one who saved everything. She put all those snipped newspaper articles into a box and tucked them into storage. Years later, I'd find them mingled with mementos from our wedding. The extra invitations and the napkins printed with KATHY AND SCOTT and the little packets of rice for guests to toss were saved along with the news stories. I left all of this behind me in Boca Raton. I had a fresh start in front of me, and I didn't need to tell my new friends and coworkers about the man who tried to kill me as I slept soundly in my bed in the Chi Omega sorority house. People in Athens, Georgia, were meeting Kathy Rubin, wife of Scott, a doctoral student at the University of Georgia, and mother of Michael. They were meeting Kathy, the new purchasing manager at the local hospital. I was Kathy, the neighbor who just bought the Tudor-style house down the block. It was almost like when I returned to school after surviving lupus, and my cousin Cynthia convinced Mama to let me wear light, teen-appropriate makeup and use tampons. Back then, I just wanted to be the normal girl from study hall or biology lab. Now

Kathy's going-away party at the hospital, May 1989.

I felt the same desire for normalcy again. To be a normal wife and mother who had pictures of her family on her desk at work and barbecues on the weekends with neighbors.

We settled into our lives. Scott did well in school, and it was clear he had made the right decision to pursue his PhD. Our biggest adjustment was losing Michael to Florida when he went to visit Simon for the summer. Scott and I missed him terribly when he was gone. The house felt empty without our boy. We missed hearing him make crashing sounds as his toy cars pummeled into each other. Mornings were not the same without him at the breakfast table in his pajamas with a bowl of cereal. The TV didn't blare cartoons in his absence, and I often thought our dog seemed bored. But I have to admit that I was glad for the arrangement during the summer of 1992 when Michael was eleven years old and away in Florida. He wouldn't be home to see me receive yet another death sentence.

(clockwise from top left)

Kathy and Scott's
wedding, July 1989.

Kathy with her parents
and son at her wedding.

Kathy, 1990.

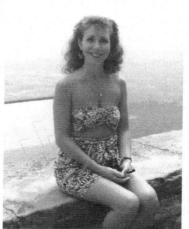

That summer, Scott and I hoped to expand our family. I was thirty-
four years old, and we wanted to have a baby together. I needed to find
an obstetrician-gynecologist who accepted patients with lupus. Given
all the possible complications, not every ob-gyn was willing to work

with lupus patients. I asked friends and coworkers for recommendations and then called different offices to see if the physician would be willing to take me on as a patient. In the summer of 1992, I was able to make an appointment with an ob-gyn who knew I had lupus and was still willing to treat me. My appointment was on the same morning that Scott left for Finland for a monthlong research project for school. He had an early flight, and he came to give me a goodbye kiss while I was still snuggled in bed. I was due at the doctor's office for a nine o'clock appointment, and I was so comfortable in bed that I almost felt like canceling. But we were serious about having a baby, and I promised Scott I would go to the appointment.

The appointment began like any other visit to the doctor's office. I sat in the waiting room and filled out forms. I followed a nurse back to an examination room, where I removed all my clothes and put on a paper gown. The doctor greeted me when he came through, and then began his exam by feeling my neck glands. Those were normal, and he next asked me to lie back and open the left side of my gown for a breast exam. He moved his fingers around my left breast, quickly tapping on the tissue, almost as if he was typing. Then, he stopped suddenly.

"What's this?" he asked.

For a moment, I thought he was being funny, as if he had never seen a breast before and was making a joke. I didn't realize he had found a lump. He kept tapping on the area, trying to make sense of the hard nodule below.

"I don't like the feel of it," he announced.

He moved on to my right breast and then removed his gloves. Apparently, my exam was over.

"Go ahead and get dressed and we'll meet in my office," he told me.

I wasn't sure what to think as I put my clothes back on. I was young, and breast cancer wasn't on my radar as something I should

fear. Mama's side didn't have a family history of early-onset breast cancer, but I couldn't really say much about my biological father's side. We'd had no contact since he had died and his parents tried to take his benefits from my widowed mother. If the doctor asked about my family history with breast cancer, I wouldn't be able to tell him much about my paternal side.

I sat uneasily in a chair in front of the doctor's desk. I felt fine, and I never realized there was a pea-sized lump deep in my left breast. This wasn't like the months before my lupus diagnosis, when I knew I was sick and I didn't have the energy for daily life. I listened as the physician explained that I needed to have a biopsy done. It was possible the lump was a benign cyst or even a benign tumor. There was also a possibility it was a malignant tumor, and they needed a sample of the tissue to test it for cancer.

I made my appointment with the surgeon's office, and my biopsy was scheduled for the next day. Breast cancer in women under age forty is aggressive, and biopsies in younger women are typically prioritized for that reason. The next morning, I found myself in a waiting room once again, filling out paperwork and trying to answer questions about my family history. The same cycle from the day before repeated itself. I followed a nurse to an exam room, undressed, and then watched as the new doctor's face grew concerned during the procedure. Again, I was told to dress and meet the doctor in his office. The lump, I learned, was problematically solid. When the doctor inserted the needle into it, he couldn't retrieve any fluid to test. He was certain the lump was cancer, and I needed to schedule a lumpectomy. Once the entire lump was removed, I would learn my official prognosis and treatment plan.

I left the office overwhelmed with the familiar feeling of dread. From my lupus, I knew what it was like to endure medical pain and discomfort, especially from chemotherapy. I didn't want to revisit that painful time, partly because I associated it with loneliness—all those

days I spent home alone during my chemotherapy, when I was too weak to go anywhere and too fragile to be exposed to any visitors. Those lonely days when the only voice I heard was when I pulled 0 on our rotary dial and listened to the operator answer. But I knew my life was different now, and I wouldn't be alone. I was married and had a child. Even if I went through chemotherapy again, I wouldn't be home alone with only a pot holder–weaving kit or green stamps for company. But my memories were my playbook on how to approach illness, and I remembered intense pain and agonizing loneliness. I didn't want to relive it again, but I already felt isolated. Michael was in Florida, and I hesitated to tell Scott and interrupt his work in Finland. I also didn't want to upset my parents. They had already worried so much about me over the years.

I finally called Scott a few days before he was due home and let him know I had surgery scheduled.

"The doctor found a little lump in my breast," I said, trying to keep my voice steady. I didn't mention that the "little lump" was now the size of a walnut.

Scott was alarmed. "What kind of lump?"

"We don't know yet," I said. This was kind of true.

Scott was upset and wanted to skip the trip to Russia he had planned with friends and instead return home immediately. I told him there wasn't any point in his coming home early, and the flight change would be expensive. He would be home in time for the lumpectomy, and that was all that mattered. I later learned he felt so helpless in Russia that he wanted to buy me an expensive gift to make me feel better. His friends had to talk him out of buying a pricey Fabergé, and they rightfully told him I would be upset if he spent all that money.

Scott and I had a lot to discuss when he returned home. If the lumpectomy confirmed the surgeon's cancer suspicions, then my medical team was recommending a radical mastectomy to prevent the cancer from returning again in the left breast. This would involve

removing my left breast as well as the lymph nodes, inserting an expander, and then giving the expander months to stretch my skin and make room for the implant. I'd have a matching implant put in on the right side. When the lumpectomy revealed I had stage 2 cancer, we had already made our decision to eliminate any future threat of the cancer returning in the left breast.

In the days following the surgery, I had to wait to find out the recommended course of treatment. I knew it might involve chemotherapy, radiation, or both. I didn't want to endure chemotherapy again. I rolled my eyes when I learned it might happen. What were the chances, I wondered to Scott, that I would have chemotherapy twice in my life before the age of thirty-five?

I soon found out that my chance of having chemotherapy twice in my young life was 100 percent. I was disappointed but resolved to be healthy. My oncologist planned six sessions to occur every three to four weeks. I would be done in six months or so, I hoped. We made our plans to the best of our ability. Michael, then eleven, came home from his summer in Florida, and I told him that I was sick but I was going to be better after the doctors helped me. I didn't want him to see me suffer or watch as clumps of hair fell from my head. Overall, I tried to be cheerful and keep my suffering from him. Kids are very perceptive, though, and Michael internalized these new worries. When Scott and I went to the parent-teacher conference at school, his fifth-grade teacher told us that he cried most days because he was so worried about losing me. Michael had been so stoic at home, and we didn't know he was living in fear. That night, I lay next to him in bed and told him that it was good to talk about our feelings and he could tell me anything. He insisted he was fine. Eventually, this proved to be true. My parents came up from Miami while I had chemotherapy. Every weekend, they took him camping with their RV trailer. As an adult, Michael says his strongest memory from this time was "getting to go camping a lot."

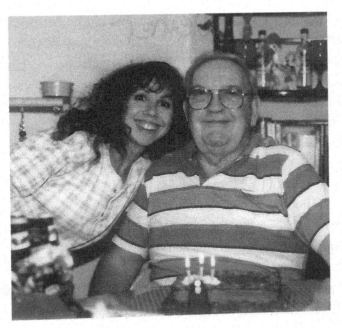

Kathy with Dad Kleiner, Athens, Georgia, 1992.

I had my mastectomy at the same hospital where I worked in purchasing. I was in the hospital for a week while I recuperated, and my coworkers brought me orders to sign and paperwork to complete. They had asked in advance if they could come and see me, and I brightly told them, "You can come in the room if I have red lipstick on." It was cheerful, and I was trying to be upbeat, but losing my breast was traumatic. I felt disfigured, and it was hard to look down or touch my chest and not miss my former self. The empty space under my hospital gown was a constant reminder that I had received my third death sentence. Left untreated, this cancer would have quickly metastasized to my organs and killed me. I was only thirty-four years

old, and I was dealing with the third attempt on my life. It made it seem as though my life would always be in jeopardy. Every ten years or so, a fatal threat materialized, and I had to battle for my life. Lupus at age twelve, Bundy at twenty, and now breast cancer at age thirty-four. It was hard not to look to the future and wonder what could possibly be next for me.

I returned to my baby-step mentality. My treatment plan involved many chemotherapy sessions as well as saline injections directly into the expander to help the skin stretch slowly. I couldn't look at the entire year in front of me and not be filled with dread. And so I took it in small stages, and I focused only on what was directly in front of me. After each chemotherapy session, I brightly told Scott, "That's the last one!" even though there were many more scheduled. But it was the last one for that moment, and I didn't have the next one for at least three weeks. In time, I was soon able to treat my breast cancer treatment like I did my recovery from the attack when I moved toward my small island. After each chemotherapy session, I moved closer to my serene island in the ocean and away from the swirling dark mass behind me. All I had to do was keep going and follow the plan, and I would reach my island.

I was fortunate to have Scott during this time. He was so loving, and he made me feel beautiful and wanted. I needed his assurance because I worried I would no longer be attractive to him with my left breast removed and a bulging expander in its place. He let me know very early on that I would always be beautiful to him, and that he would always be by my side. I don't think he realized how much he helped me. There were some days when I couldn't take my mental baby steps, and Scott took them with me. This was especially true when the expander popped unexpectedly. We had gone to Jacksonville for a football game with friends when the expander burst. I had to return home for another surgery, and it felt like I was taking a step backward. But together, we moved forward.

My chemotherapy sessions were nothing like when I had lupus. I still had the same sense of dread, but I also had Scott by my side. We scheduled my chemotherapy for Friday afternoons. Toward the end of the morning, Scott would pick me up at my office. We'd stop at Chick-fil-A for lunch and then head to the chemotherapy clinic. The clinic had a room set up with about eight stuffed lounge chairs positioned in a semicircle. The patient sat in one of the chairs, and a nurse started an IV to facilitate the chemo drip. The process took hours, but at least the lounge chair was far more comfortable than the metal table in Dr. Lavastida's office.

When I had my chemo in Dr. Lavastida's office, I tasted metal in my mouth and felt a burning sensation as the drugs spread through my body. I tasted fish this time and felt the burning sensation only on my arm near the IV. I think the most significant difference between the two experiences was not feeling alone. Scott always brought games like checkers or backgammon to help the next three hours pass. We played until I became too nauseous to focus on the game. One time, the woman in the recliner next to me began crying during her treatment. She was near retirement age and she was all alone. Scott turned his chair around and began offering her comfort. She told him that her husband had left her soon after her diagnosis, because he didn't want to be bothered with her illness. She had no one to help her when she went home and the nausea took over.

I felt fortunate to have Scott and a house full of people waiting for me when I came home after treatment. Once the nurse pulled out the IV, Scott helped me to the car and then up to bed. He placed a pail by my side in case I needed to vomit and shooed everyone from the room. I needed darkness and stillness to get through those first few hours. Mama and Dad were staying in their RV trailer in the driveway during my chemotherapy sessions. Mama cooked dinner for the family and helped the house to function while I was in bed biting back vomit. My rottweiler Roxanne stayed by my side until I

began to feel better, and then she'd move to the carpeted landing on the stairs. For the rest of the family, seeing Roxanne on the landing was a signal the worst had passed and they could come up and see me.

This went on for nine months. I was meant to have chemotherapy every three weeks, but my white blood cell count was often too low, and the sessions had to be pushed back a few weeks. It seemed like my next session occurred just as I was starting to feel better, and then the whole miserable process repeated. I kept working during this time, and it was rare I took a day off, because I didn't want to lose my job. I also think I kept working because I didn't want my life to stop like it had with lupus. I needed to keep with the rhythm of the outside world so that when the nausea from chemotherapy passed, I could begin living again.

Kathy at work in Athens, Georgia, 1996.

One of my chemotherapy sessions was planned for my thirty-fifth birthday. It was a Friday, and I didn't want to reschedule for a different day, because I needed the weekend to recuperate if I had any hope of being back in the office by Monday. I was pretty sure I had just signed up for the very worst birthday of my life. Scott, however, surprised me when he showed up at my office with a wrist corsage for me to wear during my treatment. I wore it while we had our waffle fries and chicken sandwiches at Chick-fil-A. I thought that was the extent of my surprise, but Scott had something else planned. He had gone that morning to the chemotherapy clinic and tied balloons to my usual recliner. I walked into the clinic and saw my chair was decorated festively. It made me so happy. Those balloons represented something much bigger. I wasn't alone, and I was still living, even if it was in small increments. Even if it was just in baby steps. I was still moving forward.

Eventually, the black swirling cloud was so far behind me that I could no longer see it. My chemotherapy sessions ended. I never lost all my hair, only some, and the missing strands grew back and my hair was long and thick again. My expander was soon replaced with an implant, which I insisted be generous in size. I also had a matching implant put in my right breast, and I referred to it as my "prize" for enduring surgery, chemo, and the expander. My scars faded, and soon, I realized I had survived. The mastectomy meant the breast cancer would never return in my left breast, and I had lived through yet another death sentence.

Scott and I decided to return our attention to adding to our family. I wanted Michael to have a sibling, and I was excited at the thought of having a baby with a loving partner. Scott was the type who would stand in a store aisle with me and help me figure out which stroller

was the easiest to collapse. He would happily wear a baby carrier with our little one on his chest or get up in the middle of the night if I was too tired to bottle-feed. We saw other couples who were pregnant or with a newborn and we thought it would soon be us.

We didn't have a preference for a boy or a girl. If it was a boy, we figured he would look up to Michael, who would be about twelve or thirteen years older. We imagined Michael would show him all his old toys, and it would one day be Michael's turn to act impressed when the little one demonstrated how his Transformer shifted from a car to a crime-fighting robot. But if it were a girl, then that would also be special, and it would be fun to go through babyhood and then childhood for the first time with a little girl.

Mama was not nearly as happy as we were when I told her the news on the phone. I was just coming out of cancer, and the lupus would always be with me. Once again, she shrieked when she heard the news.

"What are you thinking? You are going to kill yourself!" she wailed.

Mama dominated the conversation, so it wasn't until later that I was able to speak with Dad. He knew better than to say so in front of Mama, but he told me he was happy for us and said he would always be there to support what I wanted.

After my oncologist declared me cancer-free, Scott and I began trying for a baby. Soon I sensed I had a reason to buy a pregnancy test. I waited eagerly for the designated line to appear and confirm I was pregnant. We were overjoyed when the line materialized and we realized we were going to be a family of four. Our happiness was short-lived. I lost the pregnancy within weeks, and we were devastated. The loss was layered for me. We lost the future happiness of having a child together, which we had to grieve. I was also distraught because I couldn't protect my baby. I didn't understand why I had the miscarriage, and I often think it's something that physicians can never

Kathy, 1995.

fully explain. This lack of answers can sometimes make a situation so much harder to navigate.

We waited before we tried again. Once again, we saw the same line appear on the pregnancy test, and we began dreaming of our baby. We had hoped the miscarriage had been a one-time occurrence. So many pregnancies end early in miscarriages, and maybe that was what had happened to us. Perhaps we were going to be like other couples who had a miscarriage but were then able to have successful pregnancies. We held on to that hope until I miscarried again. It was clear that I was able to conceive, but my body wasn't able to bring a

pregnancy to term. In this sense, there was so much I had to grieve. I had to let go of the idea of our family expanding, and the sadness I felt in not ever seeing Scott hold our newborn. I also had to cope with the sadness I felt in not being able to protect our babies from the miscarriages. It's a thought that still brings me to tears. I know I have survived all these horrifying events in my life. But those were things that happened to *me*, and that I could handle.

We went through our grief quietly and alone. Young families today are much more open about miscarriage than we were in the early 1990s. I've heard how families who have experienced loss and then go on to have a successful pregnancy or adoption call their child a "rainbow baby," because like a rainbow, the child appeared after a storm. I like that. I think it's important for these parents to know they aren't alone in their grief, and I think it's wonderful for them to celebrate their happiness and hope for a future. But Scott and I realized we had little chance of having a rainbow baby of our own. It was just too painful to continue to try. We agreed to accept that this was our journey in life, and we decided to "adopt" a motorcycle and a boat we named *Serenity*.

Our journey was changing course. Scott graduated with his PhD and did three years as an assistant professor at the University of Georgia before being offered a position in Alabama. The three of us moved to Mobile in 1997, where Michael finished high school. When he moved away for college, Scott and I decided one time to visit him on our motorcycle. Anyone who rides knows that it's imperative to wear leather jackets and pants or chaps for safety. In the event that a rider is in an accident or the bike drops, the leather will protect the skin far better than regular clothes. We showed up on campus wearing our leather gear. I had on a black leather jacket that had long black-and-white fringe running under the sleeves as well as some on the chest. My chaps were matching and also had fringe along the leg. Scott had on a black leather jacket and chaps. We thought we looked

Kathy and Mama at Michael's graduation, Mobile, Alabama, 2000.

good. Michael was mortified, not so much with Scott but with me. As soon as we arrived, he asked me to take off my jacket and chaps and hide them behind his sofa so his friends wouldn't see. I then received a bit of a lecture about acting like a "normal mom." It seemed so important to him, and I didn't want to embarrass him. I took off my chaps and jacket, rolled them neatly, and placed them behind the couch as requested.

By 2005, Michael had graduated college and was working. He planned to join his grandfather's building supply firm, but his grandfather expected him to gain experience elsewhere before he came aboard. Simon had left the firm years prior, and it would be an excellent opportunity for Michael to one day make his own mark. Of all places he could work, Michael opted for a large hardware store chain and started in its lumberyard. Of course, he didn't know my story or how I worked in a lumberyard the summer after my attack to help myself learn to face men again. It just felt so eerie to think that both of our lives' paths had wound us through a lumberyard at one point.

Scott and I also had a new opportunity. In 2004, he accepted a faculty position at Louisiana State University. Although the main campus is in Baton Rouge, Scott would be at the medical campus in New Orleans. We found an amazing two-bedroom house in the heart of New Orleans, not far from the French Quarter. The house was 130 years old, and the locals called it a "shotgun" house. A shotgun house is long, narrow, and straight. If you open the front door and back door, you could fire a shotgun from one end to the other. Our house was about sixteen feet wide and seventy-five feet long. It had once been a printing shop, and we could still see faded ink marks in the original wood floors. The wood was bargeboard, meaning it came off an old barge that had once worked the Mississippi and was dismantled for scrap wood. It was charming, and our street was exactly like the New Orleans I had admired in photographs. We had just settled in and were enjoying our first year in the Big Easy when weather forecasts began warning of a developing hurricane they dubbed "Katrina." In just a few moments' time, we had to decide whether it was time to stay or to go.

Kathy driving the boat, Mobile, 2002.

20

EVERY FLORIDIAN HAS their own history with hurricanes. Some can tell you about the one that washed out their favorite pier. Others can describe the time they lived without electricity for a week and how the heat felt unbearable. Many Floridians also have their own hurricane preferences. If the government isn't ordering evacuations, some people prefer to hunker down and ride out the storm. Others get in their cars and head north as soon as the forecasters start predicting a nasty storm. By the time we moved to New Orleans in 2004, I had spent most of my forty-seven years in Florida. For me, hurricanes were typically something you could endure inside your house with a couple of flashlights, bottled water, and enough reading material to entertain you until the power came back on.

In August 2005, we heard about Hurricane Katrina swirling over the Gulf of Mexico. Forecasters predicted it was going to directly hit New Orleans. Initially, Scott and I planned to stay and ride out the storm at home, like we had done so many times before in Florida. We began questioning our decision in the early hours of Sunday, August 28. The National Weather Service warned of "catastrophic" damage to New Orleans. Around four o'clock in the morning, we decided to

accept Marilynn's invitation to wait out the storm with her in Tyler, Texas. We thought we'd be back in a few days' time, and we packed small bags with essentials. We had three dogs at the time—a Doberman puppy, a ninety-pound rottweiler, and a teeny Yorkie. We all crowded into our two-door Jeep Wrangler, the type with a cloth roof that was better suited for a day at the beach, not fleeing a hurricane.

We started on Interstate 10, heading west and north toward Tyler, Texas. So many other cars were also trying to escape the approaching storm, and we crawled slowly away from the city. The opposite side of the highway was empty, which made the landscape seem ominous. The city was in trouble, but at that moment we didn't appreciate the extent to which our new hometown would suffer in the coming days. We focused on getting to Marilynn's, and a drive that normally took us about six hours lasted ten. The dogs, to their credit, were quiet and calm. I made a comment to Scott about how nicely they were behaving, and he warned me not to jinx it.

Marilynn lived in a two-bedroom, one-bathroom apartment with her two dogs and three large turtles. It was a full house, but we figured it would be manageable because we would only be there for a few days. Scott and I took the second bedroom with our dogs. Marilynn didn't have cable television, and she only had a few fuzzy local channels. On Monday morning, Scott went to the nearby Walmart, where the television aisle had dozens of screens playing nonstop coverage of the storm hitting New Orleans. He found a nearby chair and watched hours of reporting. By the time Hurricane Katrina reached the coast, it had weakened to a Category 3 storm. It wasn't the worst to hit the city, and we continued assuming we could head back within a few days.

As the day progressed, the news reports became more alarming. Report after report detailed different levee walls failing. Floodwaters surged into the cities. In some parts, the waters rose one foot every ten minutes. People who had remained in their homes scrambled to their attics or rooftops. The next morning, Scott went again to the

Walmart electronics department to watch the news and hear of the growing death count. Hospitals and nursing homes were the first to report hurricane-related deaths. We didn't yet know about the people who were helpless in their homes and died as the floodwaters filled their rooms. We hadn't heard about the corpses floating down the flooded streets. As the days passed, we came to understand that 80 percent of our city had flooded. So much was destroyed.

Within the week, we realized we were not returning anytime soon. City officials still needed to evacuate the residents who were stuck in their homes or at the Superdome, a large arena, or the convention center. Both had been used as a shelter of last resort, and both quickly turned into a hellhole. They were hot and lacked electricity and basic services to provide for the forty-five thousand people stuck inside. At the Superdome, parts of the roof had been damaged during the storm, and the arena was uninhabitable. The people inside were stressed, and there were reports of fights breaking out as well as unprovoked attacks. Relief organizations had to get to these people first before anyone could consider returning.

Next we heard about the civil unrest in the city. The news showed people looting stores and setting fires. Some of these events might have been sensationalized by news teams, but we were hundreds of miles away in Texas, and we weren't in the position to evaluate the fairness of the reporting. As we assessed the situation, we realized we might be locked out of New Orleans for several weeks. In that first week, the floodwaters were still deep—as much as fifteen feet in the worst spots—and the city was in the midst of a humanitarian crisis. We couldn't go home, but it also wasn't reasonable for us to continue crowding into Marilynn's apartment.

Marilynn worked as a home health aide for elderly and infirm people. She worked three to four days at a time and stayed with the client in his or her home. When she wasn't working, she was home for weeks at a stretch. We couldn't continue to inconvenience her.

We also needed to find a better situation for ourselves. She had three red-eared slider turtles living in the bathtub. Anytime I wanted to take a shower, I first moved these large turtles into a plastic tub she kept on the floor. I had to sanitize the bathtub and then shower while the turtles watched and waited for me to finish. Once I was done, I refilled the bathtub and airlifted the turtles back into their home.

We decided to drive north to Nashville, where Michael was working. We crowded back into the Jeep, and Scott used washable window paint to write KATRINA BLOWS and KATRINA REFUGEES on the windows. We learned something interesting during that drive to Tennessee—Americans had strong compassion for Katrina victims. So many people had watched the news with a feeling of helplessness when they saw images of stranded residents on their roofs or people wading through chest-high water. Americans were eager to help the hurricane victims, and their kindness materialized in so many ways. Our first experience with this kindness happened while we sat in traffic on the highway. There had been some sort of accident, and we were stuck. A car pulled up next to us and the driver motioned for us to follow him so he could show us a shortcut. Scott kept a safe distance as we drove up the exit ramp and began a series of turns through back roads. Fifteen minutes later, we started to worry, and then we came upon the highway again. The other motorist had taken us around the accident and brought us back to open lanes. He saved us hours of aggravation.

We found a lot of kindness along the way. But we cringed when we overheard other Katrina refugees expecting special treatment. One time, we were in a diner and overheard a couple in another booth asking why their meal wasn't comped. They argued that they were Katrina refugees and other restaurateurs had waived their bill. Scott and I sat in our booth fuming. Yes, we were displaced, and no, that didn't make us special. We were the lucky ones—almost two thousand people died during or after Hurricane Katrina. We didn't have to hole

up in the Superdome or watch corpses float past our front door. Why be so entitled? We felt embarrassed because this couple held the exact same status as us—hurricane refugees shut out from home—and it felt in some way as though they were representing all of us. After the couple left, Scott approached the manager and apologized on their behalf, assuring him we weren't all like that.

Many hotels were reimbursed for housing hurricane refugees, especially in those early weeks before the Federal Emergency Management Agency (FEMA) designated specific hotels for Katrina victims. We were able to stay at a W hotel in Nashville for free with our three dogs for about a week. We were so appreciative, because we were able to have a clean and safe place to stay. We toured the city as if we were there on vacation and saw the famous music venues. We had as nice a time as possible, but the floodwaters in New Orleans were slow to recede and the city was submerged. After about a week in Nashville, we realized we had to find a short-term living arrangement. Scott's parents opened up their home to us in North Carolina.

We stayed with Scott's parents for six weeks in Maggie Valley, a small town near Waynesville. Scott's father was a retired podiatrist and one of the nicest people I've ever known in my life. We were glad to be with them, and the situation was as good as it could possibly be, although we felt very disconnected from our real life. Scott's parents didn't have the Internet in their mountain home. Scott regularly went to the Waynesville public library to use the computers so he could check emails from LSU. The university was telling faculty its campus was still closed, and it would let the campus community know when it was safe to return. Scott also scoured news websites to learn how the disaster relief was progressing. We were anxious to know whether our house had flooded, and we had to assume it did. We wondered how badly it was damaged and if any of our possessions had survived.

I didn't have any of our banking information or the account numbers for our mortgages, credit cards, and utilities. I called each of these

companies and was assured that Katrina victims would have a grace period with no payments due and no late charges. Unfortunately, I would later learn this was not true. The customer service representative promised me our accounts were fine, but late fees and penalties were actually amassing and doubling. It was 2005, so we didn't have any online banking or bill pay through which I could just send payments. I felt like everything I needed to solve this problem was miles away in a house I could not access.

After six weeks with Scott's parents, we learned that FEMA was going to house us in a hotel in Meridian, Mississippi, a town about ninety miles east of Jackson and an hour away from New Orleans. We herded the dogs back into the Jeep, gave Scott's parents long hugs goodbye, and drove south. Meridian was interesting, because there were a lot of other hurricane refugees who were being housed by FEMA in hotels. There were also relief workers coming through, along with utility workers. The utility workers were the most important to us, because they had information. They could tell us where the floodwaters had receded and whether the lights were back on. New Orleans was beginning to allow residents in certain zip codes to come back to assess the damage and collect valuables. We were in the Upper Ninth Ward, and we had the same zip code as the Lower Ninth Ward, which was one of the most damaged areas of the city. We weren't getting called back anytime soon.

We knew the famed French Quarter in the Fourth Ward had not flooded. We wondered if we had been as lucky. One day, Scott went to a Books-A-Million and saw a neighbor who had lived across the street from us. He heard that we hadn't flooded, and the water had stopped two blocks from our house. Of course, this was secondhand information, but we had reason to be hopeful. We began discussing the possibility of driving back to New Orleans and trying to access our house. School was going to start again soon for Scott. During all his time with LSU, Scott had been at the university's medical center

in New Orleans. Due to the flooding, he was temporarily relocated to the main campus in Baton Rouge, which was a ninety-minute drive each way. Scott and I needed to be back in Louisiana anyway, and we figured we would try to see the house. We wouldn't know for sure if there was damage until we saw it.

The National Guard didn't stop us when we entered the city. We had heard of people getting stopped and told to go back in the direction they came from. There were Humvees rolling through the streets with armed soldiers peeking out the top. We were immediately struck by how our city now resembled a war zone. It felt so menacing, and out of instinct, we avoided the soldiers whenever we saw one headed in our direction. There was also barbed wire blocking off sections of the city, and that made it seem like a city under siege. There were a few times when one of us had to get out of the Jeep and move a seven-foot section of barbed wire so the other one could drive through. The city smelled different too. As soon as we crossed the bridge on I-10, we drove into the stench. It was like a mixture of rotten eggs, sour milk, and decay. There was little breeze and the smell hung in the air. I agreed with people when they said it smelled like death.

Eventually we reached our house on Louisa Street. Our neighbor had been right. We hadn't flooded. Still, we weren't supposed to be back, because we didn't have clearance from the city to return. We snuck into our home to assess the damage. The first thing we noticed was the odor. Our house hadn't flooded, and we got home soon enough that we didn't have any mold. But the smell was putrid. The refrigerator, of course, was a main source of the foulness. It was emitting a horrible stench of rotting food. The rest of the house had a hot, stinking manure smell. Other residents told me their homes and the city smelled like death. To them, that was what the decay smelled like—death.

Eventually we could tell when someone on our street had returned because they dragged their refrigerator to the curb. But for the first

few months, I was alone, both in our home and on the block. In Baton Rouge, LSU arranged for a cruise ship to dock on the Mississippi River to house faculty who couldn't return to their homes. I was invited to join Scott in his cabin, but the ship would not permit our dogs. We had three. I couldn't leave my dogs alone or bring them to a shelter. We decided I would stay in the house with the dogs and Scott would come down on the weekends. We weren't able to communicate much during this time, because although Scott brought me a charged phone on Fridays, it was typically dead by Sunday. Our landline was out, and it was a weird, primitive existence in which most of the days blurred together.

We thought the electricity would be back within a week or two. That's why I didn't return to Meridian and the FEMA hotel. I didn't want to be more than two and a half hours away from Scott, and our second car had been destroyed in the storm when a neighbor's chimney toppled on it. Scott would have the Jeep, and I would be stuck in Meridian in a motel without a car. It wasn't exactly a walkable area, and I didn't want to be confined to the hotel for days at a time. Being without electricity in my own home seemed better, especially because I anticipated it would just be a few weeks. I was wrong. It was months.

During that time, one of my main activities was hunting down the Red Cross trucks. They brought food, bottled water, dog chow, and other needed supplies. I did this for the five months I lived alone in the house without electricity. One time, I was thrilled when a Red Cross worker handed me a warm hot dog. I rarely had warm food in those months, and I was so excited to have a hot meal that I sat on the curb and ate it right away. I had to shake my head at the situation. I was freshly forty-eight years old and I was eating a hot dog on the curb like a child who had just scored an ice-cream bar from the ice-cream truck and couldn't wait to eat it. And I was one of the lucky ones.

I learned more about other people's Katrina experiences as the city began to open. I worked at a small gallery, and one of the delivery

men, "Bubba," told us about his time in the Superdome. He saw the bodies of the three men who died, and since there was nowhere to put them, people just put a sheet over their corpses and let them be. He recalled seeing bloated dead bodies float down the street, and I could tell he was very traumatized by what he had endured. After our power came back on in March 2006, we invited him to stay in the coach house behind our main house. It wasn't much, but it was a place where he could stay until his life got back on track.

Allowing someone to stay in our coach house was a pretty typical move during those times. The news always covered people looting or setting fires, but residents were very generous with each other. If you saw someone trying to haul their fridge out to the curb, you put on a good pair of shoes, grabbed a sturdy rope, and went out to help them without being asked. We were all in a collective misery. For months, none of us had power, and the vast majority of people had to clean up water damage. There were people who were rebuilding their homes after losing everything, and there were plenty of people struggling to make their lives what they were before the storm. It was the first time in my life that I was part of a community tragedy. All my previous hardships were endured privately. My lupus and cancer affected only me, and I never took comfort in support groups, particularly after Mama introduced me to that one with dying women. And the attack at the Chi Omega house wasn't something I experienced with the other victims, because I went down to Miami to heal and then never returned. Hurricane Katrina was the first time I experienced collective misery. I wasn't the only one eating a hot dog on the curb or wondering if her house still faintly smelled like a porta potty. We had varying levels of misery, but we shared the upset of having our city and lives disrupted.

It took years for the city to rebuild, and some people never fully recovered. Scott and I had to climb our way out of a mountain of debt that accrued from six months of late fees. Our credit card, in particular, was the worst. After telling us not to worry until we were resettled, our credit card company charged us steep fees, and then, unbeknownst to us, gave us an inflated penalty interest rate. Before Katrina, our monthly payment was $200. After the hurricane, it soared to $800. Our utilities and home loans did the same. We had to dig our way out of debt, and we felt derailed. I had a playbook, however, for how to live in these moments. It wasn't the first time my life had been suddenly knocked off course, and I knew that rebuilding would take time and happen in slow increments. And then one day, I would look back and realize my struggle was over.

21

I N 2018, WRITER Tori Telfer reached out to me. She thought my story on surviving Ted Bundy would be a good fit for *Rolling Stone* magazine. I was surprised that anyone would be interested in what I referred to as "my little story," but I agreed to do the interview. Tori made it easy. She is compassionate and friendly, and I loved how she used the little details to bring the story to life. After the attack, I felt like she took readers to my parents' kitchen, where Marilynn tried to puree different foods for me while my mouth was wired shut. Both Scott and I were delighted with the article. Michael, however, was shocked. He didn't realize I had been attacked by Ted Bundy, the serial killer. He called me after he read the article. His voice was shaking and I could tell he was upset.

He kept repeating, "You were so normal."

Michael knew from the time he was a little boy and he felt the scar tissue on my jaw that something bad had happened to me. He knew someone had hit me, but he didn't fully know who or how. He had pledged one night when he was a toddler and I was putting him to bed that he would never let anyone hit me in the face again. But I soon met Scott, and I think he realized that in Scott, we both had a

protector. He didn't have to worry about being the little man of the house, and I think he was able to forget over time that someone had once harmed his mother.

I didn't keep the Bundy attack from Michael. It was never a secret. But I also didn't offer up any stories related to the attack. Every year on January 15, I didn't say anything to my family or bring up Margaret or Lisa. And after Bundy was executed, we were able to move forward without him popping up as a painful reminder through media interviews or stories about his latest court petition. It's not to say that these things didn't haunt me, because they did. I just stopped them from haunting my son's childhood. He was thirty-seven when he finally learned the full story. I think he was overwhelmed by the violence I survived and the recovery I endured. But he also knew that I had found a lot of peace and happiness in my life.

Michael was a big part of my happiness in life. During that phone call, as he kept repeating "you were so normal" he brought up the pool parties I hosted for his birthday and other things I did to make his life as ordinary as possible. To me, this was one of my greatest accomplishments in life. Bundy was on a sick and twisted journey and he dragged his victims down the path. After I survived the attack, I dug in my heels so that he could pull me no farther. I didn't ask for this journey, and I was going to forge my own way forward. It took many years of baby steps, but I eventually got where I was going. Michael was never haunted by visions of Bundy as a child or a young adult. He never felt helpless with rage because he couldn't avenge the man who had hurt his mother. That was me fighting back so that Bundy could not pull me or my son in with his evil. Bundy's journey was about death. Our journey was about healing and life.

There was one reoccurring struggle, however, that has never left me: the damage to my jaw. Between 1978 and 2016, I had somewhere between six and eight surgeries to stop the pain that Bundy inflicted. I can't remember whether it's been six or eight, I just know I've had at

least half a dozen and I will likely have more in the future. The attack left me with temporomandibular joint disorder (TMJ). Cartilage never grew back properly between my jaw joints, and eventually the bones rubbed together. Each surgery was meant to provide a buffer between the bones, but eventually the cushion rubbed away. By 2016, it was so painful that I couldn't open my mouth to take even the smallest, softest bite. I had a surgery in which a piece of muscle was placed as a cushion between my jaw joints. The surgeon went behind my ear and cut along my hairline so I wouldn't have a visible scar. He then peeled back my skin and worked directly on each of my jaw joints. The latest surgery should last me a few years, but I can feel the changes starting to take place. In the coming years, the muscle will wear down and the bones will return to painfully grinding together. I would have none of this if Bundy hadn't attacked me. And it reminds me that the attack will always be with me. I have moved on, and I have baby-stepped my way from the darkness and toward the light. But the violence he inflicted remains deep within my bones. The scars and the flare-ups of pain will always be part of my life, reminding me that Bundy never fully left me.

I've had another reminder in the past few years. Bundy victims and their families have had to contend with a resurgence of interest in Bundy. There was a Netflix biopic starring a handsome actor as Ted Bundy, as well as a few documentaries. I always felt the victims' voices were missing in these productions. The stories were about Bundy and his madness, and the victims were shadow figures. They blurred together until they were indistinguishable, and that didn't sit right with me. It was also terribly unfair that the legacy of Bundy remained distorted. The 1970s idea that naive girls had followed Bundy into his car remained even though there were only a handful of known instances of women agreeing to follow him when he said he needed help. There are many ignored accounts of women saying they met Bundy and felt uncomfortable and found him to be weird. Why have these women been silenced in favor of a false narrative?

I felt like it was time that I spoke up. The narrative had long been distorted, and it was time someone correct the record. I am one of the few known Bundy survivors, and I felt I had the strength to speak up. So when the producers of *48 Hours* contacted me for an interview, I agreed to do the show. Both Scott and Michael were also willing to give interviews, which I greatly appreciated. I did, however, have one major request for the producers. If I was going to give an interview and travel back to Tallahassee, I wanted to see Sheriff Katsaris. He had battled Bundy with such fierce determination, and he had my admiration. Most importantly, I wanted to let him know that I was well. He had seen me on the stretcher after the attack and he figured I would die from my injuries. By December 2019, I was a grandmother who had lived many happy decades. I wanted him to know that I hadn't just survived. I had lived.

Kathy and Scott with grandson
Edward, Naples, 2015.

Kathy and granddaughter
Samantha, Naples, 2020.

The producers arranged for Sheriff Katsaris and me to meet at a coffee shop in Tallahassee. I hadn't seen him in almost forty years. I was twenty-one during Bundy's trial, and now I was just days away from my sixty-second birthday. Ken was in his thirties during the trial, which made him about the same age as Bundy. I think that might have been another reason Bundy felt so enraged by Ken. He didn't like being dominated by someone in his age group. In hindsight, it's amazing the news media missed the comparison. By the late 1970s, Ken was a county sheriff with many years' experience working in law enforcement, and held both a master's and bachelor's degree in criminology. He taught extensively at police and state trooper academies and developed the criminal justice associate's degree program at the Tallahassee community college. He published, presented, and consulted. He also took any training course available to him.

Bundy, in contrast, was in his early thirties and had no real work experience. He worked on a few political campaigns short term, but he was truly a drifter. He had a bachelor's degree, but failed twice in his attempt to get a law degree. He stole to furnish his apartment, and he dined out with stolen credit cards. He had no credit, and he never rented anything bigger than a single room in a boardinghouse. And yet he was supposed to be a brilliant legal mind who, according to the judge in the Chi Omega trial, would have been well suited to practice law in his courtroom if he hadn't murdered Margaret and Lisa? Sometimes the fiction that surrounds Ted Bundy is so insane it's hard to believe it was made up. Ken never bothered with the false accolades the media gave to Bundy. He just wanted to see him put behind bars permanently. He wanted to know that the man who brutally broke into the Chi Omega house and then the duplex on Dunwoody was brought to justice.

Ken and I recognized each other immediately in the coffee shop. We hugged each other tightly and didn't let go for a very long time. We talked for hours at a table. I thanked him for the kindness he had shown my parents. We lost my dad in 2004, and then Mama in 2011. I know that if they had been at the table with me, they would have thanked Ken for relentlessly pursuing Bundy, and for being so considerate to them along the way. Ken answered their questions and tried to keep them informed of a winding process they knew little about. I also told him how I had thought about him so much over the years.

He told me he remembered being called at 3:30 AM and hearing, "Sheriff, wake up, we have an incident." He arrived at the Chi Omega house in time to see the paramedics carrying out my stretcher. He saw my split face and blood-drenched nightgown and told me he thought, *Poor thing, I don't think she will live.* Ken was still at the Chi Omega house when the emergency call came from the duplex on Dunwoody. The victim's housemates had found her in bed, bloody and unconscious. Ken told me that in that moment he thought, *What are the chances this is the same perpetrator?*

It was amazing to hear his thoughts on the investigation and the trial for the first time. It was wonderful to finally speak with someone who was as personally invested in the case as I had been. The producers eventually shooed us from our table. They wanted us to visit campus and return to the Chi Omega house for the first time. Ken and I drove in the same car, and we held hands the whole way. It was so comforting to see him again, and I don't think either of us wanted to let go. When we approached the Chi Omega house, we found it had been completely renovated. The house had been painted a bluish gray, and beautiful columns were added to the front. All the windows had been reconfigured. The balcony over the door had been removed, and a long balcony had been added to the second-floor bedrooms. It looked beautiful, but I didn't see the lovely home in front of me.

In my mind, I saw Chi Omega as it had been in 1978. Ken said he experienced the same. The house in front of him was still the same place where two women were murdered on a cold January night and another two were nearly beat to death. The place would always be memorialized in our minds as it once was. As we stood at the house, an ambulance came blaring down the street. It felt eerie to hear the sirens and see the flashing blue and red lights. We waited for the ambulance to pass, and then we looked at each other knowingly.

———————

Around the same time I filmed the *48 Hours* interview, I also appeared on Tori Telfer's podcast *Criminal Broads*. The podcast typically tells captivating stories about, as Tori puts it, "women on the wrong side of the law," but she occasionally does episodes about "crime fighting broads." She featured my story and how I not only survived the attack but also testified against Ted Bundy. Soon after the episode aired, my coauthor Emilie listened to it as she slogged through Chicago-area traffic. She met Tori when they sat on a panel for a writing conference called "Murder & Mayhem in Chicago" in March 2019. They instantly became friends after the conference organizers showed them a room filled with stacks of leftover books that had gone into attendees' tote bags. They were told to take what they wanted, and they bonded as they gleefully loaded several tote bags.

Emilie found my podcast episode compelling. She was taken with how I described in great detail the comforter in my Chi Omega bed-room. To her, it signified that I loved the little things in life, and she liked that about me. And because her mother-in-law is from Cuba, she liked that I was Cuban. We were a generation apart, but she saw that our worlds overlapped and she thought she could help me tell my story.

Emilie emailed Tori and said that if I ever wanted to write my memoir, she would be glad to partner with me. We connected in the

summer of 2020 and talked about what this project would entail. I also talked with Scott about what this project would mean. I had done some motivational speaking about my experiences as a serial survivor. But I sometimes had trouble thinking that anyone would be interested in "my little story." I realized, however, that it wasn't about me. I was a representative of the dozens of women and girls who were attacked by Ted Bundy. My book would give voice to women and girls who were brutally taken from this world by an evil man. And I would remind readers that these women were innocent and had done nothing wrong. They weren't naive girls who followed Bundy into his car. They were victims who were attacked in their beds or hit on the back of the head while they walked across campus. A few did agree to help him when he asked, and one was told he was a police officer. Several were hitchhikers. They still did nothing wrong. They were beautiful, every last one of them. They deserved to live. Bundy does not deserve to live on in the collective memory as a charming and brilliant man when he was neither.

I told Emilie I would do the book, but I wanted to incorporate as many victim stories as possible. I wanted her to create a time line that matched Bundy's story against my own and weave in stories of the lives he interrupted. I wanted readers to see that Bundy didn't charm—he harmed. I also agreed to do the book if I could do one thing at the end: address the reader directly. I wanted to give encouragement to everyone for whatever they are going through.

I have survived childhood lupus, a serial killer, and stage 2 breast cancer at the age of thirty-four. I never accepted that these bad things should be happening to me, and I never gave in to the darkness. Even when my progress was slow, I took steps away from the darkness so that I could rebuild and live again. For readers who are suffering, whether that is from violence or illness, I want you to know that I feel your pain and there are others who do as well. Even if you are bald, alone, and ready to dial 0 in the hopes the operator will keep

you company, please believe that others know your hurt. And in that sense, you are not alone.

I was saved on that cold night in January when the light shone in my room. The light in the dark stopped Bundy from murdering my roommate and me as he intended. It was the only time in my three death sentences that I had such an obvious savior. With lupus and with breast cancer, I didn't have a defining moment that ended the attack on my body. It took time to fight the disease, and then it took time to heal from the battle. Please know that your own battle might not have a defining moment as to when the tide is finally turning in your favor. You might not recognize it in the moment, and you might feel like giving up. Give yourself some time to take those baby steps away from the darkness. Seek help if you need support in taking those baby steps. And when you're ready, turn around and look back to see how far you've come. That might be the moment that you finally see the light in the dark.

ACKNOWLEDGMENTS

THE AUTHORS WOULD LIKE to begin by thanking Tori Telfer. In 2018, she interviewed Kathy for *Rolling Stone* and reintroduced Kathy's story to readers who still remembered Ted Bundy's name but likely forgot about most of his victims. Tori also interviewed Kathy for her podcast, *Criminal Broads*, which is where Emilie first learned of Kathy's story. Tori's vivid narrative abilities made Kathy's story so compelling that Emilie was prompted to ask for her email address. Thank you to Tori for the introduction, friendship, and support.

We have started referring to the many people who helped us in this process as "Team Kathy." We have many people at Chicago Review Press to thank for being members of Team Kathy, including: our acquisitions editor Kara Rota, for taking us on; publisher Cynthia Sherry, for being a champion of underrepresented voices; production editor Devon Freeny, because nothing gets past him and we are grateful; editor Jerome Pohlen for his patience and guidance; publicist Valerie Pedroche for all she has done for us; and sales manager Melanie Roth for all her help. Thank you all for responding to emails that Emilie deemed as "quick questions" and for all the ones

that involved exclamation points because we were excited about something that day.

Emilie would like to give gratitude to the following:

Thank you to Kathy for opening up to me and always being so honest and brave. Your words have proven to be an inspiration, and you are truly a light in the dark. (Hold on, it's a cicada. No, it's on me. IT'S ON ME!!!)

Thank you to the Le Beau, Lopez, and Lucchesi families for all their love and support—especially Adina, who was gracious when I talked about Ted Bundy while we did hair/makeup for her wedding. People asked what I was working on; what was I to say?

Thank you to my canine editorial assistants, Daisy, Sofia, and Gabriela. I miss my late chihuahua Mia, who once had the gall to prance across my keyboard just as Kathy was telling me something very important about the attack.

Un agradecimiento especial a mi suegra, Rosa, porque ella me ayudó con todas mis preguntas sobre la cultura cubana.

Y siempre, a mi esposo, Michael, porque tú eres el amor de mi vida. Y una vez mas, pero este tiempo en español: "Lo escucho llamar en el centro de mi corazón. Tú eres el amor de mi vida. El amor de mi vida." Y como Bomba Estéreo canta: "Somo' dos, somo' dos, somo' dos . . . para siempre."

Kathy would like to give her gratitude to the following:

Thank you to Sheryl McCollum, who first introduced me to the true crime community and then along the way, became my true friend. I also appreciate Rachel Bell and Katherine Ramsland and others from crime conventions who have helped me connect with audiences and

represent the victims of violent crime. Thank you to Em Hammon for her support and interest in my story. Thank you to Art Sears for his ongoing support. Thank you to all the reporters, producers, and content creators who have done stories or posts about me. I appreciate you taking interest in what I refer to as "my little story."

Thank you to my coauthor Emilie, who believed so deeply that "my little story" was a book that would inspire others.

I have so many people in my personal life whom I have to thank for their love and support. Thank you to Holli and Jerry, who became my family when I married Scott and have always been there for us. Thank you to my beloved high school friends, Nora, Tony, Betsy, and Suzy. You all mean so much to me. You have injected your love into me throughout my life and you have made me who I am. Betsy and Suzy, you are no longer with us, and I miss you dearly. I carry you in my heart.

I also carry Mama, Dad, and Marilynn in my heart. It is so hard for me to think that you are all gone. In my mind, I still think of Marilynn in her Texas apartment with those turtles ruling the bathtub. I hope you would have liked the book, and I wish you were here to laugh with me at the parts about Mama being Mama. To my big brother Jack—I love you. I look forward to us laughing about the parts about Mama being Mama.

To my son Michael—you are the greatest joy in my life. I was so lucky to be gifted with a son who grew to be such a strong, focused young man. People often tell me that you are such a good man because of me and Scott. But I think I'm good because of you. And thank you to Ashley. You have given us years of love, support, and amazing family memories. I am so proud of you both, your family, and the life you have created for yourselves. Edward and Samantha, you are my bright lights. I love you all.

Last, thank you to my husband Scott. You are my supporter, my lover, and my everything. I think, more than anyone, I have you to

thank for this book. Before I met you, I had Mama's tendency to keep my feelings to myself. You helped me to open up, to face my struggles and find the words to express how I was feeling. I don't think I could have done that with anyone but you. I wrote several times in the book how it was "easy with you." It was easy for you to be a loving father to Michael. It was easy for you to tolerate Mama. It was easy for you to love me. But I know it's actually not easy for anyone to be as loving a parent and spouse as you are. It requires so much caring and empathy, and a commitment to loving someone no matter what. You did that for me, and you did it so well that you made it look easy. Thank you for helping me to speak up. Thank you for being the support I needed. You always have, and always will, complete me. I love you more.

APPENDIX A

WOMEN AND GIRLS WHO LOST THEIR LIVES TO BUNDY

This is a list of women and girls who were murdered by Ted Bundy, both confirmed and unconfirmed. Bundy felt that murdering a woman was the ultimate power he could have over her. Therefore, victims are organized by their first name, not their death date, so that who they were in life takes precedence over their death. Suspected victims are also included, because even though Bundy claimed he wasn't responsible, he also proved himself a liar.

Anonymous Hitchhiker. Bundy admitted he picked up a fifteen-year-old hitchhiker near Olympia in 1973. He took her to a secluded forest and forced her to take off her clothes. He made her get on all fours and he took Polaroid pictures of her naked, defenseless body. He admitted he put a noose on her neck, raped her, and then strangled her to death. He did not know or reveal her name to investigators.

Ann Marie Burr. In 1961, Ann Marie was eight years old and living near the Bundy residence in Washington when she disappeared. She was the oldest of four children, and her mother woke before sunrise

and realized her daughter was missing. A downstairs window was open, the front door was ajar, and neighbors later reported seeing a young man peering through the windows. As of this writing, Ann Marie's remains have yet to be discovered. Bundy denied murdering her.

Brenda Joy Baker. Brenda was a fourteen-year-old girl from a troubled home in the Seattle suburbs. She had previously run away, and she tried again in May 1974. She was last seen hitchhiking half a mile from her home. Her body was found in a state park. Bundy denied murdering Brenda, but she was seen climbing into a pickup truck, similar to the one he briefly owned.

Brenda Ball. In June 1974, Brenda was twenty-two years old and living in Washington State in an apartment with several roommates. She was a community college student on summer break. She went to a nearby tavern and was last seen in the parking lot speaking with Bundy, who wore a sling on his arm. Her skull was later found on Taylor Mountain, and Bundy later admitted he murdered her. Friends described Brenda as free spirited and fun loving.

Carol Platt Valenzuela. In August 1974, Carol was eighteen years old when she disappeared. Originally from Minnesota, she married in South Dakota at the age of seventeen. She moved with her husband, also age eighteen, to Camas, Washington, a town on the Columbia River. On August 2, she told her husband she planned to hitchhike to nearby Vancouver, Washington. He reported her missing when she didn't come home. The couple had twin boys who were ten months old when their mother was murdered. Her remains were identified that November. During his confessions, Bundy admitted to murdering a hitchhiker in Vancouver in August of 1974, and Carol was suspected to have been the victim.

Caryn Campbell. In 1975, Caryn was a nurse from Michigan who accompanied her fiancé, a physician, to a medical conference at a ski resort in Colorado. She went up to their room to grab a magazine, and although other conference attendees saw her in the elevator bay, she disappeared after walking down the hall. Her frozen, nude body was found six weeks later. Bundy confessed to killing her. Her corpse was so badly decayed that investigators had to use dental records to identify her. Caryn was twenty-three years old. In 1989, a friend from high school wrote to a newspaper and described how Caryn befriended her when she transferred to their school and didn't know anyone. Caryn, the friend wrote, could be cool and detached, yet warm and wild. She was the "vibrant, bright, young woman with the contagious laugh."

Debra Kent. In 1974, Debra Kent attended a school play with her family. She had already seen the production and offered to leave at intermission to pick up her younger brother from a roller rink. Bundy was seen at the high school that evening, and he tried to lure the young drama teacher into the parking lot. She refused to follow him. After Debra left, witnesses said they heard a woman scream in the parking lot. Debra loved drama and dance. She wanted to attend college to be a social worker. She was the oldest of five children and she showed a strong sense of responsibility from a young age. For months, her younger brother hoped she would come home. He created a mental list of things he had done—such as go to the movies or a birthday party—that he planned to tell her about when she came home. While playing catch with a friend, he realized she was never coming back. Debra was seventeen years old. Bundy confessed to her killing and told investigators where to find her remains. Her remains were confirmed by DNA evidence in 2019.

Denise Naslund. In July 1974, Denise was nineteen years old and spending the day at a lake in a state park near Seattle when she

vanished. Denise had been at the lake with her boyfriend, and she left her purse and shoes on their towel when she got up to use the bathroom. It is not known how Bundy abducted Denise, though it's likely she did not engage with him or follow him willingly. Her remains were found on a mountainside along with those of Janice Ott, who also disappeared from the lake that day. Bundy admitted to killing both women.

Denise Nicholson-Oliverson. In April 1975, Denise left her apartment and rode her bike toward her parents' home in Grand Junction, Colorado. She never arrived. Her shoes and bike were found the next day under a bridge. Denise was born in 1950 to Nina and Robert Nicholson. Her maternal grandmother was from Paris, and her mother spent part of her childhood in France. She gave Denise and her sister Renee popular French names. Denise graduated from Grand Junction High School in 1968, and she married shortly after her twentieth birthday in 1970. The couple divorced the following year. By 1975, she was twenty-four years old, dating someone new, and living on her own. She worked as an assembler at a company that manufactured controllers and displays, like the type used on a car dashboard. Before his execution, Bundy admitted he had killed a woman in the area and left her body in the Colorado River. Her body was never found.

Donna Manson. In March 1974, Donna was a freshman at Evergreen State College in Olympia, Washington. She played the flute and had plans to attend a jazz concert on campus. Donna was a bit of a free spirit, and she enjoyed writing poetry. She planned to vacation with her parents during her upcoming spring break. She waved goodbye to her roommates when she left her dorm just before 7:00 PM. Her remains were never found. Bundy admitted he had abducted her from campus, decapitated her, and left her remains on Taylor Mountain.

His confession did not come until right before his execution in 1989, and in 1978 her parents had to suffer through looking at photographs of discovered remains to see if the clothing matched their daughter's. They had to repeat the painful process in 1998. Her body has never been recovered.

Elizabeth Perry. In late May of 1969, Elizabeth and her friend, Susan Davis, were on summer break from college. They spent three nights in Ocean City, New Jersey, and left on a Friday morning before sunrise. Elizabeth was from Minnesota and attended a community college with Susan in Illinois. The two planned to return to Susan's home in Pennsylvania and travel with her family to her brother's graduation in North Carolina. Susan and Elizabeth left the bed-and-breakfast where they had stayed and stopped at a diner for breakfast. Days later, their beaten bodies were found among Jersey scrub pines near the highway. Prior to his execution, Bundy denied killing Susan and Elizabeth. He had attended Temple University at the time and was in the area. He also hinted to other interviewers that he was responsible for the murders. People have long speculated that Susan and Elizabeth picked up Bundy as a hitchhiker. However, it is more likely that Bundy hid in their car while they were in the diner and then pulled out a weapon.

Georgann Hawkins. In June 1974, Georgann Hawkins was almost finished with her freshman year at the University of Washington. She was in her finals week and studying hard to finish the year strong. She took a break from studying to socialize with friends, then she stopped off at her boyfriend's fraternity house to wish him a good night. Her sorority house was just a few doors down, but she never made it. Bundy admitted to knocking her unconscious. She regained consciousness in his car, and in her disorientation, asked if he was her Spanish tutor. He later said her confusion was "funny" when he admitted to killing her.

Janice Ott. In July 1974, Janice was a newlywed whose husband was out of town. She took advantage of the warm weather to visit a lake at a state park near Seattle that weekend. She was sunbathing when Bundy approached her. He lied and said his parents' house was nearby and he needed help bringing his sailboat to the water's edge. Janice agreed to help if he was willing to give her a boat ride. Witnesses saw her pack up her items and follow Bundy to his car. Her remains were found with those of Denise Naslund, who was abducted from the lake that afternoon. Bundy admitted to killing both women.

Joyce LePage. In July 1971, Joyce was twenty-one years old and a junior at Washington State University. She was taking summer courses at Washington State University when she disappeared. In high school in Pasco, Washington, Joyce was one of twelve seniors voted "Most Likely to Succeed." She enjoyed sports, and she played the piano to relax. Joyce had four brothers, and she regularly kept in touch with her family through letters. Before she went missing, she wrote her parents and told them to expect her home in July for the community's Water Follies, an event with a boat show and racing. Her father notified police when she did not come home as expected. Police found that nothing was missing from her apartment or her car. Her remains were found nine months later. Bundy has long been suspected of the murder, although he did not confess.

Julie Cunningham. In March 1975, Julie was twenty-six years old and working at a ski shop in Vail, Colorado. On March 15, Julie left her apartment to meet friends at a local tavern. She never arrived. When confessing to his crimes, Bundy claimed he pretended he was an injured skier and asked her to carry his snow boots for him. He then says he knocked her unconscious and drove her eighty miles to a remote area, where he raped and strangled her. Her body was never located, and the case remains open as of this writing.

Kimberly Leach. In February 1978, seventh grader Kimberly Leach was in class at her junior high in Lake City, Florida, when she realized she had forgotten her purse in homeroom. She received permission to walk across campus to the building where she had left her purse. Bundy saw her alone and dragged her into the white van he had stolen from Florida State University. Kimberly was a shy, pretty, and well-liked girl. Her classmates elected her to the court for the school's Valentine's Day queen contest. She had picked out the dress she wanted to wear for the dance but had yet to buy it. After she disappeared, her father told reporters her mother bought the dress anyway. Two months later, authorities found her body in an abandoned hog shed in a state park. She had been raped and strangled. A court convicted Bundy in 1980, and he was finally executed for the crime in 1989.

Laura Aime. On Halloween 1974, Laura Aime had been staying with friends in northern Utah. She had left school and was working and trying to start an adult life. She disappeared after attending a party with friends. She kept in regular contact with her parents, and they became concerned after not hearing from her for several days. Within the month, her nude body was found by hikers. She had been raped, beaten, and strangled. The killer left a knotted stocking around her neck. Bundy admitted to killing her, although he did not know her name when asked and could not identify her when shown a picture of her during his confessions. Laura had five brothers and sisters. She was seventeen years old when she was murdered, and it's believed Bundy kept her alive for several days before killing her.

Lisa Levy. In January 1978, Lisa was asleep in her bed at the Chi Omega sorority house when Ted Bundy entered through an unlocked door. He beat and strangled Lisa, and then violated her vagina and anus with a spray bottle he grabbed off her dresser. Bundy bit Lisa's buttock and nipple before fleeing the room. Lisa was from St. Petersburg where she

worked at the mall during her school breaks. She was an ambitious and conscientious salesperson. She was also known to be friendly, fun and warm. She was generous to new members joining her sorority.

Lonnie Trumbell. In 1966, Lonnie was twenty years old and working as a flight attendant for United Airlines. She shared an apartment with two other flight attendants, Joyce and Lisa. On a June evening, Joyce spent the night at a friend's house and Lisa and Lonnie went to bed as normal. When Joyce returned in the morning, her roommates had both been beaten in the head. Lisa survived, but Lonnie died from the head injuries. Bundy lived near their Seattle apartment and worked in a grocery store where the women often shopped. Bundy denied the murders, though it should be noted their attack mirrored Bundy's assault at the Chi Omega sorority house.

Lynda Ann Healy. In February 1974, Lynda was twenty-one years old and a student at the University of Washington. She lived in a rental house with four other women, all students. Lynda had the basement bedroom, which she painted yellow. She hung a collage of black-and-white photographs on one side of her bed and an illustrated poster of Seattle on another. Most mornings, she read the "ski report" on the local radio in which she detailed weather and snow conditions. On the morning she was murdered, her roommates heard her alarm blaring and found her empty bed speckled with blood. Bundy had broken into her house, attacked her in her bed, and dragged her body to his car. Her remains were found on Taylor Mountain. Her friends say she was a cheerful and friendly person. She was also a serious student.

Lynette Culver. In 1975, Lynette was twelve years old and a junior high student in Pocatello, Idaho. Bundy admits he abducted her while she was on her lunch break and dragged her to a room he had rented at a nearby hotel. He confessed to raping her before he drowned her in

the hotel bathroom. He dumped her body in the Snake River. Lynette had an older sister, Nancy, who later told reporters how the month before Lynette disappeared, the two walked twenty miles as part of a March of Dimes fundraiser. They received McDonald's coupons for participating, and Lynette still had energy after the big walk. She begged Nancy to go with her, but Nancy was too tired to make the trip. Lynette went anyway and rode her bike to get a free Big Mac. Lynette loved swimming at the local pool, and Nancy described her as a lovable little sister.

Margaret Bowman. In January 1978, Margaret was asleep in her bed at the Chi Omega sorority house when Ted Bundy entered through an unlocked door. He beat Margaret in the head with an oak log and then strangled her with a pair of pantyhose. Margaret grew up in a military family and moved to St. Petersburg in 1973 after her father retired from the air force. She had just turned twenty-one and had returned home the weekend prior to celebrate with her family. She loved to read books, and she was taking courses in interior design.

Melanie "Suzy" Cooley. In April 1975, Melanie was a high school senior just weeks away from graduation. After school, she was seen hitchhiking. A road crew found her body in a canyon several weeks later. One newspaper described her as having "massive blows" to the head. Bundy never admitted to killing Cooley, and as of this writing, the case was still considered open.

Melissa Smith. In October 1974, Melissa Smith was seventeen years old and well liked. She had plans to attend a sleepover party, but she first wanted to stop at a local pizza parlor where a friend worked. The friend had just gone through a romantic breakup, and Melissa went to comfort her. Bundy abducted Melissa as she walked home from seeing her friend. Melissa's father was the town's police chief, and he

had to sign the missing person's report for his daughter. Deer hunters found her nude body nine days later. She had been beaten so badly in her head that her skull had fractured and she experienced multiple hemorrhages. The worst, however, happened to Melissa before she was killed. Bundy kept her alive for about a week and repeatedly beat and raped her. The medical examiner's report detailing her injuries was three pages long—single-spaced. Bundy admitted to murdering her.

Nancy Baird. In the summer of 1975, Nancy was a mother to a four-year-old boy. She worked at a service station in Farmington, Utah, which meant she was often alone between customer visits. Bundy abducted her. Bundy denied killing her, but investigators believe he was responsible. Nancy disappeared during the July 4 holiday weekend, and Bundy had been driving through the area on his way from Salt Lake City to Ogden.

Nancy Wilcox. In 1974, Nancy Wilcox was sixteen years old and walking to the store to buy a pack of gum. The road was dark and as she passed a small orchard, Bundy pulled her between the trees, restrained her, and then shoved her into his car. He brought her back to his apartment and kept her alive for one day. Bundy admitted to her rape and murder. Nancy was a cheerleader at school and also worked part-time as a waitress at a coffee shop. She was well liked by other students and had a good sense of humor. Her mother later told reporters that the family had a good life and Bundy destroyed it.

Rita Jolly. On June 29, 1973, Rita was seventeen years old and living with her family outside Portland, Oregon. She had two brothers and one sister. Around 7:30 PM, she told her parents she was going for a walk. Rita often walked in the evenings, and her parents didn't think this was unusual. Her father went to cut the grass, and the evening seemed typical. Rita was a very intelligent and responsible

young woman. She graduated high school early and was attending the nearby community college. She had done very well in her first year, and her parents described her grades as "nearly perfect." Rita was introverted and preferred to have a few close friends. Her remains were never found. Bundy admitted to killing two women in Oregon in the summer of 1973, and Rita is thought to have been one of his victims.

Roberta "Kathy" Parks. In 1974, Roberta was an education major at Oregon State University. She left her dorm room to meet a friend for coffee on campus. One investigator suspected Bundy hid among the thick lilac bushes and jumped out at her. Her father had had a heart attack earlier in the day, and her family waited a week to tell him she was missing. Bundy admitted to killing her.

Sandra Weaver. In June 1974, Sandra had finished her freshman year at Western Wisconsin Technical College. Along with a friend, she was traveling the country during her summer break. The two stopped in Salt Lake City for several weeks and worked at a warehouse to earn a little money. On July 1, the friend felt too sick to go into work, so Sandra went alone. The warehouse called that afternoon saying Sandra never showed. The next day, hikers found her nude body facedown in a canyon by the Colorado River. She was eighteen years old. Her body was sent home to Wisconsin and buried with a brother, Joseph, who had died at two days old. Bundy mentioned the murder during his confessions, but local authorities did not see a link between Bundy and the murder.

Shelley Robertson. In June 1975, Shelley disappeared from her Denver home. Two months later, amateur spelunkers found her nude body at the bottom of a mine shaft. Bundy confessed to the murder. Shelley was attending community college and studying Spanish. Along with

her classmates, she studied abroad in Mexico. She was twenty-three years old when she disappeared.

Susan Curtis. In the summer of 1975, Susan was fifteen years old and attending a high school student conference at Brigham Young University in Provo, Utah. On a warm summer evening, Susan went to a banquet at the student union and then told her roommate she was headed back to the dorm. The walk was less than two blocks. Susan never made it. Bundy admitted to killing her and told investigators before his execution where he dumped her body on the highway.

Susan Davis. In late May of 1969, Susan and her friend Elizabeth Perry were on summer break from college. They spent three nights in Ocean City, New Jersey, and left on a Friday morning before sunrise. Susan was from Pennsylvania and attended a community college with Elizabeth in Illinois. The two planned to return to Pennsylvania and travel with her family to her brother's graduation in North Carolina. Susan and Elizabeth left the bed-and-breakfast where they had stayed and stopped at a diner for breakfast. Days later, their beaten bodies were found among Jersey scrub pines near the highway. Susan was nude and had been sexually assaulted. Prior to his execution, Bundy denied killing Susan and Elizabeth. He had attended Temple University at the time and was in the area. He hinted to other interviewers that he was responsible for the murders. People have long speculated that Susan and Elizabeth picked up Bundy as a hitchhiker. However, it is more likely that Bundy hid in their car while they were in the diner and then pulled out a weapon.

Susan Rancourt. In 1974, Susan was a student at Central Washington University. On the day she disappeared, Bundy wore a fake sling and asked women on two separate occasions if they would help him carry his books. Both refused. After dark, he changed tactics and hid

in the shadows of a railway bridge and waited for a small woman to pass. Susan was on her way to a meeting for students interested in becoming residential advisers. The job offered free room and board, and because she was one of six children, Susan had to work multiple jobs to support herself in school. She was a biology major and had dreams of attending medical school.

Vicki Lynn Hollar. In August 1973, Vicki was twenty-four years old and working as a seamstress for Bon Marche in Eugene, Oregon. After work, she walked with a coworker to their parked cars in a nearby lot. The coworker reported seeing Vicki get into her car. She was never seen again. Vicki lived with several other women, and she was due back at her apartment to meet one of her roommates so they could attend a party together. Vicki never showed, and the roommate left a note explaining she had gone ahead. Vicki's remains were never found. Bundy admitted to killing two women in Oregon during the summer of 1973. Vicki is thought to have been one of them. People have long speculated that Vicki picked up Bundy as a hitchhiker. However, it is more likely that Bundy hid in her car and waited for her.

APPENDIX B

SETTING THE RECORD STRAIGHT

I N JUNE 1986, three reporters for the *Olympian* in Washington wrote about the possibility that Bundy had murdered more than the thirty women he admitted to at the time. They wrote: "The handsome young man who charmed his way into the confidence of nearly every woman he met was convicted in 1979 of killing two Chi Omega sorority sisters in their bedrooms at Florida State University and of killing Kimberly Diane Leach, 12, his youngest known victim."

Let the record show the newspaper needs to run a correction. Bundy attacked most of his victims from behind or while they slept in bed. He charmed few women. This list also includes survivors (last names omitted) and suspected victims:

Attacked while sleeping in bed or abducted from bedroom:
1. Ann Marie Burr
2. Cheryl T. (January 1978; duplex on Dunwoody; survived)
3. Karen C. (January 1978; Chi Omega; survived)
4. Karen S. (Seattle, January 1974; survived)
5. Kathy Kleiner (January 1978; Chi Omega; survived)
6. Lisa Levy

7. Lisa W. (Lonnie's roommate; Seattle, 1966; survived)
8. Lonnie Trumbell
9. Lynda Healy
10. Margaret Bowman
11. Shelley Robertson

Abducted/attacked from behind:
1. Caryn Campbell
2. Debra Kent
3. Denise Naslund
4. Denise Nicholson-Oliverson
5. Donna Manson
6. Georgann Hawkins
7. Joyce LePage
8. Kimberly Leach
9. Lynette Culver
10. Melissa Smith
11. Nancy Baird
12. Nancy Wilcox
13. Rita Jolly
14. Roberta "Kathy" Parks
15. Susan Curtis
16. Susan Rancourt

Unknown:
1. Brenda Ball
2. Elizabeth Perry
3. Laura Aime
4. Sandra Weaver
5. Susan Davis
6. Vicki Lynn Hollar

Picked up as a hitchhiker:
1. Anonymous hitchhiker, age fifteen
2. Brenda Joy Baker
3. Carol Platt Valenzuela
4. Melanie Cooley

Misrepresented himself as a police officer:
1. Carol D. (Utah, 1974; survived)

Attacked after agreeing to help him:
1. Janice Ott
2. Julie Cunningham

APPENDIX C

HOW TO HONOR THE WOMEN AND GIRLS WHO LOST THEIR LIVES TO BUNDY

TED BUNDY HAS received significant attention in recent years. He's been the subject of movies and documentaries, and the lore that surrounds him diminishes the memory of the dozens of women and girls he murdered. We can work together to minimize these media memorials and instead replace his narrative with remembrances of his victims. Much of this involves correcting the Bundy legacy and changing how people talk about him. A few ways to help:

1. **Direct Bundy conversations into one about his victims.**
 Please consider memorizing the story of one of the victims described in Appendix A. When people talk about Bundy, redirect the conversation toward one of these victims. Give her name, say where she was from, and offer one of the personal facts from the appendix. Tell them how Lynette Culver was only twelve years old and that she loved swimming at her local pool. Only weeks before her death she had been delighted

about receiving McDonald's coupons. Or make mention of how Rita Jolly graduated high school early and was studying at the local community college. People should know that Susan Rancourt wanted to be a physician.

2. **Stomp and discredit the Bundy legacy.** The Bundy legacy has persisted because of a media fascination with serial killers. For decades, entertainment and news media have focused on various serial killers. Each became a character, and for Bundy, that character was an intelligent, talented, and handsome young man who used his charm to trick women into following him. This wasn't true, and it's time to stomp and discredit this character.

 - **Correct people when they call him charming.** This is all myth. Few people were close to Bundy, and the few who knew him admitted he was creepy and struggled in his personal relationships.

 - **Correct people when they call him intelligent.** Bundy struggled to obtain his undergraduate degree, and he took eight years to graduate. He was first admitted to a failing law school, where he performed poorly. He performed even worse when he transferred to a ranked law school, and he admitted later he didn't have the aptitude. He didn't have much to show for himself by the time he was imprisoned in Utah for the kidnapping of a teenage girl.

 - **Correct people when they say he targeted women with long, dark hair parted in the middle.** He attacked most of his victims from behind or while they were asleep. He mostly looked for women whom he could overpower.

 - **Correct people when they say he charmed women into his cars.** This is a misogynistic holdover from the 1970s that needs to be retired. Bundy beat women's heads while they slept or walked unknowingly. Scholars have been trying to make this correction for decades.

- **Correct people when they say he lived a double life.** Part of the Bundy lore was that he was law student by day, serial killer by night, and he moved seamlessly through these two worlds. This lore allows people to feel safe, as if Bundy was a special monster and now that he's gone, no one can ever be harmed again. Bundy didn't actually operate well in daily life. He stole most of his possessions, and he never accrued significant work experience. The truly scary part of his story was how others always gave him the benefit of the doubt because he was a White, middle-class male in the 1970s. Witnesses looked away when he dragged Kimberly Leach into his car or abducted Denise Naslund outside the bathroom at a state park. Men like him had privilege and they could do what they wanted. *That's* the scary part.

3. **Stop people when they make light Bundy's violence.** It's surprising how many jokes about Bundy or his victims show up in social media.

 - **Bundy is not a verb.** On the social media app TikTok, for example, users know their videos will get flagged and removed if they use words like *kill* or *murder*. To avoid seeing their content deleted, they use words like *Bundy* as a replacement verb. Please call users out when they make these choices and ask them to find a new replacement word.

 - **Bundy is not an "effect."** Effects are features on social media apps that allow users to make a video showing them reacting to music or to an animated effect. Some of these are cute, like "which college should I attend" or "which Disney princess am I," and then an automated response reveals the answer. One recent "effect" created a cartoon spinner that hovered over friend groups and then

determined which person would be most likely to get into a car with Bundy. Some users made a video with this effect and then laughed at the results. Please educate others when they use a Bundy-related effect.

4. **Stop people when they blame the victim.** People often blame a victim because it is their way of making themselves feel safe. Caryn Campbell, for example, was described as being distracted from a fight with her boyfriend and thus vulnerable to Bundy's charms. But we don't know if Caryn was distracted. She might have been fully focused on zooming down the hotel hallway to retrieve her magazines from her room and return to the lobby. But what if she was distracted? The only person to blame for her murder was Bundy. She played no part in her own demise. With that in mind, please remind people:

 - **Hitchhiking was common in the 1970s.** Young men hitchhiked; young women hitchhiked. Please remind others to not judge hitchhiking Bundy victims by modern standards.

 - **Social norms were different:** Bundy misrepresented himself as a police officer or first responder on several occasions. Many young women at the time were raised to be deferential to authorities. Any young woman or girl who followed Bundy after he misrepresented himself as an authority was adhering to the social standard at the time. She should not be blamed for his actions.

 - **It's OK to walk alone.** These women were living their lives. They had a right to walk from point A to point B at any time of day or night. They did nothing out of the ordinary. The only person to blame was Bundy.

5. **Don't support fictionalized stories of Bundy or his victims.** Please ignore any film, book, or TV show that claims to be "inspired" by Bundy and his victims. Making up stories about

Ted Bundy does not honor his victims, no matter what a TV producer, book author, or film executive says. It's not fair to use the savage murders of real women for entertainment, and it's not fair that someone would try to profit by recreating these stories.

NOTES

CHAPTER 2

His prime killing years were: "A List of Women Bundy Has Confessed to
Killing," Associated Press, January 24, 1989, https://apnews.com/article
/85640d6b994971c78b6489ba93f462ab.

Even his friend: Ann Rule, *The Stranger Beside Me* (New York: Pocket
Books, 2008), 12.

born on the East Coast in 1946 through *gave him his last name*: Stephen G.
Michaud and Hugh Aynesworth, *Ted Bundy: Conversations with a Killer;
The Death Row Interviews*, vol. 1 (New York: Union Square, 2019), 18.

His aunt told reporters: Myra MacPherson, "The Living Victims of Ted
Bundy," *Washington Post*, January 23, 1989.

As a teenager: Myra MacPherson, "The Roots of Evil," *Vanity Fair*, May
1989, 140–149.

Bundy was an incessant shoplifter: MacPherson, "Roots of Evil."

His mother, Louise: Gene Miller, "2 Faces of Theodore Bundy," *Miami
Herald*, July 30, 1978.

Bundy's postsecondary education: "A Bundy Chronology," *Orlando Sentinel*,
January 23, 1989.

He had to settle for a struggling law school: Anita M. Steele, "History of
the University of Puget Sound School of Law," *Seattle University Law
Review* 12 (1989): 309–321.

He was known for staring at women through *all was well in the relationship*:
 Al Carlisle, *The 1976 Psychological Assessment of Ted Bundy* (Magna: UT:
 Carlisle Legacy Publishing, 2020), 102.
Suicidal callers: MacPherson, "Roots of Evil."
One magazine article: MacPherson, "Roots of Evil."
The first woman he would ever confess: Jill Sederstrom, "Ted Bundy's First
 Known Victim Believes a Random Coincidence Saved Her Life," Oxygen.
 com, October 4, 2020, https://www.oxygen.com/true-crime-buzz/what
 -does-ted-bundy-victim-karen-sparks-believe-kept-her-alive.
In the coming months, nine other women: "A List of Women Bundy Has
 Confessed to Killing," Associated Press.
The law program at Utah was not a good fit: Rule, *Stranger Beside Me*, 12.
Melissa Smith, age seventeen: Mike Carter; "Utah Lawmen Exposed Bundy's
 Horrible Masquerade," *Salt Lake Tribune*, January 29, 1989; Bruce Hills,
 "First Victim Found 1 Year Ago," *Deseret News* (Salt Lake City, UT),
 October 28, 1975.

CHAPTER 3

Bundy's in the Utah State Prison: Will Cannon, "Judge Sentences Bundy to
 1–15 Year Term," *Salt Lake Tribune*, July 1, 1976.
The attempt had happened in: Will Cannon, "Alleged Kidnap Victim Testifies,
 Trial for Bundy Begins in S.L.," *Salt Lake Tribune*, February 24, 1976.
Carol sat cautiously: Cannon, "Alleged Kidnap Victim Testifies."
Bundy went to an area high school: FBI file, Debra Kent, File No. 79-125-1a.
More than a year later: Will Cannon, "Bundy Case Reveals Handcuffs," *Salt
 Lake Tribune*, February 25, 1975.
The evidence mounted: Bruce Hills, "Kidnapping Victim Terrified, Court
 Told," *Deseret News*, February 24, 1976.
He made it over the prison wall: "Bundy Gets Punishment," *Salt Lake Tribune*,
 November 13, 1976.
he was wanted in Colorado: George A. Sorensen, "Bundy Charged in
 Colorado Nurse Slaying," *Salt Lake Tribune*, October 23, 1976.
Caryn was a twenty-three-year-old nurse: "Hair in Car Linked to 2 Slayings,"
 Salt Lake Tribune, April 6, 1977; "Witness Fails to Identify Bundy at
 Murder Hearings," *Salt Lake Tribune*, April 5, 1977.
He ripped off the top layer: Clark Lobb, "Possible Accomplice Tie Probed,"
 Salt Lake Tribune, June 9, 1977; "2 Deputies Quit over Bundy Escape,"

Salt Lake Tribune, June 30, 1977; "5 Coloradans Resign," *Deseret News*, June 30, 1977; "Bundy Claims Silver Lining in Predicament," *Deseret News*, August, 1, 1977; "Bundy Left Alone in Aspen Courtroom Leaps out Window, Escapes into Hills," *Salt Lake Tribune*, June 8, 1977.

By the time police found him: "Bundy to Face 4 Trial Counts," *Salt Lake Tribune*, July 30, 1977; "Back in Courtroom, Dead-Tired Bundy Hears New Charges," *Salt Lake Tribune*, June 14, 1977.

CHAPTER 4

For the holidays: "Colorado Calls Off Search for Bundy," *Deseret News*, January 3, 1978.

In the time he had been at the jail: "Utah Hitchhiker Link to Bundy?" *Salt Lake Tribune*, January 2, 1978.

He didn't get far before: Alex Zorn, "Colorado Man Recalls the Time He Gave Ted Bundy a Ride," VailDaily.com, February 17, 2019, https://www .vaildaily.com/news/colorado-man-recalls-the-time-he-gave-ted-bundy -a-ride/.

The FBI quickly: FBI Vault file, part 2 of 3.

He went far: Rule, *Stranger Beside Me*, 208.

In early January 1978: Stephen G. Michaud and Hugh Aynesworth, *Ted Bundy: Conversations with a Killer* (New York: New American Library, 1989), 20–22.

He assumed a fake name: Theodore R. Bundy v. State of Florida, Initial Brief of Appellant, March 30, 1982, Appeal No. 57, 772, Capital Case Appeal, 2nd Judicial Circuit of Florida.

Nearby at Sherrod's: Theodore R. Bundy v. State of Florida.

Margaret Bowman was waiting: MacPherson, "Living Victims."

He entered through the back door: Polly Nelson, *Defending the Devil: My Story as Ted Bundy's Last Lawyer* (New York: William Morrow, 1994), 291.

He slammed the oak log through *when investigators*: State of Florida v. Theodore Bundy, Case No. 78-670, testimony of Raymond Crew and Henry Newkirk; Tex O'Neill, "FSU Student May Have Just Missed Meeting Murderer," *Orlando Sentinel*, July 9, 1979.

One sister was actually in the communal bathroom: MacPherson, "Living Victims."

CHAPTER 6

Nita saw: Testimony of Nita Neary, State of Florida v. Theodore Bundy, Case No. 78-670.

She hurried upstairs: Amy Wilson, "Sisters in Grief," *Chicago Tribune*, January 23, 1989.

Nita and Nancy looked at the bloody face: Wilson, "Sisters in Grief."

posttraumatic delirium: Mario Ganau, Andrea Lavinio, and Lara Prisco, "Delirium and Agitation in Traumatic Brain Injury Patients: An Update on Pathological Hypotheses and Treatment Options," *Minerva Anestesiologica* 84, no. 5 (2018), 632–640.

One of the sisters, Diane: MacPherson, "Living Victims."

Police told the sisters: Gene Miller and James Buchanan, "Bundy's Cool as He Tests Cop Who Found Bodies," *Miami Herald*, July 10, 1979.

She told the police officer through *He thought he was protecting*: Tex O'Neill, "Bundy Jury Hears Grisly Details," *Orlando Sentinel*, July 8, 1979.

His next victim: Don Pride, "Theodore Bundy: A Psychiatric Portrait," *Tallahassee Democrat*, August 5, 1979.

The walls were so thin through *One of the women called her boyfriend*: Rick Barry, "Gory Night Recalled During Bundy Trial," *Tampa Tribune*, July 10, 1979; Don Pride, "Bundy Jury Hears Testimony on Night of Horror at FSU," *Tallahassee Democrat*, July 10, 1979.

The dispatcher didn't anticipate mass murder: Miller and Buchanan, "Bundy's Cool."

CHAPTER 7

My roommate's family was local: Transcript of podcast *You Matter*, episode 77, New York University, September 21, 2021, https://www.nyu.edu/life/safety-health-wellness/campus-safety/you-matter--podcast/episodes/episode-77--karen-chandler-pryor--ted-bundy-survivor.html.

Back in Fort Lauderdale: Emilie Le Beau Lucchesi interview with source, February 1, 2022.

Nora's mom, Goody: Lucchesi interview.

Cocoanut Grove nightclub in Boston: Emilie Le Beau Lucchesi, "Living with Anticipatory Grief," *Discover*, January 18, 2022, https://www.discovermagazine.com/mind/living-with-anticipatory-grief.

studies on anticipatory grief: Lucchesi, "Living with Anticipatory Grief."

Tony had been the houseboy: Emilie Le Beau Lucchesi, interview with source, January 31, 2022.

The university immediately put out a statement: Statement, Florida State University, Department of Public Safety, January 15, 1978.

candlelight vigil: "Sobbing Students Say Goodbye," *Miami News*, January 17, 1978; James Cramer and Deanna Thompson, "Shadow of Murder Looms over Campus," *Tallahassee Democrat*, January 16, 1979.

Male students slept in the hallways: Denise Williams Newman, "40 Years Ago, Ted Bundy Terrified City with Chi Omega Murders," *Tallahassee Democrat*, January 13, 2018, https://www.tallahassee.com/story/life /2018/01/13/lest-we-forget-remembering-margaret-and-lisa /1026999001/.

Tony called: Lucchesi interview with source, January 31, 2022.

Nora came up: Lucchesi interview with source, February 1, 2022.

CHAPTER 8

The morning after the attacks: Don Pride and David Schultz, "Jury Finds Bundy Guilty," *Tallahassee Democrat*, July 25, 1979.

Serial killers have been known: Robert D. Keppel and Richard Walker, "Profiling Killers: A Revised Classification Model for Understanding Sexual Murder," *International Journal of Offender Therapy and Comparative Criminology* 43, no. 4 (1999): 417–437; Vernon J. Geberth, *Sex-Related Homicide and Death Investigation: Practical and Clinical Perspectives* (Boca Raton, FL: Taylor & Francis, 2010), 455.

Think of the BTK strangler: Katherine Ramsland, *Confession of a Serial Killer: The Untold Story of Dennis Rader, the BTK Killer* (Lebanon, NH, University Press of New England, 2016), 1.

The murder of the family: Ramsland, 91.

The officer explained that he needed me: Tallahassee police files, Death Investigation: Levy and Bowman, 78-00083, #44-9.

In the coming weeks: Michaud and Aynesworth, *Ted Bundy* (1989), 187.

By this point: FBI Vault file, part 1 of 3.

During the second week of February: Stephen G. Michaud and Hugh Aynesworth, *The Only Living Witness: The True Story of Serial Sex Killer Ted Bundy* (Authorlink, 1999), 189.

One student, Leslie: Frank DeLoache and Virginia Ellis, "Bundy Tried to Pick Me Up, Girl Says," *St. Petersburg (FL) Times*, February 22, 1978.

Bundy tried a line: Michaud and Aynesworth, *Only Living Witness*, 190.
Bundy drove the next day to Lake City: Michaud and Aynesworth, 10.
One witness later testified: Bundy v. Dugger, 850 F.2d 1402 (11th Cir. 1988).
Her remains: Michaud and Aynesworth, *Only Living Witness*, 10.
The former paramedic: Bundy v. Dugger, 850 F.2d 1402 (11th Cir. 1988);
 J. Craig Crawford, "Execute Bundy Next Tuesday, Governor Orders,"
 Orlando Sentinel, January 17, 1989.

CHAPTER 9

She twice emailed: Emilie Le Beau Lucchesi, emails to Leslie Herington,
 February 1 & 3, 2022; Emilie Le Beau Lucchesi, certified letter to
 Herington, February 16, 2022.
Time was running out: George R. Dekle Sr., *The Last Murder: The
 Investigation, Prosecution, and Execution of Ted Bundy* (Santa Barbara,
 CA: ABC-CLIO, 2011), 15.
Bundy was indeed: Michaud and Aynesworth, *Only Living Witness*, 191.
In the second week of February: Dekle, *Last Murder*, 13; Michaud and
 Aynesworth, *Ted Bundy* (1989), 64; Michaud and Aynesworth, *Only
 Living Witness*, 198.
A few days later: Michaud and Aynesworth, *Only Living Witness*, 192.
At the Pensacola jail: Dekle, *Last Murder*, 49; Allie Norton, "Bundy's Last
 Stop: Recounting a Serial Killer's Arrest 40 Years Earlier," WEAR-TV,
 February 13, 2018, https://weartv.com/news/local/bundys-last-stop
 -recounting-a-serial-killers-arrest-40-years-later.
Bundy was now the prime suspect: Thomas E. Slaughter, "Ted Bundy: His
 Case Has More than One Story," *News-Press* (Fort Myers, FL), July 30,
 1978.
He had been at the Chi Omega house: Kleiner interview with Katsaris,
 December 2019.
Katsaris made him wear a leg brace: Slaughter, "Ted Bundy: His Case."

CHAPTER 11

But Sheriff Ken Katsaris: Dekle, *Last Murder*, 85; Thomas Slaughter, "Bundy
 Dental Impressions Taken for Murder Probe," April 28, 1978, *Bradenton
 (FL) Herald*; Colin Evans, *The Casebook of Forensic Detection: How
 Science Solved 100 of the World's Most Baffling Crimes* (New York:
 Penguin, 2007), 153.

The police had looked into the victims' lives: Tallahassee police files, Death
 Investigation: Levy and Bowman, 78-00083.
Bundy stepped off the elevator: Slaughter, "Ted Bundy: His Case"; Jim McGee,
 "Bite Marks Are Key Part of Evidence in Sorority Murder," *News-Press*
 (Fort Myers, FL), July 3, 1979; Carol DaRonch, "Raw Unedited Full Ted
 Bundy Indictment Reading," YouTube, March 2, 2022, https://www
 .youtube.com/watch?v=cD2BYhl1Oq4.

CHAPTER 12

Bundy wanted a Georgia attorney: Theodore Robert Bundy and Milliard C.
 Farmer, Jr. v. John A. Rudd and Charles McClure, Writ to the Supreme
 Court of the United States, October 1978, Case No. 78-670; State of
 Florida v. Theodore Robert Bundy, Order Denying Admission Pro Hac
 Vice, Circuit Court of the 2nd Judicial Circuit, Case No. 78-670; "Judge:
 Atlanta Attorney Can't Represent Bundy," *Miami Herald*, August 4, 1978.
He had the Georgia attorney file: "Ruling Expected on Bundy's Complaint
 over Jail Conditions," *Tampa Bay Times*, August 31, 1978; "Court Order
 Backs Bundy," *Spokane (WA) Daily Chronicle*, November 3, 1978.
Minerva had negotiated a plea: Theodore Robert Bundy v. Richard L.
 Dugger, United States District Court, M.D. Florida, Orlando Division,
 No. 86-968-CIV-ORL-18, December 22, 1987.
the manual used by mental health professionals: American Psychiatric
 Association, *Diagnostic and Statistical Manual of Mental Disorders*, 5th ed.
 (Washington, DC: American Psychiatric Association, 2013), 271–272.
In May 1979: "Woman's Death Believed Suicide," *Pensacola (FL) News*, May
 2, 1979.
In the spring of 1979: State of Florida v. Theodore R. Bundy, deposition of
 Kathy Kleiner, Leon County Courthouse, April 16, 1979.

CHAPTER 13

"No Cake": Barbara Frye, "There's No Celebration for Bundy's Birthday,"
 Tallahassee Tribune, November 25, 1979.
"Bundy Seeks": "Bundy Seeks Dental Care," *Miami Herald*, March 24, 1979.
He motioned through Bundy griped: Robert D. Shaw Jr., "Pretrial Witness
 Interviews by Bundy Must Be Public," *Miami Herald*, April 12, 1979.
The prosecution brought in: "Judge: Bite Marks Linking Bundy to Killings
 Admissible," *Miami Herald*, May 23, 1979.

Around that time: "Spenklink Attorney Named to Aid Bundy," *Miami Herald*, June 5, 1979; Gene Miller, "Bundy Trial Shifted to Miami," *Miami Herald*, June 13, 1979.

"fat payoff": Edna Buchanan, "Fired Stewardess Sues for Fat Payoff," *Miami Herald*, June 25, 1979.

The trial resumed: Gene Miller, "Nation's Eyes on Bundy," *Miami Herald*, June 25, 1979.

One headline called it: Gene Miller, "Bundy Trial Begins—Tediously," *Miami Herald*, June 26, 1979.

One man admitted: Miller, "Bundy Trial Begins."

Bundy's team filed several pretrial motions: "Judge Delays Decision on Evidence Until After Bundy's Jury Picked," *Miami Herald*, May 15, 1979.

In early July, Bundy's team challenged Nita's through *the judge dismissed the motion*: "Defense Tries to Match Bundy Profile," *Miami Herald*, July 6, 1979.

The next day focused through *"my attorneys are entirely unprepared"*: Gene Miller, "Policeman: Bundy 'Felt Like a Vampire,'" *Miami Herald*, July 7, 1979.

Opening statements through *which meant Haggard had to withdraw his statement or rephrase it*: Gene Miller, "'Fantasy Tape' Barred from Bundy trial," *Miami Herald*, July 8, 1979.

CHAPTER 14

My roommate went first through *The prosecutor had no more questions for me*: ABC News, raw footage, Ted Bundy trial, VideoSource Collection, Archive .org, https://archive.org/details/bandicam-2021-09-29-01-20-37-183.

One of the jurors shook her head: Gene Miller and James Buchanan, "Survivors Recall Only Sleep, Pain," *Miami Herald*, July 10, 1979.

Melanie, who was Margaret's good friend: Miller and Buchanan, "Survivors Recall."

Another sister, Carol: Miller and Buchanan, "Survivors Recall."

He pressed the officer: Miller and Buchanan, "Survivors Recall."

Bundy wanted to hear: ABC News, raw footage, Ted Bundy trial.

called the testimony "too gruesome": Gene Miller and James Buchanan, "Jury Views 'Gruesome' Photos," *Miami Herald*, July 12, 1979.

hoped that Lisa's parents: Miller and Buchanan, "Survivors Recall."

CHAPTER 15

He listened to the tapes: Gene Miller, "Slipping Out or 'Fitting In' Simple for Bundy, *Miami Herald*, July 11, 1979.

in Ann Arbor: Mark Pinsky, "The View from Ted Bundy's Cell: A Conversation with the Accused Murder," *Tropic* (*Miami Herald*), March 4, 1979.

The prosecution began by displaying through *it was a disgraceful character attack:* Miller and Buchanan, "Jury Views 'Gruesome.'"

The Dunwoody victim through *unrelated to her client:* ABC News, raw footage, Ted Bundy trial.

The prosecution began introducing evidence through *scissors to cut them off:* Gene Miller and James Buchanan, "Bundy Jury Won't Hear About Mask," *Miami Herald*, July 13, 1979.

The prosecution called an expert through *I couldn't handle this:* Gene Miller and James Buchanan, "Hair in Mask Like Bundy's Expert Says," *Miami Herald*, July 17, 1979.

With his case weakened through *"Giddy up":* Gene Miller and James Buchanan. "Bundy in Contempt After Jail Incident," *Miami Herald*, July 18, 1979.

They questioned two young men: Miller and Buchanan, "Bundy in Contempt"; Don Pride, "Judge Cites Bundy for Contempt After Tantrum," *Tallahassee Democrat*, July 18, 1979.

Nita came to testify that afternoon through *Not the houseboy:* ABC News, raw footage, Ted Bundy trial.

They called a dental expert: Gene Miller and James Buchanan, "Expert Says Bite Marks Are Bundy's," *Miami Herald*, July 19, 1979.

gave their final statements: ABC News, raw footage, Ted Bundy.

she said she would like to wring Simpson's neck: Rick Barry, "Bundy Guilty of Two Slayings," *Tampa Tribune*, July 25, 1979.

Bundy stared straight ahead through *"so say we all":* ABC News, raw footage, Ted Bundy.

Two guards blocked the main entrance through *but they had access to Bundy:* Patrick McMahon, "Bundy Guilty, All Counts," *St. Petersburg Times*, July 25, 1979; ABC News, raw footage, Ted Bundy.

"I haven't lost any sleep": "Bundy: I Haven't Lost Sleep About the Verdict," *Anderson (SC) Independent*, July 28, 1979.

Louise Bundy portrayed: "State Urges Death Penalty," *Palm Beach (FL) Post*, July 29, 1979; "We Know He Is Innocent," *Boca Raton (FL) News*, July 25, 1979; Tex O'Neill, "Jury Asks for Execution for Bundy," *Orlando Sentinel*, July 31, 1979.

"See you at the next trial": O'Neill, "Jury Asks for Execution."

Before he gave his verdict: George Thurston, "Judge Sentences Ted Bundy to Death in the Electric Chair," *News Tribune* (Tacoma, WA), July 31, 1979.

The state was paying: "Bundy's $120,000 in Legal Fees Paid," *Miami Herald*, August 12, 1979.

In the coming months, Mama had: S. Lynne Walker, "Bundy's Behavior in Courtroom Triggers Memory of Woman," *Tampa Times*, January 22, 1980; Neil Chethik, "Bundy Trial Calls Family of Dead Girl," *Tallahassee Democrat*, January 22, 1980; Neil Chethik, "Witnesses May Point to Bundy," *Tallahassee Democrat*, January 22, 1980.

During the mitigation hearing: Rick Barry, "Bundy, Girlfriend Wed Before Jury Asks Death," *Tampa Tribune*, February 12, 1980.

"Tell the jury they were wrong": Miriam Conrad, "Jury Calls for Death of Bundy," *Miami Herald*, February 10, 1980.

He also agreed with Judge Cowart: "Wasted Life'; Bundy Gets 3rd Death Sentence," *Spokesman-Review* (Spokane, WA), February 13, 1980.

CHAPTER 17

The State of Florida paid his legal bills: Ken Cummins, "Washington Firm Spent $1 Million to Defend Bundy," *South Florida Sun-Sentinel*, January 29, 1989; Nelson, *Defending the Devil*, 327–328; Linda Kleindienst, "Bundy Has Cost the State About $7 million," *South Florida Sun-Sentinel*, January 18, 1989.

The Supreme Court had rejected a writ: Theodore Robert Bundy v. Florida, 479 U.S. 894, 107 S.Ct. 295, 93 L.Ed.2d 269, No. 85-6964 (1986).

Bundy soon had a new attorney through *"her baby"*: Nelson, *Defending the Devil*, 27.

She motioned the Florida Supreme Court: 850 F.2d 1402, 25 Fed. R. Evid. Serv. 322, Theodore Robert Bundy v. Richard L. Dugger, No. 86-3773, United States Court of Appeals (11th Cir., 1988).

Nelson admitted: Nelson, *Defending the Devil*, 42.

The Supreme Court declined to review the cert in May: "Judge Delays Bundy's Date with Death," *Savannah (GA) Morning News*, July 2, 1986; Nelson,

Dancing with the Devil, 67; Monte Plott, "Furor Aroused over Bundy's Fate," *Dayton (OH) News*, July 2, 1986; Monte Plott, "Demonstrators Wait, Watch as Bundy Gets One More Stay," *Atlanta Constitution*, July 2, 1986.

she also filed three petitions: "2 Appeals by Bundy Rejected," *Chicago Tribune*, July 1, 1986; "Lawyers for Ted Bundy Will Ask a Judge Monday to Overturn His Conviction," United Press International, June 28, 1986, https://www.upi.com/Archives/1986/06/28/Lawyers-for-Ted-Bundy-will -ask-a-judge-Monday/6515520315200/.

Cowart approved two of the petitions: Nancy McVicar, "Cowart Rejects Latest Bundy Appeal," *Miami News*, June 30, 1986; Diane Hirth, "Chronology: Ted Bundy's Florida Criminal History and Days in Court," *South Florida Sun-Sentinel*, January 22, 1989.

Nelson expressed her disappointment: Nelson, *Defending the Devil*, 94.

She wrote in her memoir that through *deep thinking*: Nelson, 22.

Bundy was scheduled to die the week: Brent Kallestad, "Florida Supreme Court Rejects Bundy's Appeal," Associated Press, January 20, 1989, https://apnews.com/article/01925eecbb3479ef646c0cdcfc3160da.

by the end of 1988: Dave Von Drehle, "Killer Running Out of Options," *Kansas City Star*, December 18, 1988; "Experts Predict 1989 Death for Serial Murder Bundy," *Evansville (IN) Press*, December 12, 1988; Dave Von Drehle, "Bundy's Last Stand," *Bradenton Herald*, December 11, 1988.

CHAPTER 18

prison superintendent had ordered a test: Roger Roy and Craig Dezern, "Hundreds Celebrate Execution," *Orlando Sentinel*, January 25, 1989.

Supreme Court had denied: Michelle Cohen, "Bundy Loses Appeal; Death Warrant Signed," *South Florida Sun-Sentinel*, January 18, 1980; Mark Silva, "Court Rules Against Bundy; Execution Date Set," *Boca Raton News*, January 18, 1989; "Judge Rejects Bundy Case; State Justices Last Resort," *South Florida Sun-Sentinel*, January 20, 1989.

The Friday before the execution, he began confessing: "Martinez: State Won't Bargain with Bundy to Delay Execution," *Boca Raton News*, January 19, 1989; "State Won't Delay Bundy Execution," *Boca Raton News*, January 21, 1989.

including Georgann Hawkins: Diane Hirth, "Bundy Becomes Subdued; Emotional with Psychiatrists," *South Florida Sun-Sentinel*, January 24, 1989.

The Washington investigator: Donna O'Neal, "Bundy's 'Tell All' Scheme—Play Victims' Families for Time," *Orlando Sentinel*, February 22, 1989.

As the weekend progressed, Bundy admitted to murdering thirty: "Bundy Tells Investigators of Slayings in Other States," *Boca Raton News*, January 22, 1989; "Bundy Opens Up About Unsolved Slayings," *South Florida Sun-Sentinel*, January 22, 1989.

Lynda Healy through *Susan Rancourt*: Hirth, "Bundy Becomes Subdued"; "Ted Bundy's Trail of Death," *Palm Beach Post*, January 25, 1989.

interview with religious broadcaster James Dobson: Ron Word, "Bundy Loses Last Appeal, Set to Die at 7 a.m.," *Boca Raton News*, January 24, 1989; "Bundy's Last Interview: I Deserve Punishment," *South Florida Sun-Sentinel*, January 25, 1989; "Bundy on Tape: 'I Deserve Most Extreme Punishment,'" *Boca Raton News*, January 25, 1989; "The Last Testament of Ted Bundy," *South Florida Sun-Sentinel*, January 29, 1989.

sexually sadistic serial killer: Janet I. Warren, Robert R. Hazelwood, and Park E. Dietz, "The Sexually Sadistic Serial Killer," *Journal of Forensic Science* 41, no. 6 (1996): 970–974.

His mother told reporters: "My Precious Son," United Press International, January 24, 1989, https://www.upi.com/Archives/1989/01/24/My-precious-son/2196601621200/.

"You'll always be my precious son": "My Precious Son," UPI.

last meal: Charles Holmes, "Most Outside Prison Cheer Electrocution," *Palm Beach Post*, January 25, 1989.

inmates serving breakfast: Rule, *Stranger Beside Me*, 475.

His hands were shackled: Roy and Dezern, "Hundreds Celebrate Execution"; Florida Department of Corrections (FDOC), "Execution by Electrocution Procedures."

Bundy cried: Barry Berak, "Bundy Electrocuted After Night of Weeping, Praying," *Los Angeles Times*, January 24, 1989.

connection with the governor's office: Berak, "Bundy Electrocuted."

more murders to confess: "Utah, Colorado Victims' Whereabouts Revealed," *Tallahassee Democrat*, January 27, 1989.

Her father, Donald Blackburn: Dirk Johnson, "For Families, Killer's Death Eases Doubts but Not Pain," *New York Times*, February 13, 1979.

There had been rumors: Donna O'Neal, "News of Death Touches Off Celebrations, Grisly Jokes," *Orlando Sentinel*, January 25, 1989.

Two guards brought the condemned: FDOC, "Execution by Electrocution Procedures"; Dave Von Drehle, "Execution Follows Confessions," *Boca Raton News*, January 25, 1989.

Bundy if he had any last words: Von Drehle, "Execution Follows Confessions."

"There are no stays": Roy and Dezern, "Hundreds Celebrate Execution."

executioner pulled the lever: Roy and Dezern, "Hundreds Celebrate Execution"; Berak, "Bundy Electrocuted After Night."

"The sentence of Florida": "Von Drehle, "Execution Follows Confessions"; Roy and Dezern, "Hundreds Celebrate Execution."

crowd erupted into cheers: Holmes, "Most Outside Prison Cheer Electrocution."

Bundy's remains: "Bundy Wanted Cremation, Ashes Spread over Cascades," Associated Press, January 25, 1989, https://apnews.com/article /dee0f69d1b24a612c64e963683bdd77b.

candlelight vigil: Charles Holmes, "Carnival Mood Marks Death Watch," *Palm Beach Post*, January 25, 1989.

Eleanor Rose: Johnson, "For Families, Killer's Death Eases."

Belva Kent had lost: Christopher Scanlan, "A Porch Light Stays On, Though Hope Has Gone," *St. Petersburg Times*, July 8, 1986.

APPENDIX A: WOMEN AND GIRLS WHO LOST THEIR LIVES TO BUNDY

Anonymous Hitchhiker: "The Victims," *News Tribune*, January 22, 1989.

Ann Marie Burr: Tess Wagner, "Did Ted Bundy Kill His First Victim When He Was 14? Police Not Ruling Him Out in Tacoma Cold Case," KING-5 (NBC affiliate), November 8, 2019, https://www.king5.com/article /news/local/did-ted-bundy-kill-his-first-victim-when-he-was-14/281 -14a065de-dba1-4ff8-a882-14d32f57228c.

Brenda Joy Baker: "The Victims," *News Tribune*.

Brenda Ball: "Missing Persons List Grows to Seven Women," *Daily Chronicle* (Centralia, WA), August 7, 1974; "The Victims," *News Tribune*.

Carol Platt Valenzuela: "The Victims," *News Tribune*.

Caryn Campbell: "Frozen, Nude Body of Woman Identified," *Daily Sentinel* (Grand Junction, CO), February 19, 1975; Valerie McNay, "Eulogy to a Murdered Friend," *Parsons (KS) Sun*, January 28, 1989.

Debra Kent: "Salt Lake City Airtel to Bureau," Salt Lake City Division, March 27, 1975, FBI files, part 3 of 3, p. 68; Scanlan, "A Porch Light Stays On"; Andrew Adams, "DNA Evidence Confirms Remains of Utah Bundy Victim," KSL-TV (NBC affiliate), March 12, 2019, https://ksltv .com/409756/dna-evidence-confirms-remains-utah-bundy-victim/.

Denise Naslund: "Bones Are Remains of 2 Missing Women," *Daily Chronicle*, September 11, 1974; "The Victims," *News Tribune*; Ted Bundy confession to Robert Keppel on January 22, 1989, Florida State Prison, Raiford, Florida.

Denise Nicholson-Oliverson: "Police Look for Missing Woman," *Daily Sentinel*, June 24, 1975.

Donna Manson: "Resolved: College Coed Died at Bundy's Hands," *Bellingham (WA) Herald*, July 28, 1989; Ted Bundy confession to Robert Keppel on January 20, 1989, Florida State Prison, Raiford, Florida.

Elizabeth Perry: "Investigator: Bundy May Have Killed More than 100," Associated Press, January 26, 1989, https://apnews.com/article/662ac77f 95cdc7d9490d3a9bbf5e68de.

Georgann Hawkins: "Georgann Hawkins Is Still Missing a Week After Her Disappearance," *Statesman Journal* (Salem, OR), June 19, 1974; "The Victims," *News Tribune*; Bundy confession, January 20, 1989.

Janice Ott: "Seattle Police Puzzled by Missing Girls," *Lubbock (TX) Avalanche-Journal*, July 24, 1974; "Bones Are Remains of 2 Missing Women," *Daily Chronicle*, September 11, 1974; Bundy confession, January 22, 1989.

Joyce LePage: Fay Tolley, "Bundy Tie to WSU Death Unresolved," *Tri-City Herald* (Kennewick, WA), January 25, 1989.

Julie Cunningham: "The Victims," *News Tribune*; "Killer, Facing Death, Is Confessing Many Slayings," *New York Times*, January 22, 1989.

Laura Aime: Ron Barker, "Slay Victim Identified as Salem Girl, 17, Investigation Intensifies," *Daily Herald* (Provo, UT), November 29, 1974; Carter; "Utah Lawmen Exposed."

Lonnie Trumbell: "2 Girls Beaten, One Dies," *Orlando Sentinel*, June 24, 1966; "The Victims," *News Tribune*; "Assaulted Stewardess Back Home," *Statesman Journal*, July 26, 1966.

Lynda Ann Healy: "The Victims," *News Tribune*.

Lynette Culver: "Lynette Culver Goes Missing from Pocatello, Idaho," *Idaho State Journal*, May 12, 1975; "Interview Identifies Victim, 12, in Idaho," *Orlando Sentinel*, January 25, 1989.

Melanie "Suzy" Cooley: "The Victims," *News Tribune;* "Nederland Woman Died of Blows to Head," *Fort Collins Coloradoan,* May 9, 1975.

Melissa Smith: "Melissa Smith Still Missing; Police Seek Help in Search," *Jordan Valley Sentinel* (Midvale, UT), October 24, 1974; Carter; "Utah Lawmen Exposed."

Nancy Baird: Carter, "Utah Lawmen Exposed."

Nancy Wilcox: "The Victims," *News Tribune.*

Rita Jolly: "The Victims," *News Tribune;* "Daughter Remains Missing," *Statesman Journal,* July 15, 1973.

Roberta "Kathy" Parks: "Reward Offered for OSU Coed," *Statesman Journal,* May 14, 1974.

Sandra Weaver: FBI files, part 3 of 3, "To: Salt Lake City Division, From: Harry L. Lee" (memorandum), February 7, 1975, p. 63.

Shelley Robertson: "Execution Relieves Many Victims' Families," *Minneapolis Star Tribune,* January 25, 1989.

Susan Curtis: "Police Ask Help Locating a Girl," *Daily Herald,* July 4, 1975.

Susan Davis: Klahn, "Investigator: Bundy May Have."

Susan Rancourt: "Parents Ask Help in Finding Susan," *Daily Chronicle,* April 30, 1974; Michaud and Aynesworth, *Only Living Witness,* 26–30; Mike Prager, "Anguish and Waiting Ends," *Spokesman-Review,* January 25, 1989.

Vicki Lynn Hollar: "Are Missing Women Dead or Abducted by Space People?" *Greater Oregon* (Albany, OR), December 21, 1983.

APPENDIX B: SETTING THE RECORD STRAIGHT

Alice Watts, Bob Partlow, and Mike Oakland, "Does Bundy Have Answers to More than 30 Killings?" *Olympian* (Olympia, WA), June 22, 1986.

ABOUT THE AUTHORS

Kathy Kleiner Rubin is a sought-after motivational speaker who specializes in survivor impact. Since 2018, Kleiner Rubin has been sharing her story with audiences eager to hear of her courage and survival. She has spoken to universities, law enforcement agencies, forensic nursing organizations, and true crime conventions. Kleiner Rubin has given dozens of interviews to the country's top news agencies including CBS News, *48 Hours*, *20/20*, *USA Today*, CNN, and *Newsweek*. She has also been interviewed in *Vanity Fair*, *Cosmopolitan*, and *People*. Kleiner Rubin lives in South Florida with her husband and dog.

Emilie Le Beau Lucchesi is the author of *Ugly Prey* and *This Is Really War*. She is a regular contributor to *Discover* magazine and her work has appeared in the *New York Times*, *Chicago Tribune*, *Atlantic*, and the nation's other top newspapers. She lives in the Chicago area with her husband and three dogs.